How to Draw Awesome Stuff

CHILLING CREATIONS

A DRAWING GUIDE FOR ARTISTS, TEACHERS, AND STUDENTS

FROM THE BESTSELLING AUTHOR OF
How to Draw Cool Stuff

Catherine V. Holmes

HOW TO DRAW
AWESOME STUFF

Catherine V. Holmes

HOW TO
DRAW
COOL
STUFF

Library Tales Publishing
www.LibraryTalesPublishing.com
www.Facebook.com/LibraryTalesPublishing

For general information on our other products and services, please contact our Customer Care Department at 1-800-754-5016, or fax 917-463-0892. For technical support, please visit www. LibraryTalesPublishing.com

Library Tales Publishing also publishes its books in a variety of electronic formats.

*** PRINTED IN THE UNITED STATES OF AMERICA ***

ISBN-13
978-1-956769-80-7
978-1-956769-79-1

About the Author

Catherine V. Holmes is a mother, artist, art educator, and author of the "How to Draw Cool Stuff" and "The 15 Minute Artist" series of drawing books.

Holmes previously taught students in the juvenile justice system, helping to educate, rehabilitate and create a positive social-cultural outlet for court-involved youth working towards their educational, behavioral and vocational goals. Because of this experience, Holmes is a firm believer that exposure to the arts is crucial with benefits that include improving our quality of life and well-being, enhancing self-esteem, reducing stress and offering a sense of accomplishment.

As well as teaching students in the classroom, Holmes is also an online instructor for Craftsy.com, focusing on interactive lessons that teach drawing dimension through shading techniques.

Currently, Holmes is teaching visual art to an amazing school of elementary students, including her twin daughters Charlotte and Taya Cate.

TABLE OF CONTENTS

How to Draw Awesome Stuff!

DEDICATION

As always, for Charlotte and Taya Cate.

FOREWORD

Welcome to the wonderful world of drawing, where creativity and imagination take center stage! **How to Draw Awesome Stuff** is an indispensable step-by-step drawing guide by Catherine V. Holmes, author of the bestselling **How to Draw Cool Stuff** series. This book was designed for those who dare to explore the darker and more unconventional side of drawing. Within these pages, you'll learn how to create creepy and scary images that are sure to give your friends and family nightmares, and the best part? All of the lessons in this book have been student-tested and teacher approved. That means you can trust that each project is engaging and effective for students of all ages.

This book is jam-packed with interesting and informative drawing lessons that offer clear objectives and foster achievement, all without the need for expensive or multi-dimensional supplies. Whether you are new to the world of drawing or an intermediate artist, this book will provide you with the necessary tools and inspiration to unleash your creativity and inspire your creative spirit. With easy-to-follow tutorials, you'll learn how to recognize the basic shapes within objects, and how to use these shapes to create images that are both dynamic and visually stunning.

I have designed these tutorials to be as straightforward and accessible as possible; each step is broken down into easy-to-follow instructions, allowing you to follow along at your own pace. Typically, we will start simple with foundational shapes, and build incrementally to more intricate details like shading and depth. I have also included tips and tricks along the way that will help you refine your technique and produce truly unique, impressive artwork.

So how did all of this come to be? As an art teacher, I've always struggled to find the perfect "how to draw" resource. Despite my scouring art catalogs, libraries, and bookstores, I never managed to find a supplement that ticked all of the boxes I was looking for. Many were too basic for my older, more advanced students; meanwhile, others were heavy on artwork but light on

actual instruction. That's when I decided to take matters into my own hands and create a series of books that met all of my needs as a traveling art teacher. I also suspected that I wasn't alone in my strife. I wanted a resource that was easy to transport, that was streamlined, and, more importantly, that could be used to teach students of all levels, from middle school to high school and beyond. I'm excited to share it with you now.

With my **How to Draw Cool Stuff** series, and specifically, this **How to Draw Awesome Stuff** addition, you will not only develop your drawing skills, but you will also tap into your imagination and learn to express yourself in new, exciting ways. Whether you're yearning to draw a handsome female foot (obviously) or to bring your darkest nightmares to life with a strange monster or a creepy spider with the head of a baby, this book has got you covered.

So, grab your pencils, pens, and paper, and let your imagination run wild! With **How to Draw Awesome Stuff**, you will discover the joy of drawing and the satisfaction of creating something truly unique and unforgettable. Let's get started!

The Process

Creating art is a personal experience for every artist. While some artists need to follow every step of a tutorial to achieve their desired result, others may not require as much structure in their approach. Every artist is different, and it's important to find a balance that works best for you.

To achieve a successful outcome when following these tutorials, it's crucial to keep a few tips in mind:

• For beginner artists, do not skip any of the steps! Even though it may appear to be the quicker option, skipping steps can result in frustration and an unsatisfactory outcome. I have structured these lessons specifically to make sure you are able to build on a comprehensive foundation. Start simple. It'll make the more complex steps simpler as well. It's best to follow the sequence of steps in each tutorial to ensure the best possible outcome.

• When sketching out the basic outline, draw lightly. This allows for easier erasing and reduces the likelihood of crumpling up and throwing away paper. Many of the tutorials begin with guidelines that will be erased later, so using lighter marks is a must.

• While it's natural to want to replicate an exact copy of the image in the tutorial, it's best to embrace your personal artistry! It's okay, and even preferable, that you add personal touches and extras to make it uniquely you. This adds a personal touch and makes each drawing stand out as original.

• If a drawing appears to be too challenging, taking a break can help. Stepping away from the work and coming back with fresh eyes can offer new ideas and approaches for all artist levels. Even the Greats need a new perspective now and then.

• If a tutorial appears overwhelming, a helpful tactic is to cover all the steps with paper so that you cannot see them. Once you complete said step, uncover the next and repeat. This simple approach breaks down the challenge of creating an image, allowing the artist to focus on one action at a time. It also prevents one from being tempted to skip ahead.

In conclusion, creating art is a process that takes time and effort, and every artist approaches the process differently. But the one thing that most can agree on, is patience. Rushing through the process will not yield the desired result. Begin with the first step and build from there; take your time and practice; examine your artwork to determine which lines work and which do not; and if necessary, step away and take a break!. And don't forget, this is *your* piece of art, don't be afraid to explore your style. Follow these tips and before you know it, you'll find that creating art can be both a rewarding and enjoyable process.

All that said, this book provides specific information on how to draw images from a particular point of view. *Advanced artists* may want to challenge themselves by changing an image to suit their personal desired outcomes or take their art to the next level by combining images to create an even more unique piece of artwork. I said they were tips, not rules!

Supplies

To fully engage and follow along with the artwork presented in this book, you will require the following materials:

- 4B, 6B and 8B pencils
- A charcoal pencil
- A mechanical pencil
- Kneaded erasers and a blending stump.
- A fine marker
- A drawing paper pad (or an iPad with an Apple Pencil)
- A good supply of coffee or tea, and a "can do" attitude!

Shading

Shapes and forms make up the world as we know it; they are found in nature and so, are also found and used in the composition of paintings, sculptures, and (you guessed it) drawings. The basic geometric "shapes" that are used in art are referred to as two-dimensional or 2D; having only width and height, but no appearance of depth. "Forms", meanwhile, are three-dimensional or 3D– having the appearance of width, height and depth. Along with these geometric shapes and forms, there are also organic shapes and forms (also known as free form or biomorphic shapes). These are also depicted in art, and are frequently found in nature as well, though they do not have formal names (i.e. square or circle). Using basic forms when drawing an object helps simplify the process by making it easier to see what shapes make up said object. It is then that the artist can successfully show height, width, and depth. Shadows added to these forms enhance the perception of depth, and ultimately make the art appear more realistic and three dimensional. Use of blending, contrast, highlights, shading, shadows, and value scale accomplishes this and refines the desired effect: a realistic drawing.

Once shading and light sources are reviewed, forms can then be turned into recognizable objects. Shapes and forms can be seen in almost every object (or subject) imaginable. Although an object may not perfectly resemble a specific form, there are always basic forms present in some manner. Think of shapes and forms as the building blocks of the object you're trying to depict. Once you identify the forms, you can then express the realism of your object through shading and other detail oriented techniques.

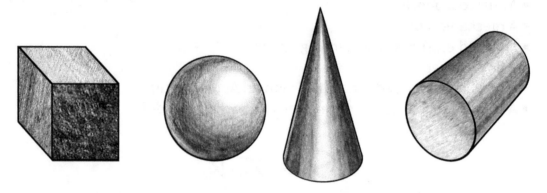

Shading is one of the easiest ways to add depth, contrast, character and movement to your drawings. Shading captures the shadows and highlights within an image to help make artwork more realistic and interesting.

You may want to invest in a few specialized art pencils that are made specifically for shading or sketching. Specialized artist pencils come in two major graphite categories. These categories are labeled as "H" or "B" and they measure the hardness (H) or softness (B) of the marks made by the pencils' core. Along with the "B" or "H" letter grade, the graphite will also have a number next to that letter to indicate just how soft or hard a pencil mark is.

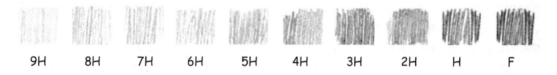

| 9H | 8H | 7H | 6H | 5H | 4H | 3H | 2H | H | F |

"H" Graphite Pencil Grading Scale

"H" stands for "hard" and refers to a hard graphite pencil. Hard pencils leave lighter, thinner marks and can sharpen to a very fine tip. These pencils are usually labeled with a number to indicate the degree of hardness followed by the letter H.

Generally, the higher the number is, the harder the pencil, and therefore, the lighter and thinner the mark will be. A 9H pencil will leave a mark that is much lighter and thinner than a 2H. Some scales will show an "F" grade between the "H" and the "HB". "F" often indicates "fine", "fine point" or "firm".

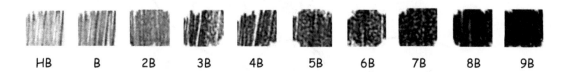

| HB | B | 2B | 3B | 4B | 5B | 6B | 7B | 8B | 9B |

"B" Graphite Pencil Grading Scale

"B" stands for "soft" and refers to a pencil that has soft graphite. Soft pencils leave darker, thicker, smudgy marks. These pencils are usually labeled with a number to indicate the degree of softness followed by the letter B. The higher the number, the softer and darker the mark will be. A 9B pencil will leave a mark that is much more smudgy and dark than a 2B. Softer pencils will dull faster than harder pencils and usually require more frequent sharpening. As you see by each chart, the scale goes up to 9 at each end, 9B being the softest to 9H being the hardest graphite. Both of these extreme ends of the scale are often too light or too dark for regular use.

Artists sometimes use a range of different pencil types in one drawing to render different effects. A hard pencil is often used for outlining, sketching, or fine mechanical work, while softer pencils, which allow for easy blending, are used for shading. Remember, these pencils are not necessary for you to be able to draw cool or awesome stuff. If only regular pencils are available – that is fine!

HB/2/2HB is by far the most common type of pencil out there and most likely the one that is most easily available.

Before you begin shading, you will need a drawing of an object or scene to shade. Draw an outline of an object from real life, a photo or one of the images in this book that shows shading. Take your time and draw lightly. Drawing lightly allows the artist to erase any mistakes easily if needed. The outline of an image on paper is often referred to as line art. When sketching a drawing that will eventually be shaded, light outlines are best, not dark. Start with a light, sketchy outline and add more detail as the drawing progresses. Once all the lines look good to you, then they can be drawn darker and more permanent.

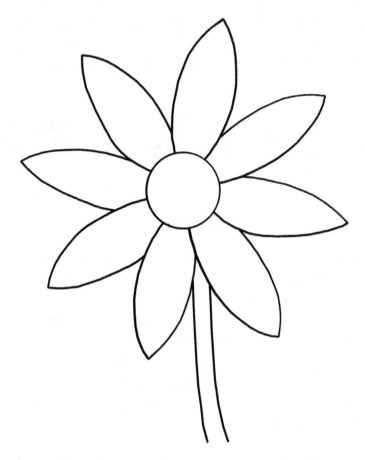

When drawing an item from life or a photo, look at the negative space around the object. Negative space is the area and spaces around the object that have no marks, whereas positive space is the area of the actual object or the area of interest. Basically, positive space is the space occupied by your subject while negative space is the space that is not your subject. The negative space in the drawing above is seen as white while the positive space is enclosed in black lines.

By paying attention to the negative space, an artist is more likely to draw an accurate representation of the object. People usually focus on the positive space in an artwork when drawing, However, for best results, it is best to pay attention to both positive and negative areas.

A value scale is a helpful tool to use when shading artwork. A value scale, also known as a gray scale, is a visual series showing the progression of a single color's value, or gradient from lightness to darkness. The lightest tint on one end is white, while the darkest expression of the color on the other, is black. The in-between is the scale of tint.

Special artist pencils are helpful but NOT necessary to create a value scale. If using a regular pencil, press gently to get light shades and harder for darker shades. By controlling the pressure of the pencil, an artist can create a variety of shades.

| white | lightest gray | light gray | gray | dark gray | black |

Different pressures will leave different marks. Notice that the darkness intensifies as shades are filled in from left to right. When used in art, a value scale translates into expression of light and shadow, or the light areas and dark areas in a drawing.

The above value scale was created by "coloring" with a back and forth motion using a regular pencil. This is a popular type of shading, especially when depth is needed in a pencil drawing. There can be hundreds of different gray tones between white and black. The value scale shown is just a small representation of the tones that can be created with your pencil.

Why is value needed in a realistic artwork? Value is a very important aspect in a drawing, perhaps even more important than color when it comes to its success. Darkness and lightness are used to create a focal point, or an area within a work that a viewer immediately looks at. A light element against a dark element creates contrast that instructs the eye on where to look. Not only does value create focal points, it also creates the illusion of three dimensional form.

SHADING STEP 1: Once you have chosen a method of shading, begin your preliminary shading within the drawing. Lightly press down on the areas of the artwork that have the deepest shadows. This is just the beginning of the process so there is no need to draw too dark too quickly, less is truly more. By keeping the initial shading somewhat light, erasing areas of highlight or mistakes will be much easier. In the preliminary shading done below, just the tips of each petal, the outside of the round center, and the right side of the stem have been lightly shaded. Only the right side has been darkened to indicate a potential light source on the left. When drawing an item from life or from a photo, it is important to locate the direction from which the light is coming, since you will be shading away from the light source; the brightest (lightest) areas will be those closest to the light source, and the darkest areas will be the furthest away.

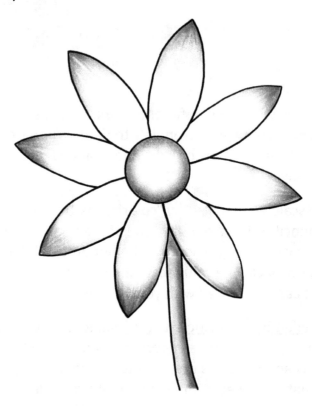

SHADING STEP 2: Once the first layer of shadows has been laid, the pencil marks should become darker and more detailed. Leaving the brightest parts of the drawing white, the middle gray tones (from your value scale) can be added, and the darker areas can be darkened even further. Lines have been drawn along the length of each petal for texture and the tips have been darkened more. The edges of the petal surrounding the center circle have been darkened slightly and the center has been filled in to be the darkest area on the drawing. Small dots (or stipples) have been added to the eye of the flower for texture as well. As you are drawing or shading any object, look at the subject frequently and compare it with the drawing to see where the main shadows and reflections lie. Keep darkening the drawing with a thin layer of shade. The contrast between light and dark areas will become more clear and distinct.

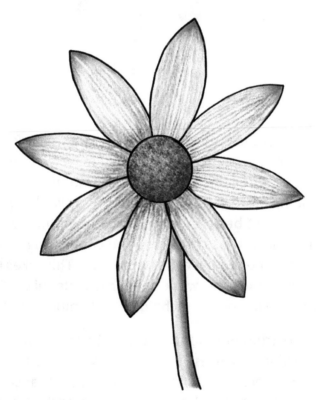

SHADING STEP 3: Continue to darken the outer edges of each petal and use your value scale as a guide. This will help the tones remain consistent throughout the shading process. As the shading deepens, the original outline of the drawing should disappear. Objects in real life don't have a solid outline around them, simply a change in value. The same goes for a realistic drawing; don't darken the outline, darken the shadows.

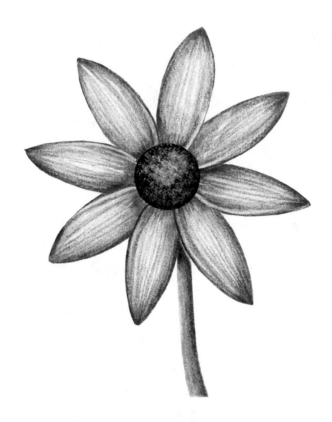

Once all of the tones are laid down, an artist may choose to blend the tones together for a smooth appearance (smudging). Fingers, cotton swabs or blending stumps can be used for this step. This will smooth out any rough edges and make the shading more gradual and realistic, as well as help with softening the original lines. Just beware of overdoing it and making mud! Rubbing too much will cause all of those fine lines and contrasting shades to smudge together and become one muddled, flat, gray tone. This takes the depth away from a drawing and makes the work appear less detailed. For best results when shading with the finger rub technique, just smudge a little!

On the opposite spectrum of shadow, the very brightest parts of the drawing (those lightest in value or closest to the light source) should stay white to create highlights or reflections. If blending was done, chances are the lighter areas have become smudged with some residual blending. This is easily fixed by gently erasing those smudged areas. Glares and reflections tend to be the brightest parts of a subject so be sure to indicate these areas in the artwork.

TIPS:

• When drawing from a photo, consider converting it to gray scale to use as a reference (make a copy of it using a copy machine on the photo setting). This will help with visualizing the shading since the object will already be in black and white.

• Having a hard time determining the dark areas from the lighter ones? Squint your eyes and these areas will become more evident.

• Using heavy pressure with your pencil will leave dark lines, as light pressure will leave light marks. A combination of both with a gradual transition from one to the other is one approach to realistic shading. Practice using different pencil pressures to create a variety of tones.

• Remember to be careful if you choose to smudge your artwork to create shading effects. When done properly, smudging can be a quick and effective way to add depth, however, smudging an artwork with a finger to create shadows can blur some intricately drawn lines and ruin a beautiful drawing. A good rule of "thumb", don't rub more than three swipes!

• If available, use different grades of pencils from hard (H) to soft (B). This can make drawing with value easier. By letting the pencils do some of the work, you won't have to press as hard with the pencil to achieve dark values. This also offers more control when adding light values.

Quick and Simple Shading

When shading an object without a specific light source, there are a few tips and tricks to use to quickly create shadows and depth.

There are more technical and detailed ways to shade an object, however, below are two methods that are quick and simple. Try them both!

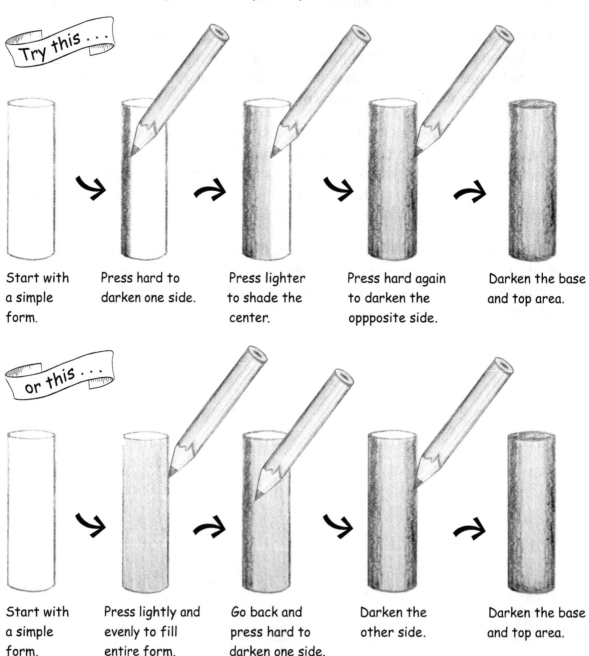

Try this . . .

Start with a simple form.

Press hard to darken one side.

Press lighter to shade the center.

Press hard again to darken the oppposite side.

Darken the base and top area.

or this . . .

Start with a simple form.

Press lightly and evenly to fill entire form.

Go back and press hard to darken one side.

Darken the other side.

Darken the base and top area.

Quick and Simple Shading 2

When shading quickly or from memory without a specific light source, it makes sense to have darker shaded areas at the bottom of the object and lighter areas near the top.

top ↘

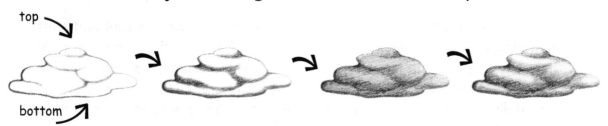

bottom ↗

For example, even an organic blob has a top and a bottom.

Darken the areas underneath each blob curve.

Shade the remaining areas lighter.

Erase some areas near the very top of each curve for a highlight.

Another example can be seen in this bowl. . .

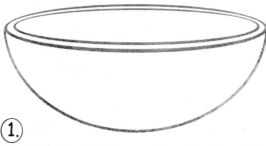

① Start with this basic bowl shape using a 1/2 oval and an ellipse. (Don't forget the inner "thickness" rim of the bowl.)

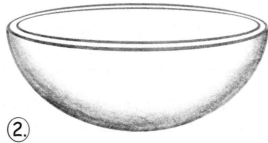

② Darken just the outer edges of the bowl using a curved motion. Follow the curve of the base.

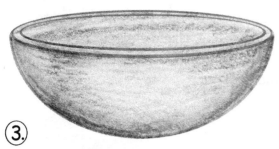

③ Shade the remaining areas of the bowl lightly until it is completely filled in.

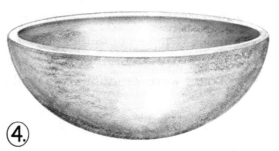

④ Darken each side of the inside area of the bowl and erase spots on the rim and centers as shown to create a highlight.

USING PENCILS

Here are some informative tips to help you create your drawing masterpieces:

• Choose your pencil wisely. Don't just grab any old writing tool and start scribbling. Pencils come in different graphite hardnesses, ranging from H (hard) to B (soft). The higher the H number, the harder the graphite, while the higher the B number, the softer the graphite. So, if you want to create fine, delicate lines, go for a hard pencil. And if you're feeling bold and want to make a statement, reach for a softer one.

• Decide on the type of line you want to create. Different pencil hardnesses produce different effects. For example, a harder pencil can produce a thin, precise line, while a softer pencil can create a thicker, darker line. So, pick the pencil that matches your desired line style.

• You can also vary the pressure you apply to the pencil to create different effects. A lighter pressure creates a lighter line, while a heavier pressure creates a darker line. So, if you're feeling frustrated with a piece, try using some anger-management techniques and apply some heavy pressure to your pencil!

• Try out different techniques. Pencils aren't just for shading in the traditional way, they can be used for different techniques, such as cross-hatching, stippling, or smudging. Don't be afraid to get a little creative and experiment with different techniques to see what works best for your project. You never know what masterpiece you might create!

• Erase with care. Pencil lines can be easily erased, but be careful not to smudge the lines or damage the paper when erasing. Use a clean eraser and gentle strokes to remove unwanted lines. And if all else fails, just pretend the smudges were intentional and call it abstract art.

Using Blending Stumps

Blending stumps are an essential tool for artists, allowing for the seamless blending of charcoal or graphite in their work. With the use of these tightly rolled paper stumps, artists can smudge and shade their drawings' light and dark values to create captivating visual effects. Personally, I find blending stumps especially useful when working with charcoal as they can spread the medium evenly across the page. In the case of graphite, I mainly use them to darken specific areas of my drawing, which saves time when working on details like clothing and backgrounds.

There are different techniques for using blending stumps effectively:

(1) Dragging the stump over your drawing can create smudged effects, while circular motions produce interesting patterns for objects such as trees and shrubs.

(2) To create a shaded effect, apply graphite to the stump by drawing tight scribbles on a scrap piece of paper before layering the graphite on your portrait with light strokes.

(3) Blending can be achieved by lightly pushing the graphite on your drawing back and forth with a clean stump until the tones blend together seamlessly. When working with light values, a clean blending stump should always be used, and tissue paper is ideal for the lightest areas. For dark values, the grooves in the paper caused by graphite can be filled by the use of a blending stump to achieve a smooth finish. Finally, if small black dots appear after blending, a kneaded eraser can be used to remove them one by one.

Using Kneaded Erasers

Kneaded erasers are an amazing tool for artists, thanks to their unique properties. Unlike traditional erasers, you can mold them into any shape, making them perfect for detailing work. Gone are the days of erasing a large area of your drawing just to fix a tiny flaw!

One of the great benefits of kneaded erasers is that they don't leave residue. They can easily pick up graphite or charcoal without leaving any trace behind. You don't even need to rub the paper, just press and lift. However, if the pencil marks are too dark, you may need to apply more pressure or use a different eraser.

For best results, try the "press and lift" method. Simply press the eraser onto the paper and lift it off, repeating as needed. For more delicate areas like hair, you can pinch the eraser and swipe lightly. Be careful not to apply too much pressure or you might bend the eraser out of shape.

As you use your kneaded eraser, it will become dirty with graphite and other particles. To clean it, simply stretch and knead it until the color turns light gray. Eventually, you may need to replace it if it becomes too dirty to use effectively. Don't worry though, kneaded erasers are inexpensive and easy to find in art supply stores.

When you first get your kneaded eraser, you may need to break it in. If it's too hard to manipulate, try cutting it in half or using only a quarter at first. The eraser should become softer as it picks up more graphite. You can also make it softer by folding in graphite shavings from a pencil sharpener and stretching it out.

LET'S DRAW!

A Dude's Face

A Dude's Face

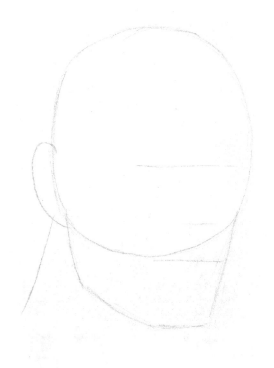

Start with circle for cranium shape, draw horizontal guidelines for facial features placement, add geometric lines below for a chiseled jaw and a rounded ear. Notice the eye line is close to the center of the circle, the nose line in near the base, and the mouth line is just below.

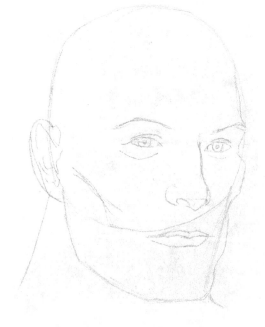

Refine jawline to create a skull shape. Add eyes, nose and mouth on the guidelines. Start to draw ear detail.

A Dude's Face

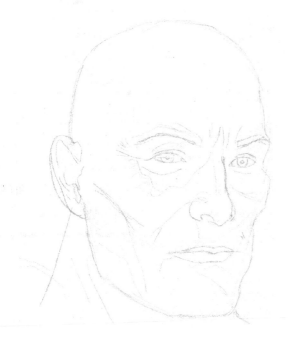

3

Erase the guidelines no longer needed. Add some creases and wrinkles to give the face character.

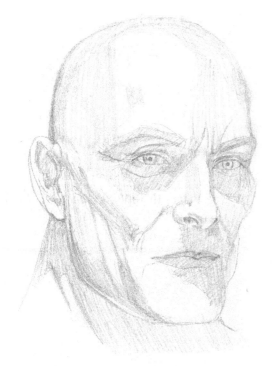

4

Add a light gray layer of tone. Start to lay down where shadows will be. Have fun and exaggerate it!

A Dude's Face

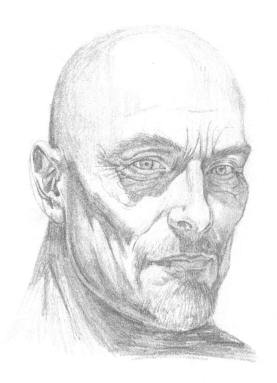

5

Once the initial tones are placed, more detail can be added. Start to add facial hair and more wrinkles. Create more contrast by using darker tones on areas of shadow.

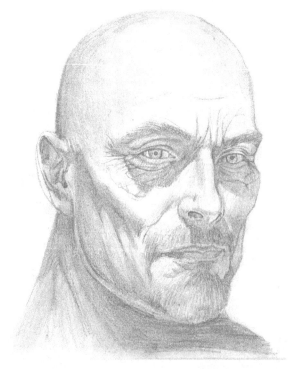

6

Smooth tones using a blending tool.

A Dude's Face

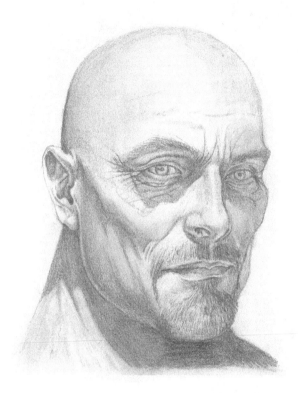

Go back in and add even more detail: darken some hairs on the beard, add light lines for wrinkles, and deepen the contrast by adding more pressure with the pencil to areas of darkness.

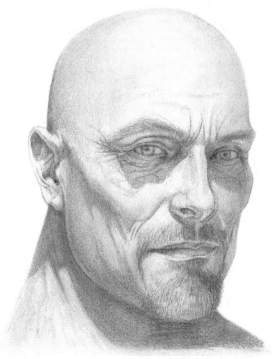

Repeat step 7 if necessary to add contrast. Use a kneaded eraser to remove tone from the lightest areas for highlights.

AN AWESOME FLOWER

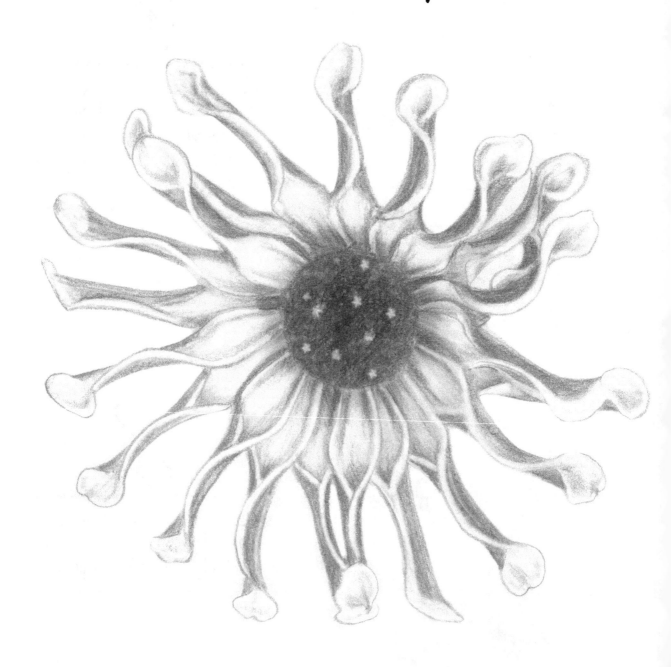

An Awesome Flower

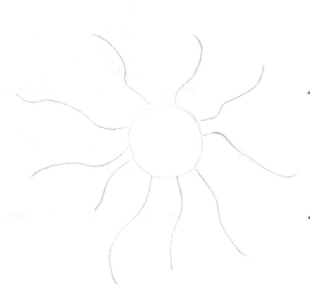

Start with a circle in the center. Add curved lines that radiate from it like a stylized sun. These will be the petals.

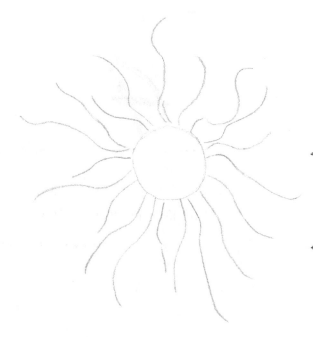

Add more curvy lines radiating from the center.

An Awesome Flower

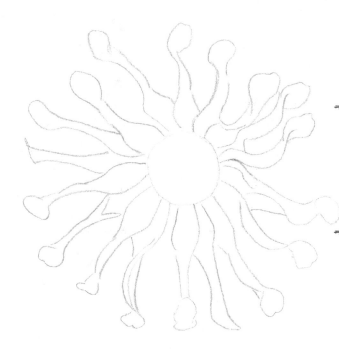

3

Connect the ends of the petals with curves.

4

Add more curves within the curves to create folds for added interest.

An Awesome Flower

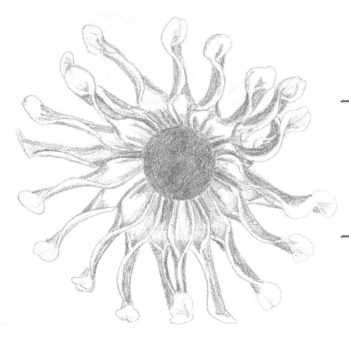

5

Use a kneaded eraser to clean up the smudging, to sharpen muddy tone, and to remove some of the shading from the center. Add more tone to the contour of the center for more contrast.

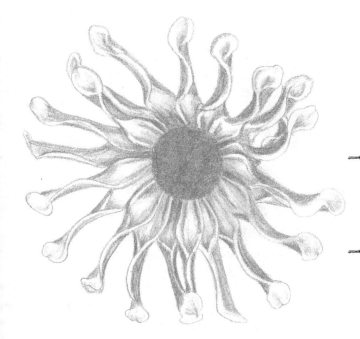

6

Smooth tones using a blending tool.

An Awesome Flower

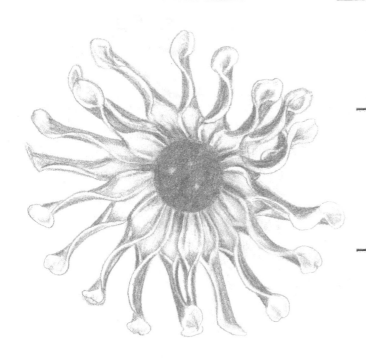

Use a kneaded eraser to clean up some of the smudges and areas of murky tone and to remove some pigment from the center. Add more tone to the contour of the center to create contrast.

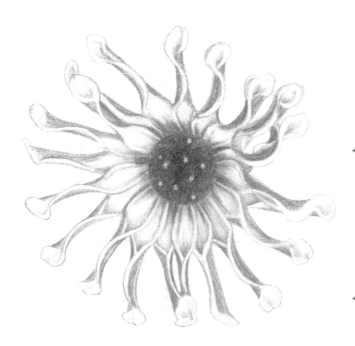

Refine the design by adding more contrast and smoothing tones. Use a kneaded eraser shaped to a point to remove pigment from the center in a small flower or dot shape.

A Baby Elephant!

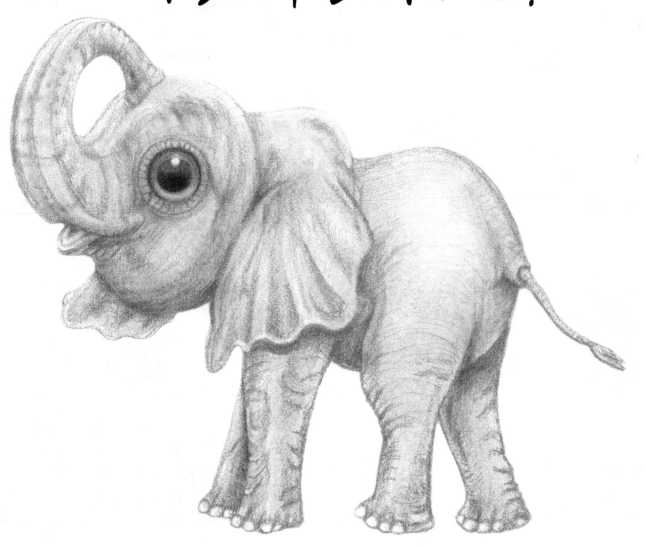

A Baby Elephant

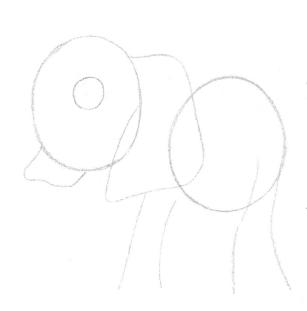

Start with two circles: one for the head and one for the rear. Add ears. Add stick legs. Draw a big circle for the eye.

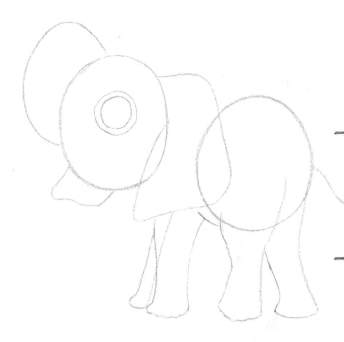

Add a line for the trunk. Make a pupil with a shiny spot. Refine ear shape. Thicken legs and add feet and belly. Draw a line for the tail.

A Baby Elephant

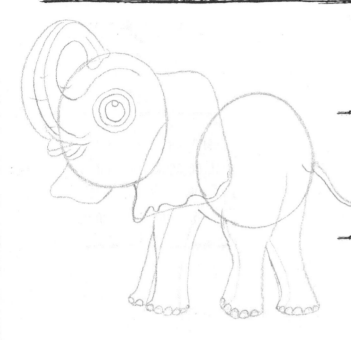

3

Add detail to the tail. Add another circle around outside of eye. Add the toes to the feet. Thicken the trunk with more lines. Add a mouth.

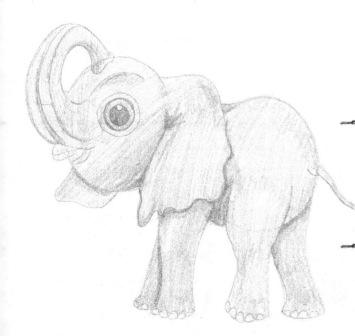

4

Erase the guidelines that are no longer needed. Add a quick layer of tone, pressing harder in areas of shadow, lighter in areas of highlight.

A Baby Elephant

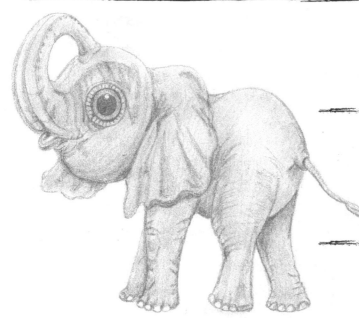

5

Blend the tones using a tissue. Next, go back over your work with a pencil to add shadows, wrinkles, and definition to eye.

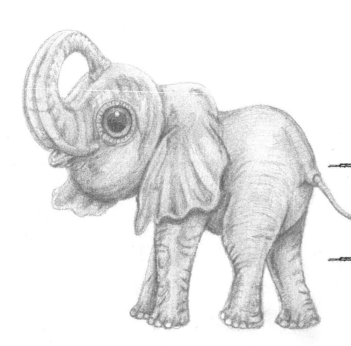

6

Refine those wrinkles and then add some more. Darken areas of shadow more as well.

A BABY ELEPHANT

This is an **exaggerated** creature. Make things bigger or smaller as desired for a cool effect.

7

Once again, smooth with blending tool. Use a kneaded eraser for highlights and to remove any excess smudging. Deepen the darkest shadows and pupil for contrast.

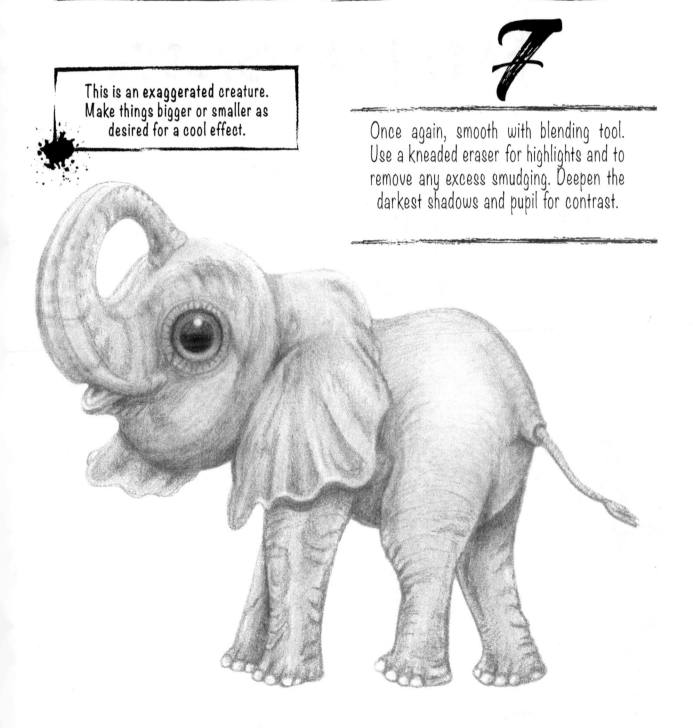

BABY HEAD SPIDER

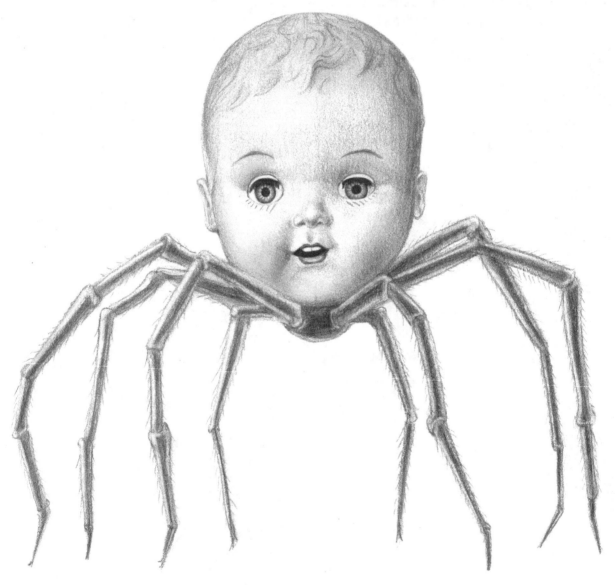

A Baby Head Spider

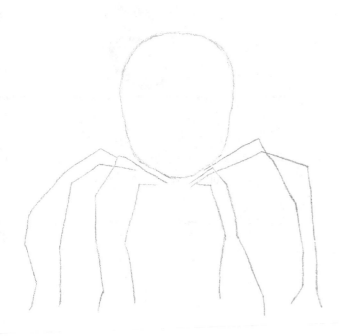

Draw head. Have 8 lines coming from the head to serve as guidelines for the spider legs. They don't have to bend in a natural way. Have fun with it!

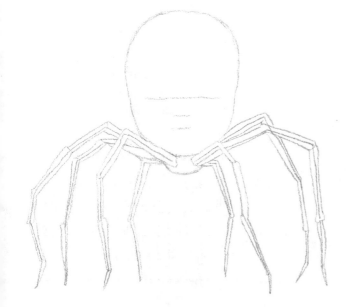

Add thickness to the lines. Add lines to indicate where facial features will go. Outline the abdomen (under the head.)

A Baby Head Spider

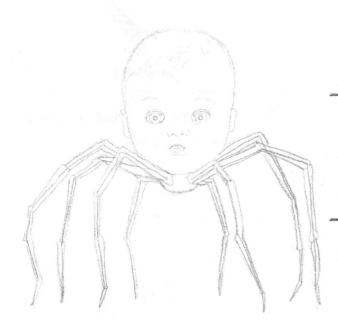

3

Add facial features to guidelines. Also draw ears. Indicate where the hair will be with a few small lines.

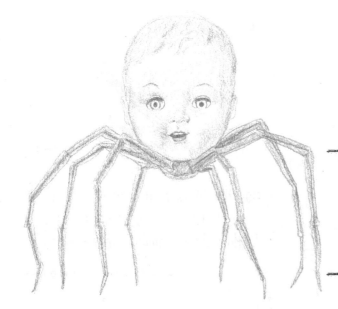

4

"Add a light layer of tone, including light shadow shading. Use more pressure on darker areas such as spider legs, pupils, eyes and mouth.

A Baby Head Spider

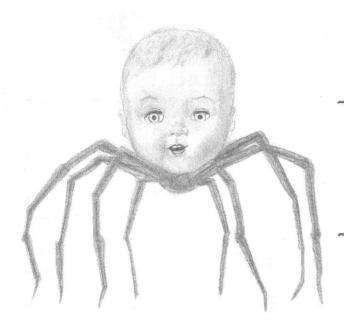

5

Use a blending tool to gently smooth the tones.

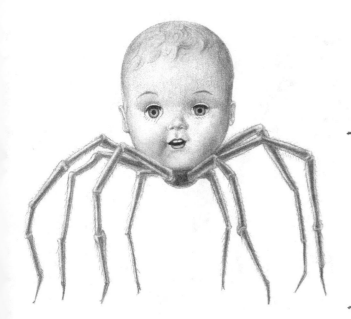

6

Go over with another layer of tone to create more contrast. Use a kneaded eraser to add highlights. Add short lines for hairs on legs. Add "spokes" around pupils in eyes and short lines for lower lashes.

A Baby Head Spider

Once more, clean up edges and brighten highlights with a kneaded eraser. Deepen darker areas with heavier tone to create contrast.

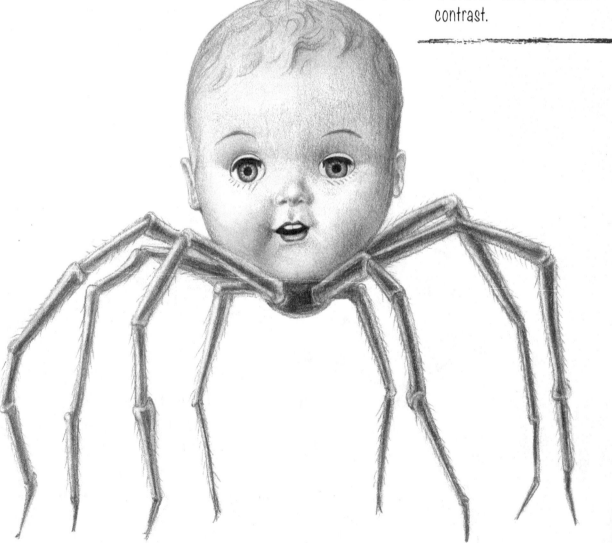

BABY BRO

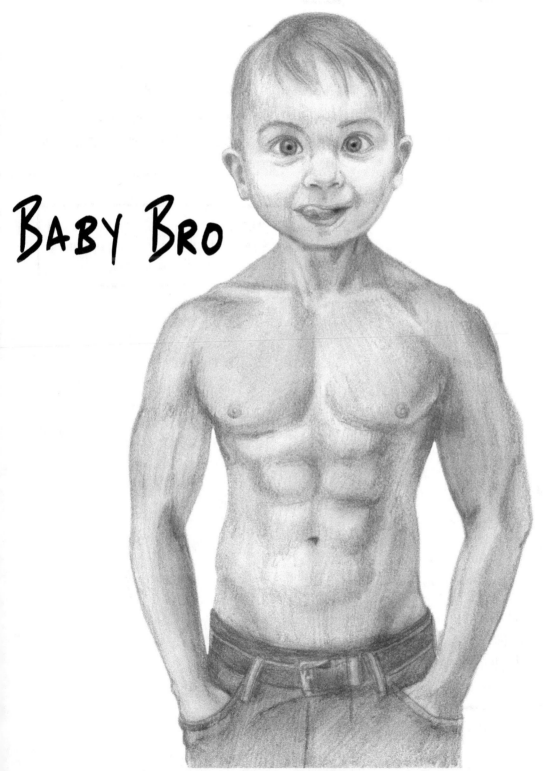

BABY BRO

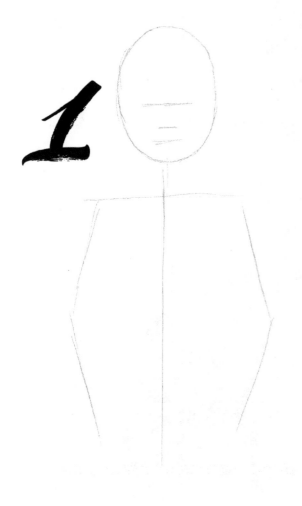

(1) Start with a circle for the head, add guidelines for the facial features, and additional lines for the shoulders, arms, and torso of the body. These lines will help us to decide where the form of the body will go.

Children's faces are typically characterized by a large head, round face, big eyes and a small nose or mouth.

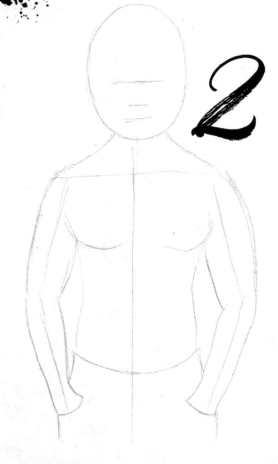

(2) Use the body guidelines to add form to the body including the neck, torso and arms. Add a waistband and simplify the hands by sticking them in pant pockets!

BABY BRO

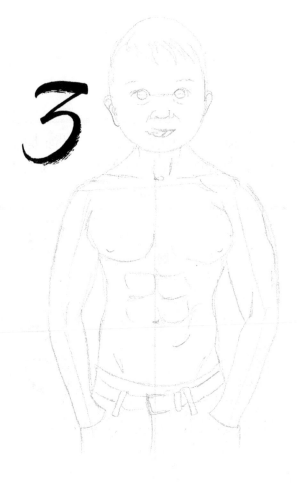

3

(3) Draw facial features on the head guides along with some lines to suggest hair. Add curved lines on arms, chest and abs to show muscle structure.

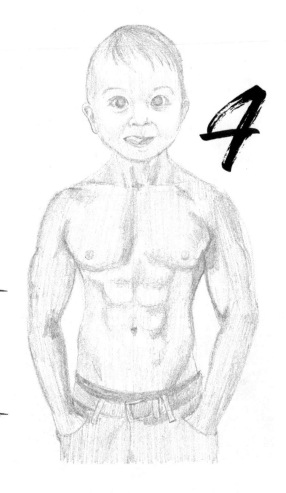

4

(4) Add a layer of tone. Use heavier pressure on areas of darkness, less on areas of highlight.

BABY BRO

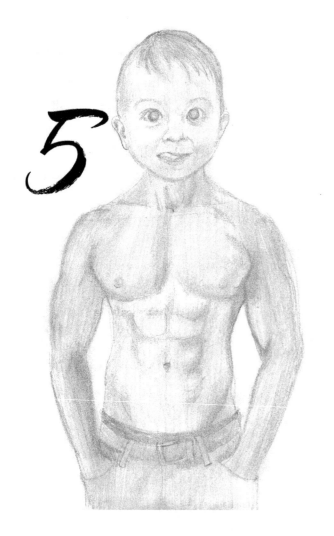

5

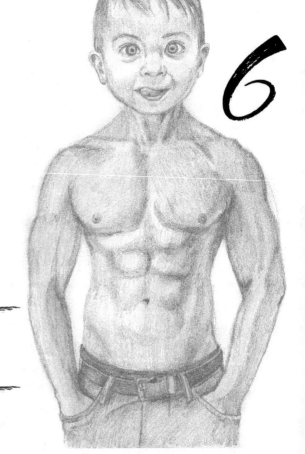

(5) Remove guidelines. Add another layer of shading, further defining shadow and features.

6

(6) Blend

BABY BRO

7

Add more contrast and highlights as needed to create depth and interest.

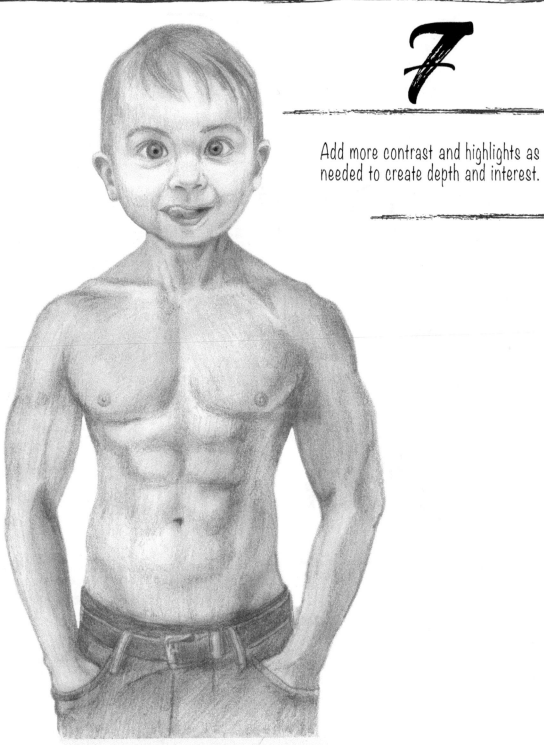

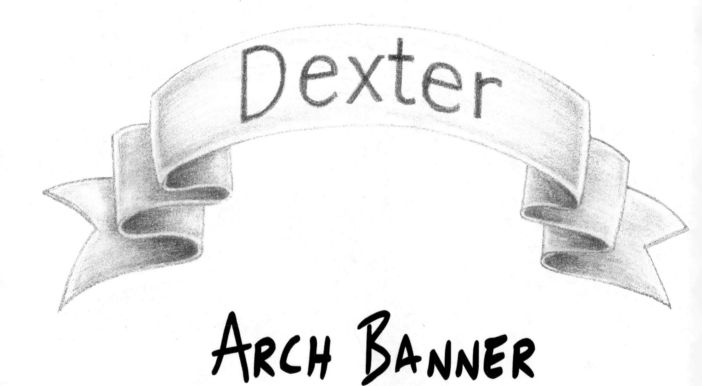

Dexter

ARCH BANNER

Arch Banner

1

(1) Draw two arched curves that run parallel to one another.

2

(2) Close the lines with slightly curved lines on the sides as shown.

3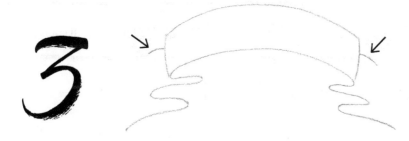

(3) Draw a curving swirl coming from one end of the banner. It should look like two S's stacked on top of on another. Mirror on opposite side as shown.

Arch Banner

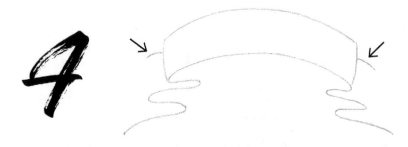

(4) Add a short curve coming from the center of each side of the main banner as shown (see arrows).

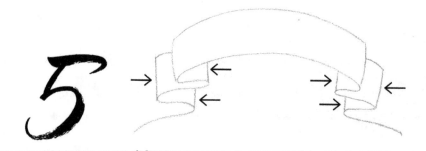

(5) Connect the banner scroll with vertical lines as shown. (see arrows).

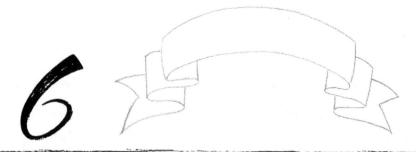

(6) Finish the ends.

ARCH BANNER

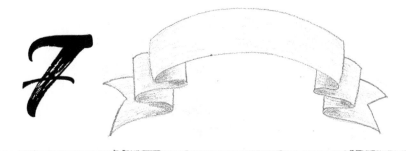

(7) Add a layer of tone to emphasize shadow and light.

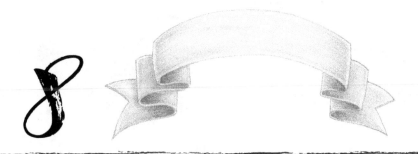

(8) Blend tone and refine details.

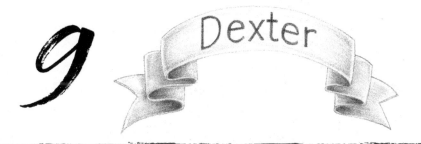

(9) Add text if desired. Make sure to follow the curve of the arch.

DOUBLE WAVE BANNER

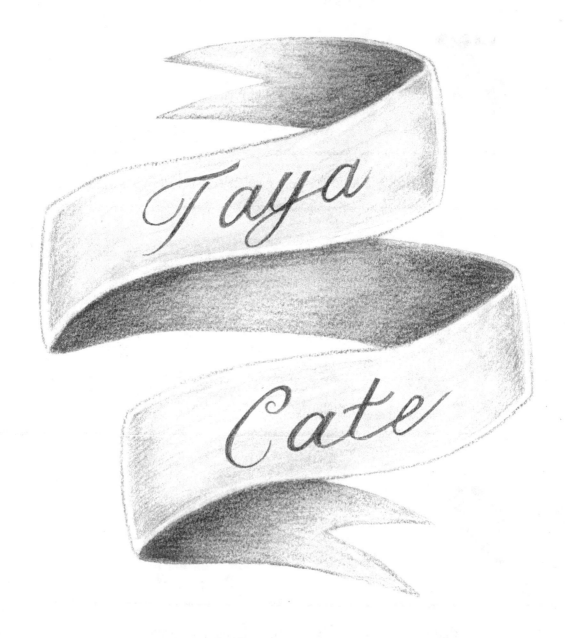

1

Draw two subtle curves that run parallel to one another. Repeat those two lines below and slightly to the right of the first set.

2

Close each set of lines with slightly curved lines on the sides as shown.

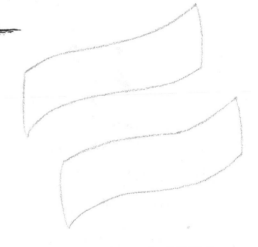

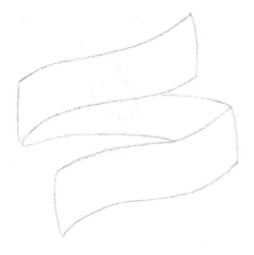

3

Connect the two sets of connected lines with two more lines in between as shown. These should appear to be joining them from behind.

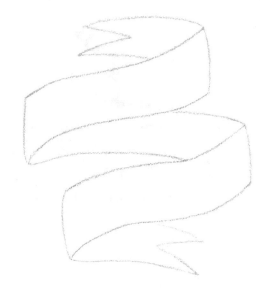

At the top and bottom of the design, draw the banner ends. They can have straight edges or points cut out as shown.

Shade. Start by adding darker tone to the areas where the banner appears to recede into space (areas "behind"). Give tone to the rest.

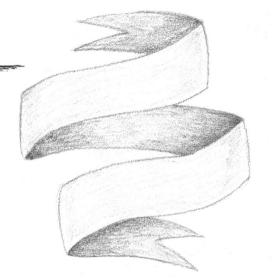

Blend.

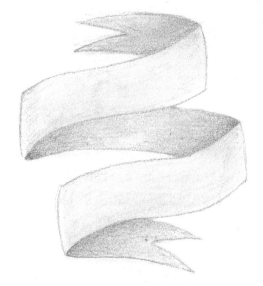

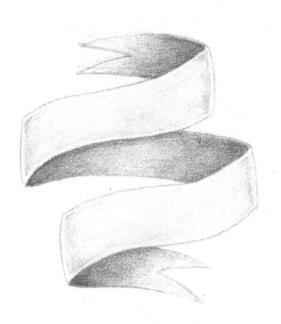

7

Refine shading by using heavier pencil pressure in areas of darkness and using a kneaded eraser to highlight areas of lightness.

8

Add text if desired. Make sure to follow the waves of the banners when writing the letters.

Taya

Cate

SCROLL BANNER

A Scroll Banner

1

Draw two long, subtle curves that run parallel to one another.

2

Close the lines with slightly curved lines on the sides as shown.

3

Draw a curving swirl coming from one end of the banner.
Do the same for the opposite side.

4

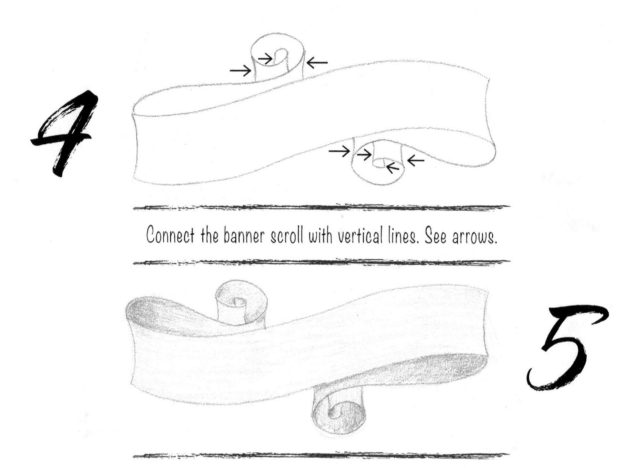

Connect the banner scroll with vertical lines. See arrows.

5

Shade. Start with adding darker tone to the areas where the banner appears to recede into space (areas in the back). Add a light layer of tone to the areas that appear to move forward.

6

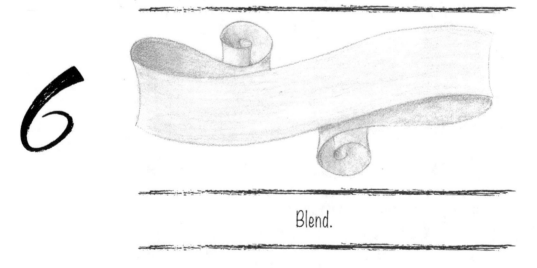

Blend.

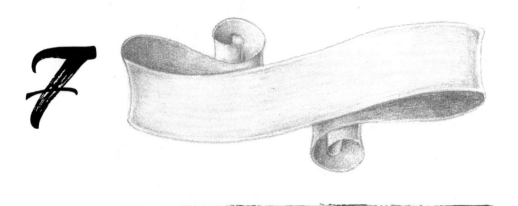

7

Refine shading by using a heavy pencil pressure in areas of darkness and using a kneaded eraser to highlight areas of lightness.

8

Add text if desired. Make sure to follow the curves of the banner.

BIRTHDAY GIRL!

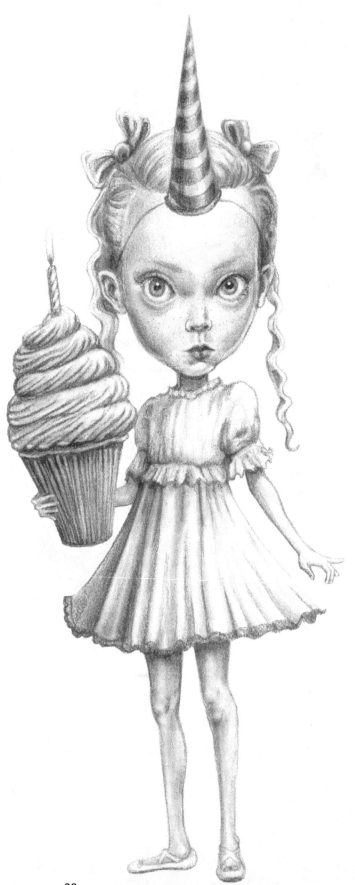

Birthday Girl

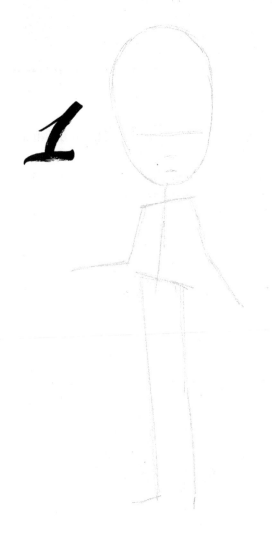

1

(1) Start with a egg-shaped head. Add facial guidelines, however, start the eyes in the center of the face with the nose below that, and the lips low on the chin area. Add stick figure-like guidelines for the body.

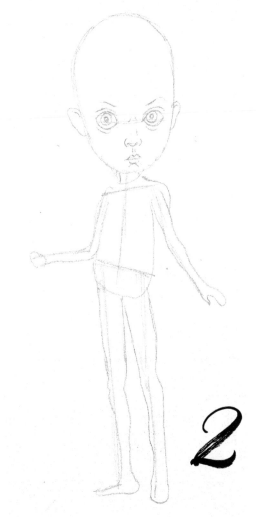

2

(2) Add facial features and ears. Fill in the body using the figure lines as guides, also add hands.

BIRTHDAY GIRL

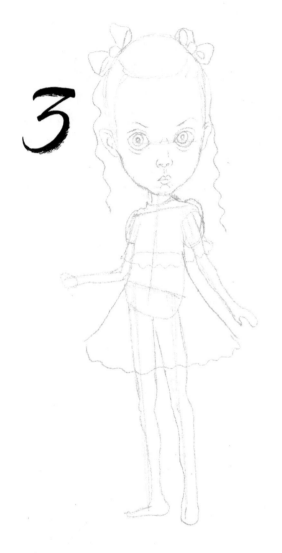

(3) Add lines to begin clothing and hair.

(4) Add a layer of tone while also darken-
ing the emphasize shadow. Flesh out hair
and dress details.

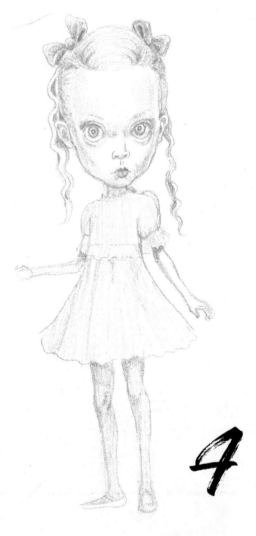

BIRTHDAY GIRL

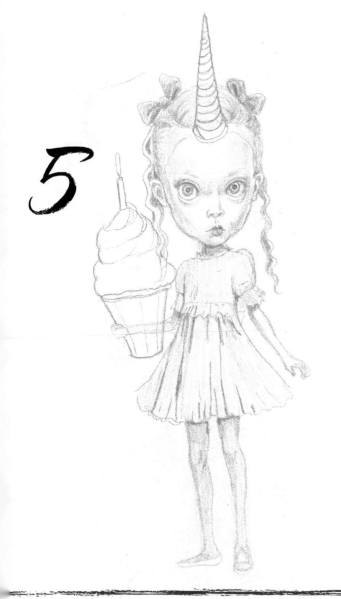

5

(5) Add "extras" including a party hat or cupcake.

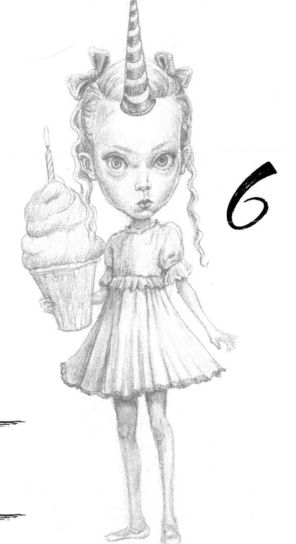

6

(6) Add another layer of tone, adding
more value range and details. Fill in cake
and hat, and other extras.

BIRTHDAY GIRL

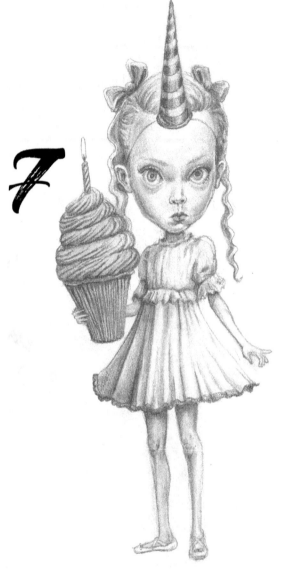

(7) Blend tones and add fine details on the cupcake including frosting, candle and more contrast all over.

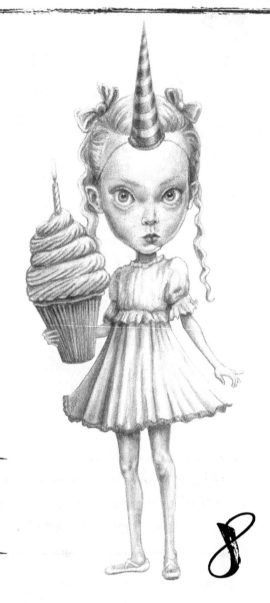

(8) Darken and lighten areas as needed to create more contrast with shadow and highlight. Add freckles and other details.

CAT CRAB

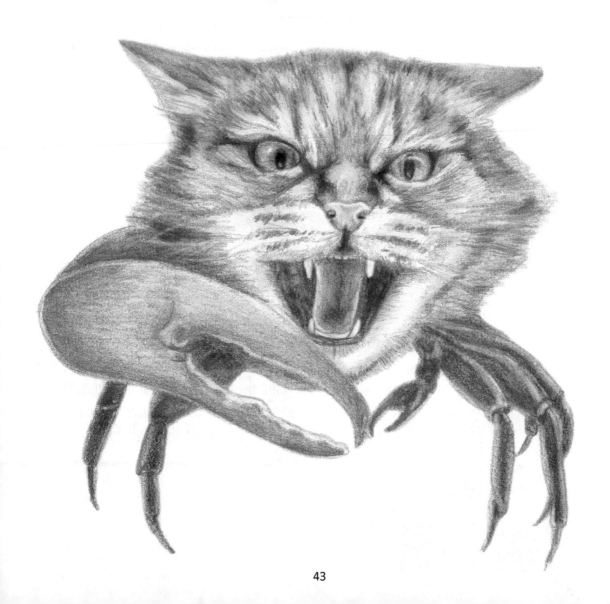

CAT CRAB

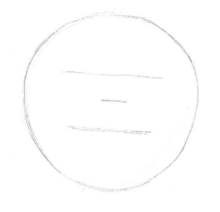

1

Start with a circle head. Draw guidelines for eyes, nose and mouth. The upward tilted angle of the head will have the features placed higher than if the view were straight on."

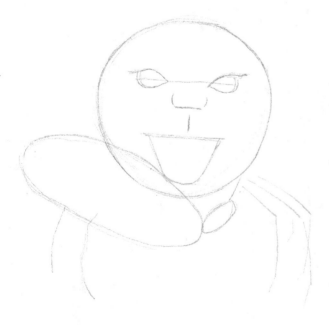

2

Draw eye shape on eye guideline. Add curves above nose line and a vertical line below it as shown. Draw a big smile under the mouth guideline. Add an oval that over-laps the head for the large claw with a small oval that touches it as shown. Draw lines beneath the ovals for legs.

CAT CRAB

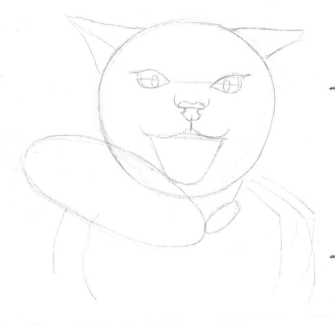

3

Draw ovals for a pupils inside the eye shape. Add two curves for the top of the nose above the guideline and curves beneath it to finish the shape. Add a "W" shape for the cheeks under nose. Add triangle shapes for ears.

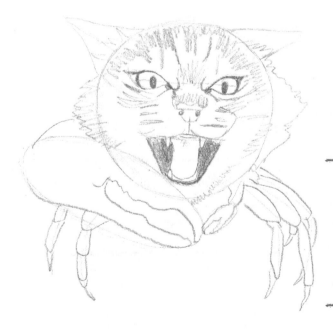

4

Refine claw shape. Add leg segment details and scribble in a quick face pattern that follows the direction of the fur. Sketch in the teeth and tongue then fill in the mouth with tone.

CAT CRAB

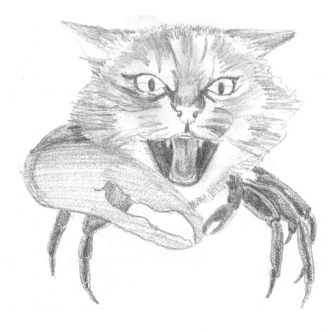

5

Erase the guidelines that are no longer needed. Blend. Add more tone to indicate areas of shadow and highlight.

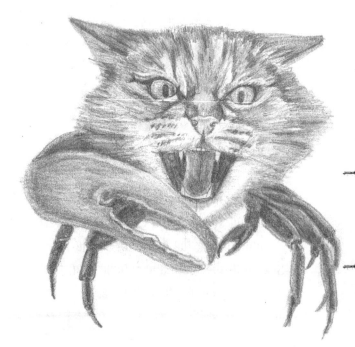

6

Deepen tones and add more patterns to create detail. Use close zig-zag lines to indicate fur texture.

Cat Crab

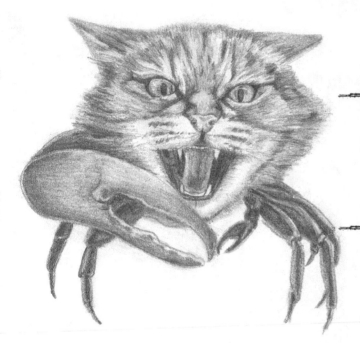

Smooth tones, add more darks and lights as needed to add depth and interest.

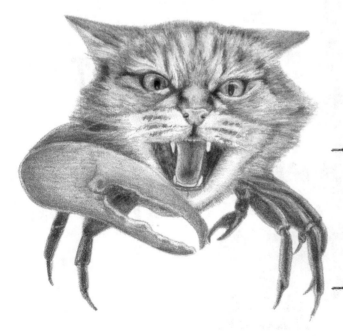

Clean up smudges with a kneaded eraser. Use the eraser to also pull up some of the pigment on the lighter areas to create more of a highlight. Deepen areas of darkness for more contrast.

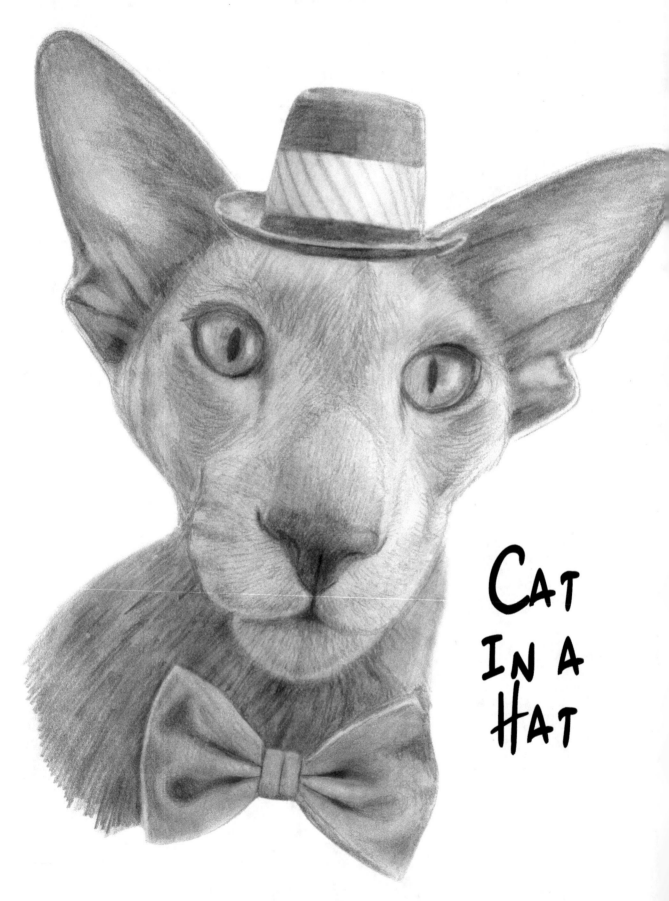

CAT IN A HAT

CAT IN A HAT

1

Start with an oval head and triangular ears. Draw circles for eyes (somewhat higher on the head than usual because of the perspective.) Add a mushroom shaped nose on the lower circle as shown, followed by a "W" shape below it for the mouth. A "U" shape below that will form the chin. The shoulders will taper down from slightly above the mouth.

2

Refine the head and ears shape, add a pupil to the eye, a hat to the head and bow tie at the neck.

Cat In a Hat

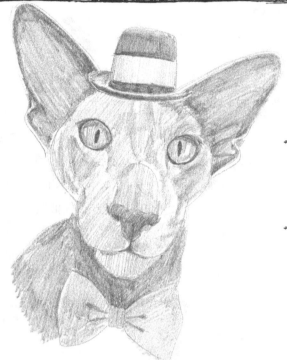

3

Add a light layer of tone all over, using heavier pencil pressure in areas of darkness.

4

Blend the tones to smooth them into a flat gray.

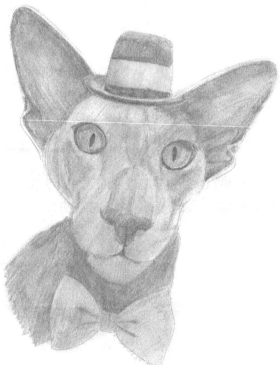

Cat In a Hat

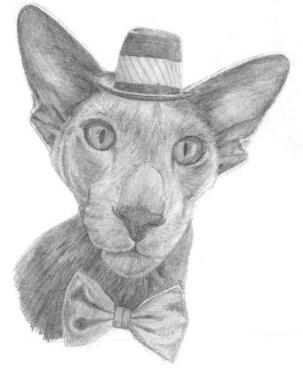

5

Draw a pattern on the hat. Add small hatch lines all around the face to replicate a fur texture and add more detail.

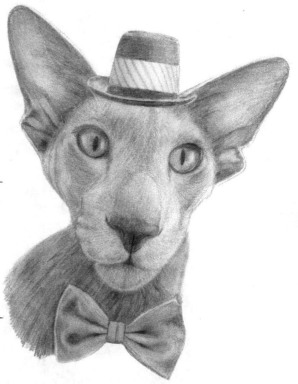

6

Use a 6B or 8B pencil for darker tone and to create more contrast. Follow the form of the face and add even more hatch marks. Use a kneaded eraser to lighten the highlights.

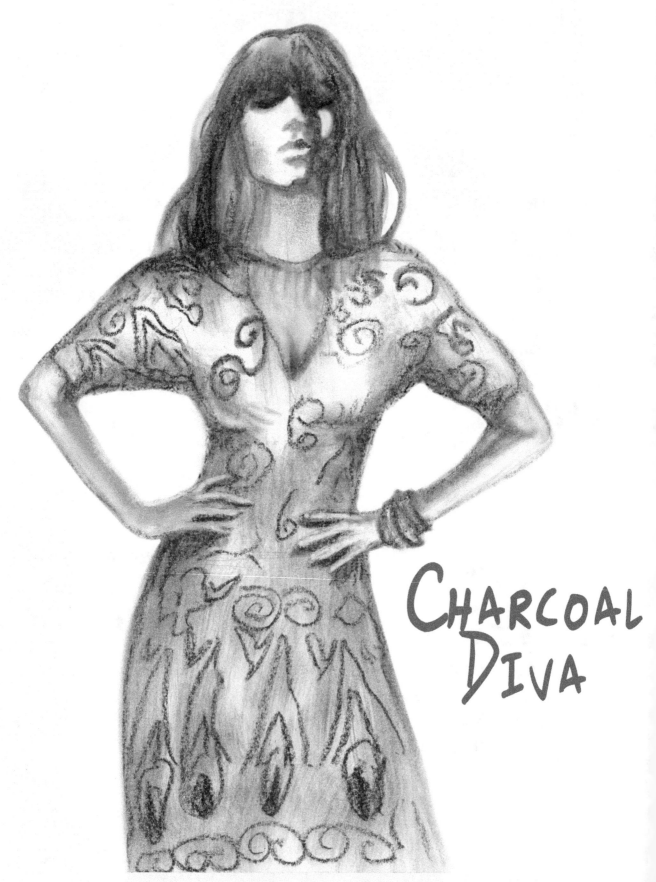

CHARCOAL DIVA

52

Using Charcoal

Charcoal is a medium that has been used by artists for centuries, and for good reason. Technically speaking, this burnt organic material, usually made from wood, is a versatile tool that can be used in many ways, from creating light, wispy lines to bold and dramatic strokes.

There are two main types of charcoal used by artists: vine and compressed. Vine charcoal is made from burnt willow wood and is usually a round stick. It is easy to spread on a surface and easy to erase, making it ideal for creating light marks and smudging. On the other hand, compressed charcoal is darker than vine charcoal and is held together by a gum binder. Compressed charcoal may come as a round stick, square stick, or pencil form. While it is harder to erase and smudge, it makes a darker mark, which can be used for creating bold, dramatic strokes. For this tutorial, we're using compresses charcoal.

When drawing with charcoal, it is important to have the right tools. In addition to a variety of charcoal types, artists may also want to have a kneaded eraser and blending stumps. A kneaded eraser is a special type of eraser that is designed to lift the material off of the surface, and works especially well with charcoal.

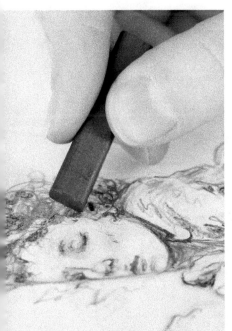

Blending stumps allow for full control over the blending and smearing of the charcoal. It is also a good idea to have a paper towel handy when drawing on a flat surface, as it can be used to lay between your hand and the surface of the drawing to prevent smudging.

To hold charcoal, vine charcoal sticks should be held differently than a drawing pencil, with the thumb and forefinger and the palm facing the surface of the paper. This allows for marks using the shoulder and elbow instead of just the wrist. For detailed marks, a charcoal pencil can be held just like a traditional pencil.

Tips for Using Charcoal

- Prepare your workspace. Charcoal can be messy, so make sure to work on a surface that can be easily cleaned or covered.

- Use a rough sketch. Since charcoal can be difficult to erase, it is best to start with a rough sketch in graphite pencil or light-colored charcoal.

- Experiment with different techniques. Charcoal is versatile and can be applied in different ways. Try out different techniques such as hatching, cross-hatching, blending, or stippling to create different effects.

- Be patient. Charcoal requires patience, especially when building up tones. Apply the charcoal in layers and use a blending tool or your fingers to smudge the lines and create a smooth transition of tones.

Pencil is appropriate for smaller artworks with fine detail (since pencils have small points.) Pencils will take more time to cover large areas while charcoal is more suitable for larger, less detailed drawings (as they leave broader strokes.)

Charcoal Diva

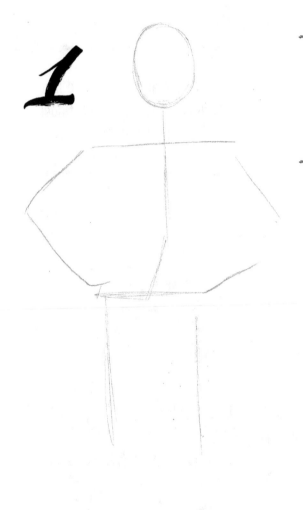

1

(1) Start with basic head shape. Use lines as guides for where the torso and arms will be.

2

(2) Add outline shape of woman. Simplify the fingers with lines. Draw lines for the hair as well as more lines to define the clothing.

CHARCOAL DIVA

3

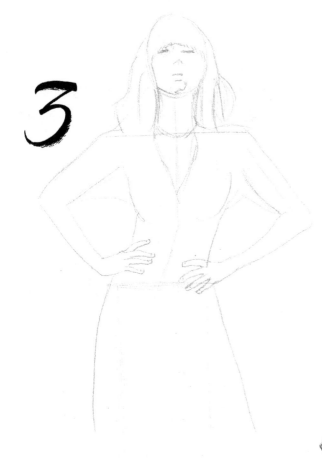

(3) Hint at facial features and hair style with line markings. Add finger and outfit detail.

(4) Use charcoal to lightly fill in the dark areas and shadows of the figure. Add a pattern to the clothing if desired.

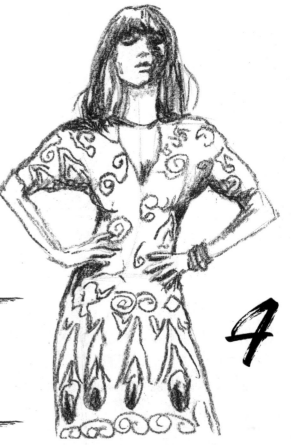

4

Charcoal Diva

5

(5) Use a blending tool to strategically blend the tones to create shadows. Leave areas white to represent highlights.

Note about charcoal: it is thick and chunky, making small details difficult. This tool will force the artist to simplify!

6

(6) Clean up any smudges with a kneaded eraser. Use it to also add areas of highlight, focusing on the face and fingers. Refine facial features and add darkness as needed to create even more contrast.

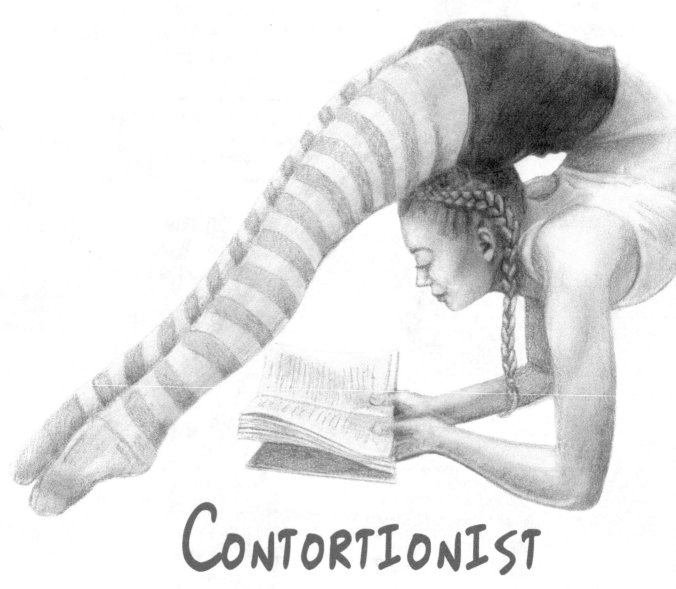

CONTORTIONIST

CONTORTIONIST

Start with an oval head and lines as guides for the body. Contort the body in anyway you like! Looking at the human figure and noticing the forms and joints will help to make it look realistic.

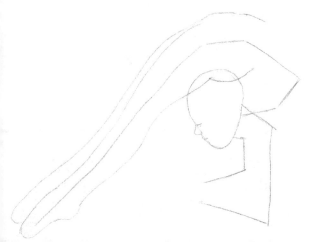

Follow the guidelines and draw individual body parts around them. Start with the legs as shown.

CONTORTIONIST

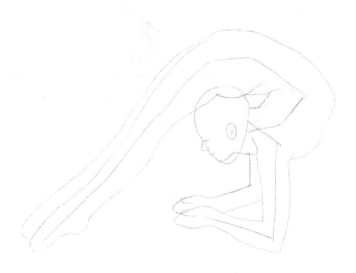

3

Continue to create the form of the body around the torso and into the arms.

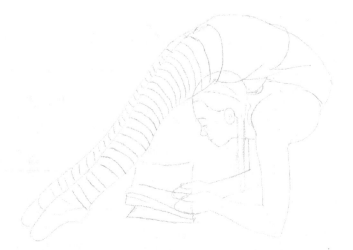

4

Erase the guidelines no longer needed. Add lines for clothing, book and hair detail.

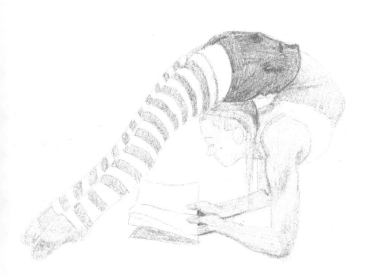

5

Add a layer of tone.

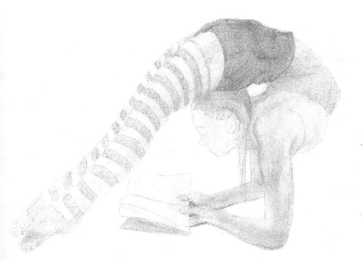

6

Blend tones to smooth out rough marks and to create a seamless transition of values.

CONTORTIONIST

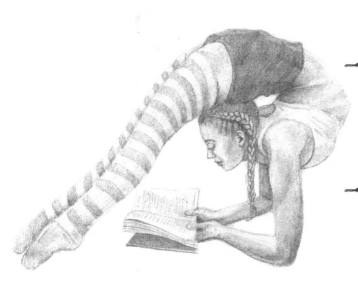

Add shading. Press harder in areas of darkness and lighter in areas of highlight. Add detail lines to skin and hair style. Start to add subtle shades to book, belly, etc.

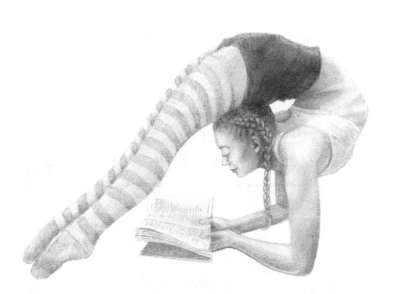

Add final touches, including more contrast, highlights, texture, and other minutiae.

A Very Cool Shark

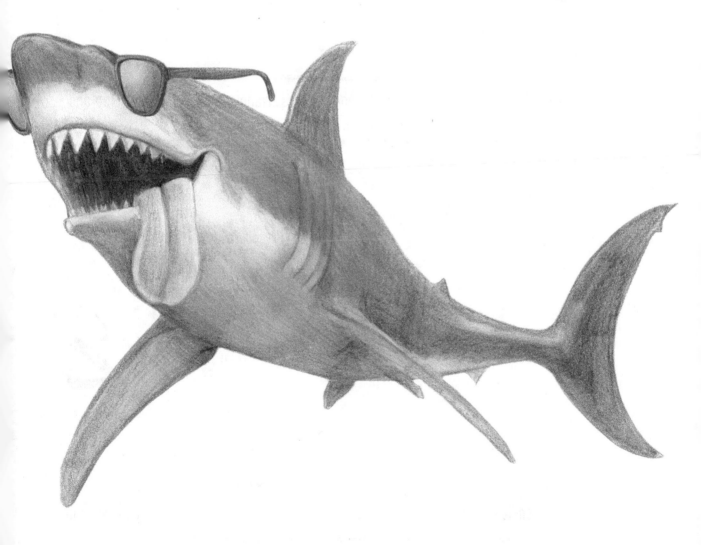

A Very Cool Shark

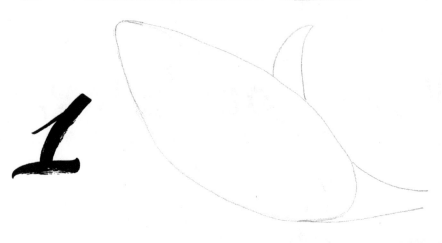

Start with a football shape for the shark body. Add a triangle shaped fin at the top and two lines to start off the tail towards the back.

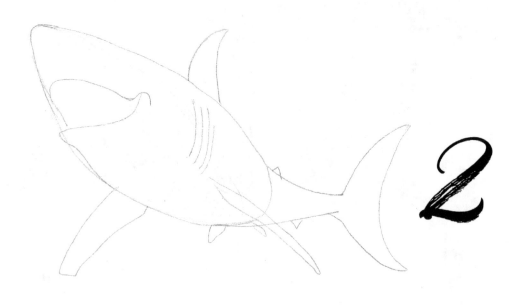

Draw a smile mouth as shown. Add fins and gills along with a moon shaped tail fin.

3

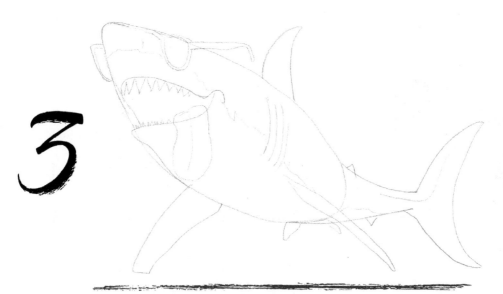

Add the finer details including the teeth, glasses and tongue.
Add a line to separate the value of the top and bottom.

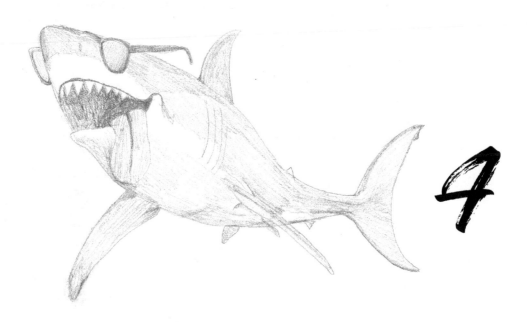

4

Erase any parts of the original guidelines that are no longer needed.
Add a light layer of tone.

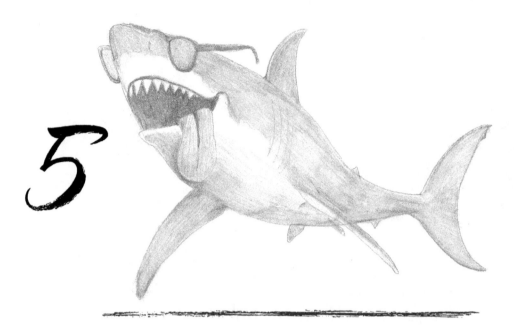

5

Smooth tones with a tissue or blending tool.

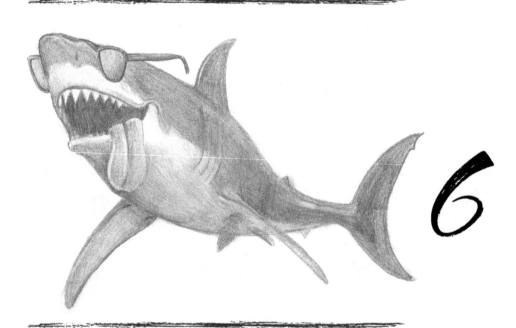

6

Go over the drawing again with more pencil;
using heavier pressure on areas of darkness, less on areas of highlight.

Deepen tones and smooth them to blend.
Add more contrast as necessary for
interest.

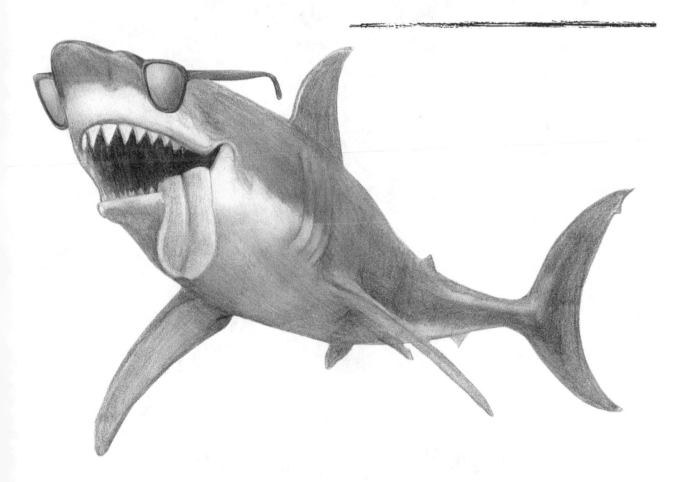

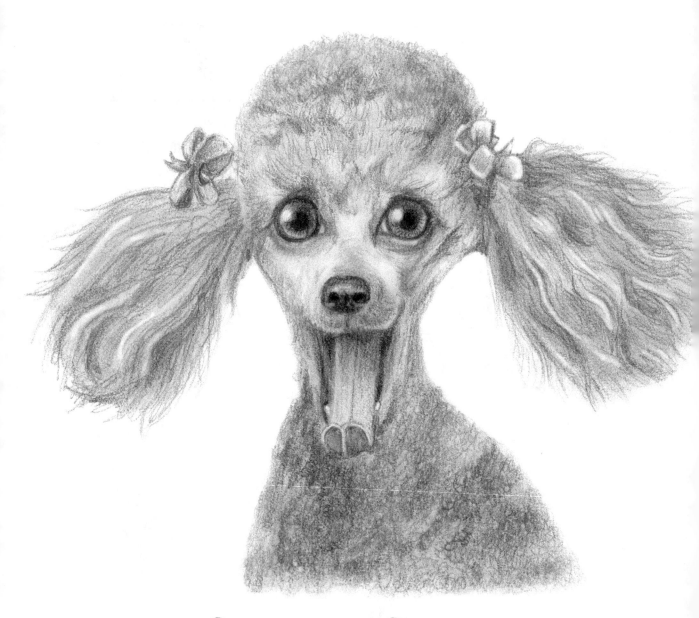

CRAZY POODLE

CRAZY POODLE

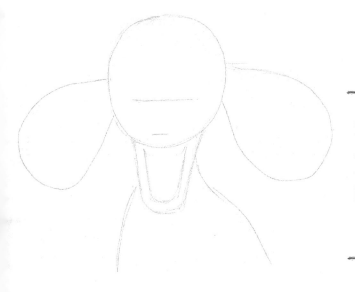

1

Start with a circle for the head shape. Add a long, upside down, rounded trapezoid for the lower jaw. Draw curves for ears and lines as guides for facial features. Draw simple lines for the body as shown.

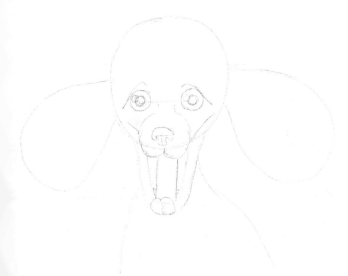

2

Add the facial features: circles for eyes, a mushroom shape for the nose with a "W" shape beneath it and a long tongue. Draw eye highlights and draw curves above the circle eyes for brows.

CRAZY POODLE

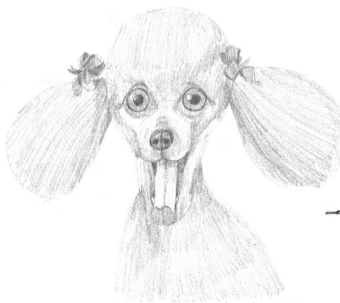

3

Add a layer of tone. Use more pressure with the pencil in areas of darkness, lighter pressure in areas of lightness, including the pupils, bows, snout and mouth.

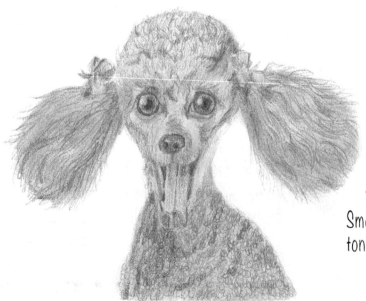

4

Smooth tones with a blending tool. Deepen tone in the eye area. Start to add fur texture to the head, ears and body.

CRAZY POODLE

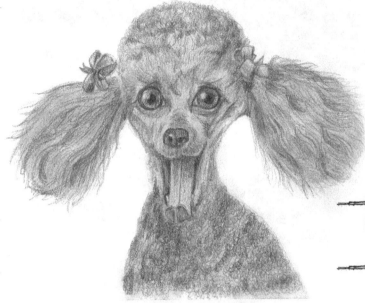

5

Use more pencil pressure to deepen the darkest tones to create contrast.

6

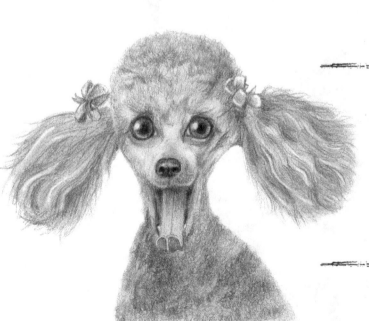

Gently blend tones to smooth them. Darken the eyes and nose even further. Use a kneaded eraser to highlight the whitest spots including the eye highlight, snout shine and strands of fur in the ears.

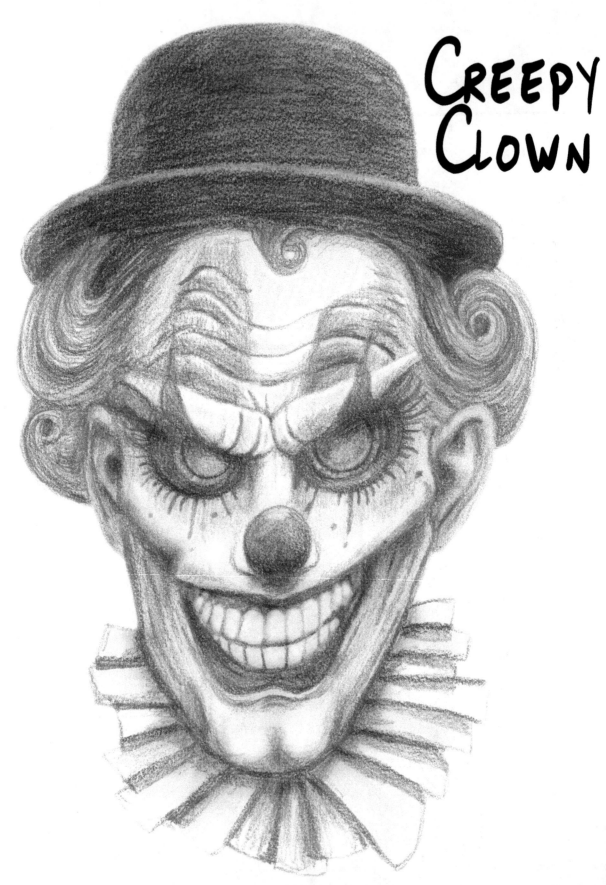

CREEPY
CLOWN

CREEPY CLOWN

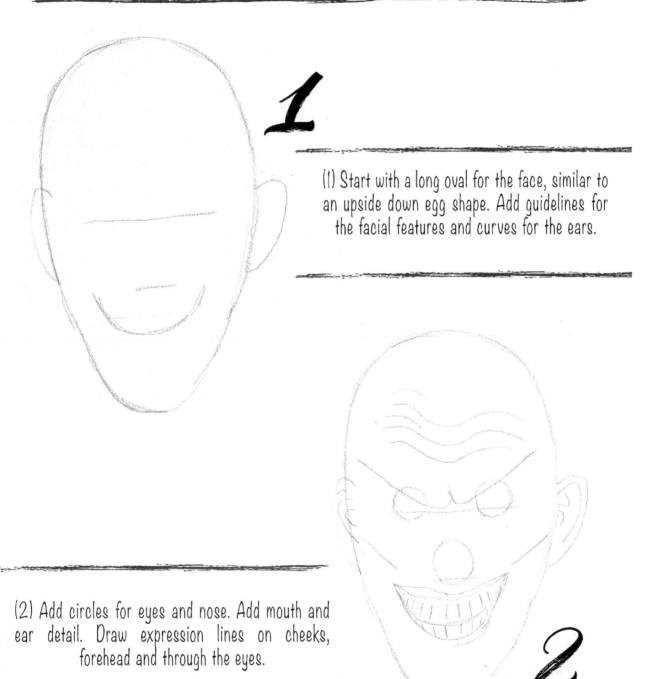

1

(1) Start with a long oval for the face, similar to an upside down egg shape. Add guidelines for the facial features and curves for the ears.

(2) Add circles for eyes and nose. Add mouth and ear detail. Draw expression lines on cheeks, forehead and through the eyes.

2

CREEPY CLOWN

3

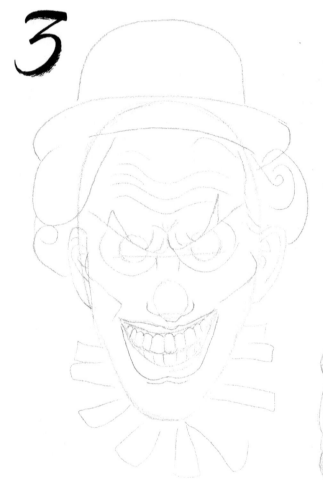

(3) Add more detail to eye shape and mouth. Add some lines to start the collar, hat and hair.

4

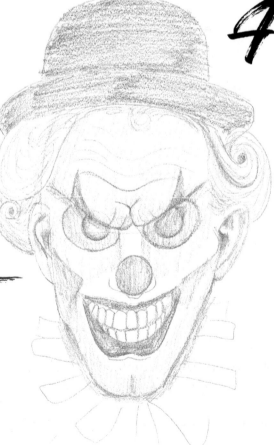

(4) Add a layer of tone. Shade the bottom half of the eye. Remove the guidelines that are no loner needed, including the top part of the circle eye. Add a light layer of tone using heavier pencil pressure in areas of darkness, lighter pressure in areas of highlight.

CREEPY CLOWN

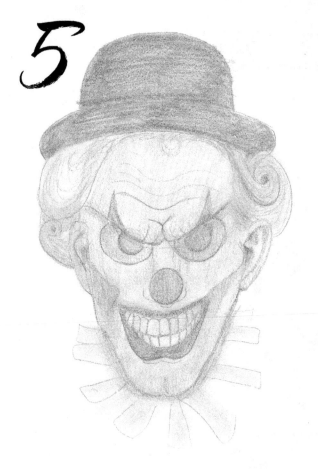

(5) Smooth tones with a blending tool. This will turn the tones into a flat gray.

(6) Go over the drawing with another layer of tone. Deepen the wrinkles and shadows where darker values are needed and add hair detail as well.

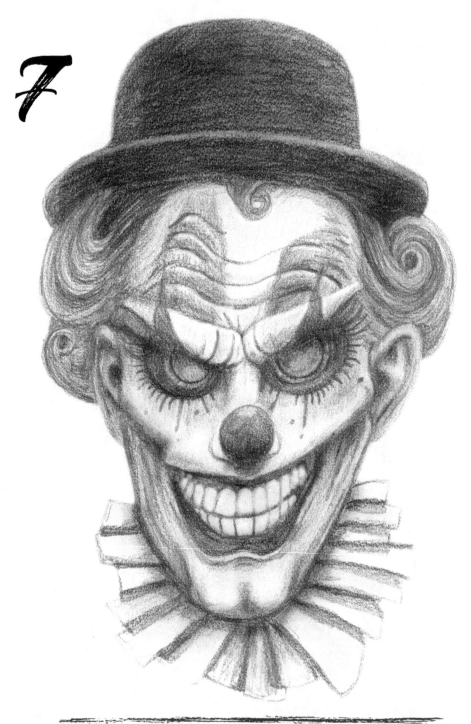

Add further tone for increased contrast. Also add more wrinkles and designs around the eyes. Use a kneaded eraser to remove any smudges or pigment from the lightest areas for highlight.

BEE REX

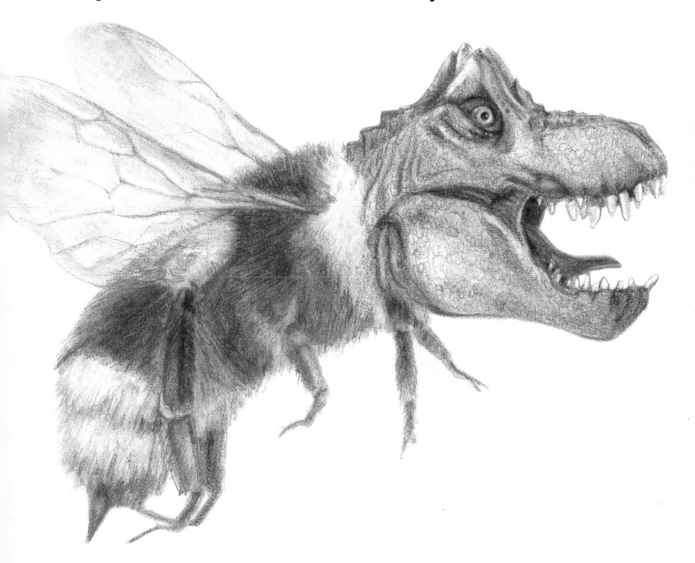

Bee Rex

1

Start with three circles to represent the abdomen, thorax and head.

2

Draw curves for a mouth and a spike on the head. Connect the head to the thorax on top with a curve.

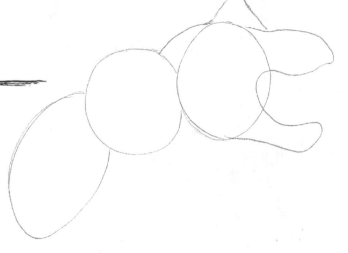

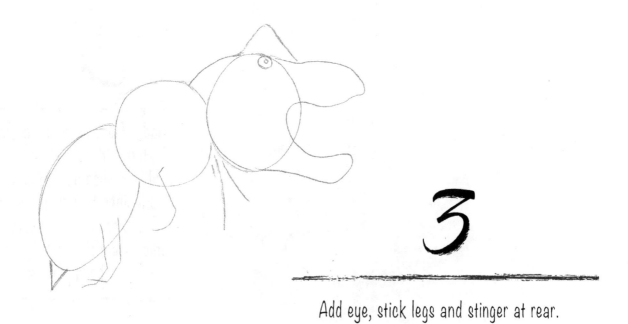

3

Add eye, stick legs and stinger at rear.

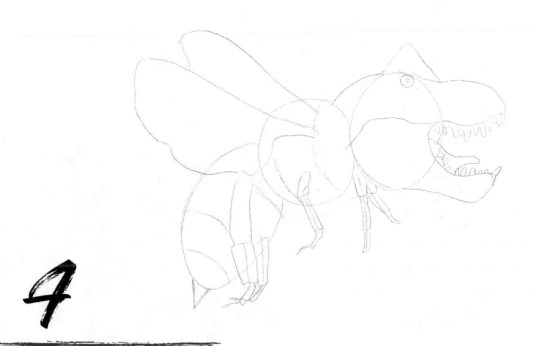

4

Add wings, teeth, tongue, thicken legs, and
add lines to show where stripes will go.

5

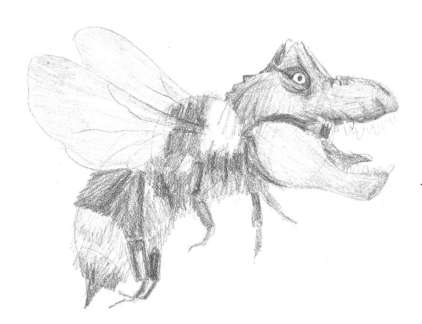

Add a few bumps and grooves for texture. Add a light layer of tone. Add light shading on the wings with subtle lines to indicate veins. Also, use heavier pencil pressure on every other bee stripe to help create the body pattern.

6

Blend tones. Use a kneaded eraser to pick up smudges and to add highlights.

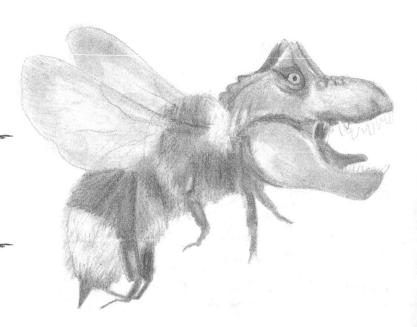

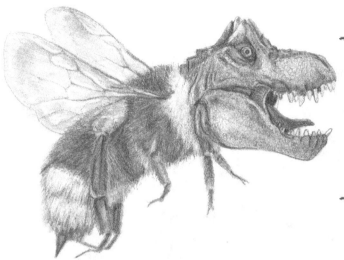

Add more detail with another layer of tone. I added texture using the scumbling technique on the Dino head to simulate scales. Define the contrast on the wing vein lines using eraser to highlight and pencil to darken as needed.

Scumbling is a shading technique achieved by overlapping lots of tiny swirls and circles. The texture created with this technique is determined by the size of the circles, and the pressure used on the pencil.

SCUMBLING TECHNIQUE

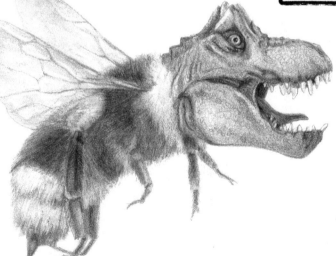

Add contrast with more tone. Remove some pigment using a kneaded eraser, focusing on highlights on the head and body as well as bright spots on the wings.

DRAGON TREE

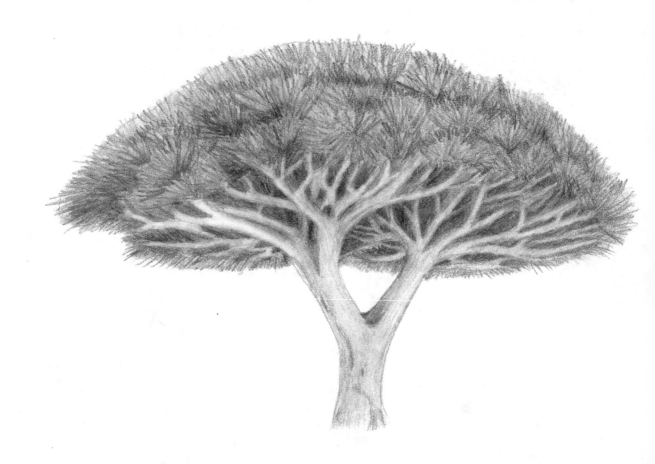

DRAGON TREE

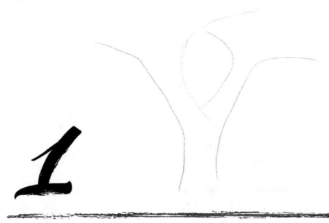

1

Start with a "Y" shaped trunk for the base. Add curves at the top of each "Y" shape to start the upper portion of the tree.

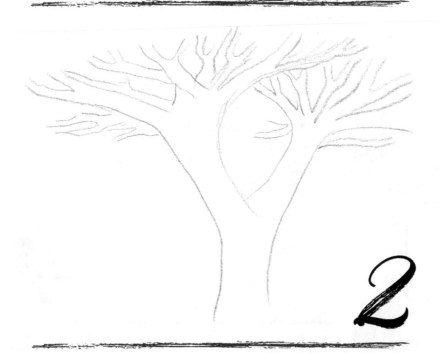

2

Add a series of smaller letter "Y's" that branch off towards the top of the page.

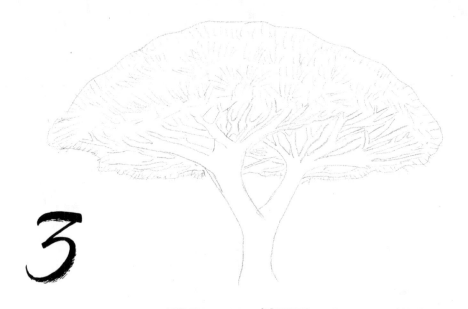

3

Extend branches to be a bit longer. Add a guideline around the top to indicate where leaves will be. Add hatch lines throughout to start the spiny leaves.

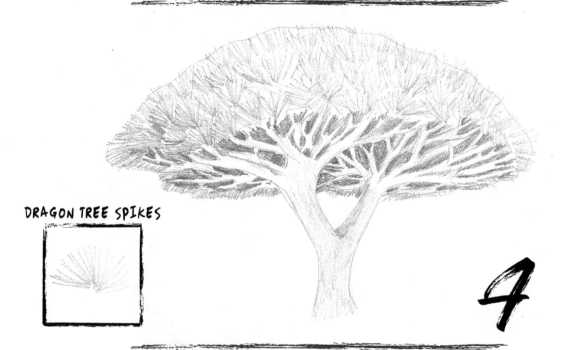

DRAGON TREE SPIKES

4

Add a light layer of tone; using heavy pencil pressure in areas of darkness, light pressure in areas of highlight. Note the fan shape of the Dragon tree's spiky leaves.

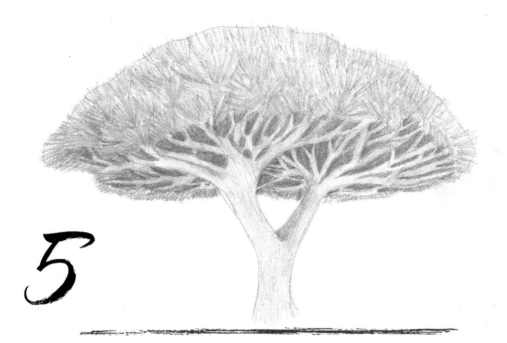

5

Smooth tones using a blending stump.

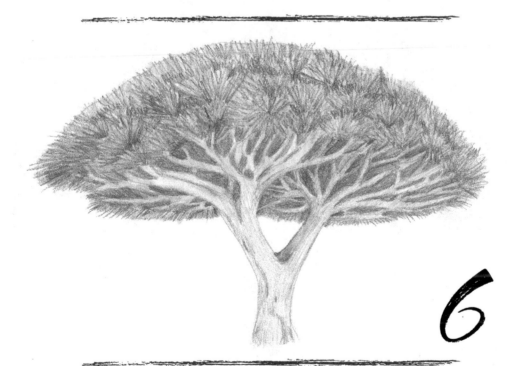

6

Go over the darkest areas with a 6B or 8B pencil to create depth and contrast
Use a kneaded eraser to create highlight.

Smooth tones and add more contrast as needed to create depth and interest.

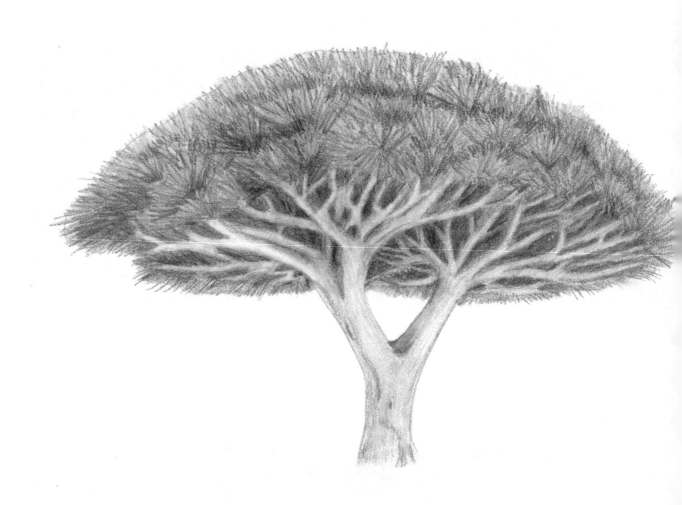

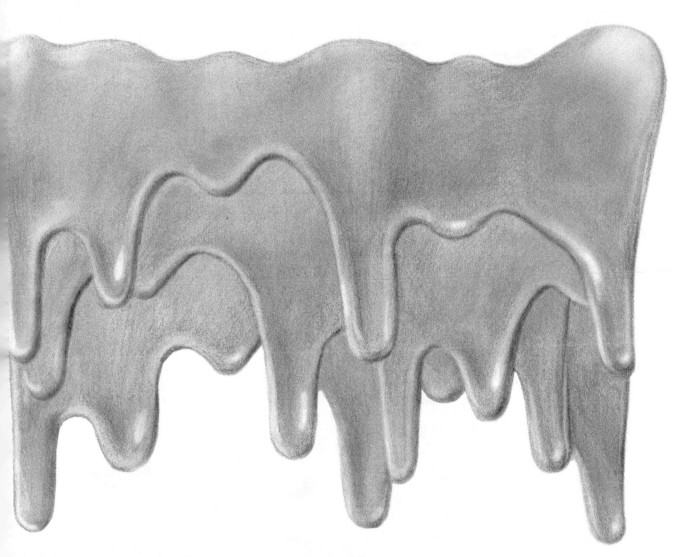

GOOEY DRIPS

Gooey Drips

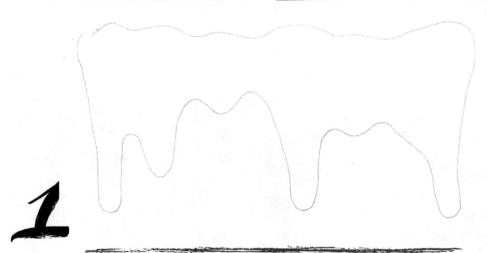

<big>**1**</big>

Draw a few drippy line shapes at the top the page. It's like a wavy line except some waves are long and some are a bit shorter.

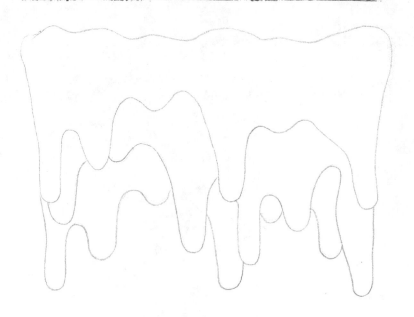

Add two more layers of drips beneath the first.

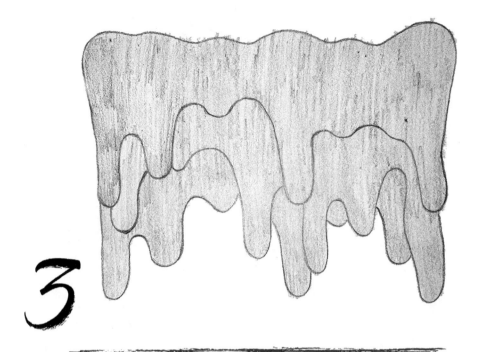

3

Add a layer of tone.

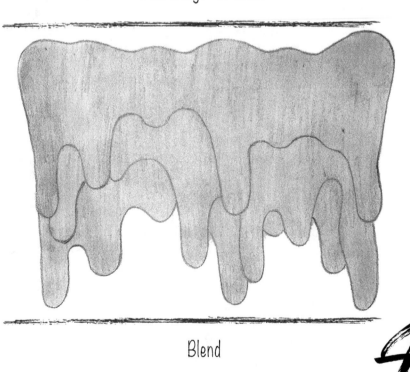

Blend

4

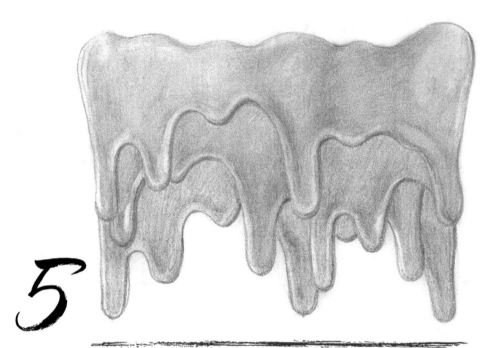

5

Add another layer of tone, focusing on creating a shadow beneath each drip. Use a kneaded eraser to remove some pigment where the drip will be highlighted.

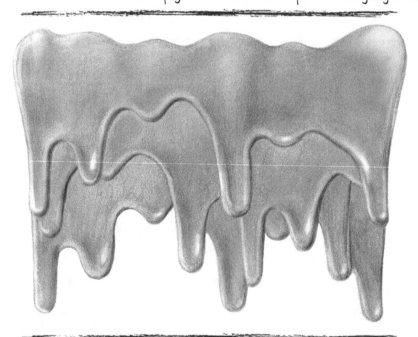

Refine the drawing by creating more dark and light contrast while smoothing the pencil marks with a blending tool.

6

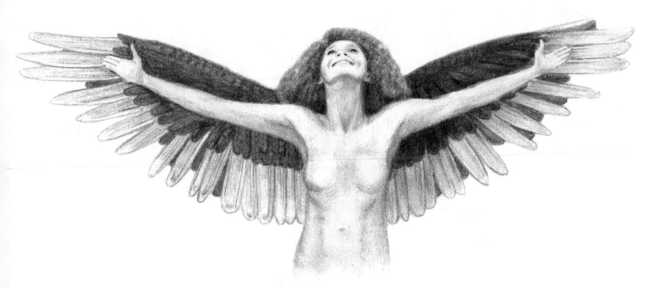

EAGLE LADY

EAGLE LADY

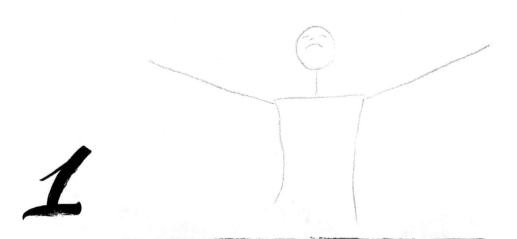

1

Start with a circle head shape. Add simple lines for the neck, a rectangular body, and lines for outstretched arms. Add guidelines for facial features. Since the face is turned upward, the features will be place towards the top of the circle

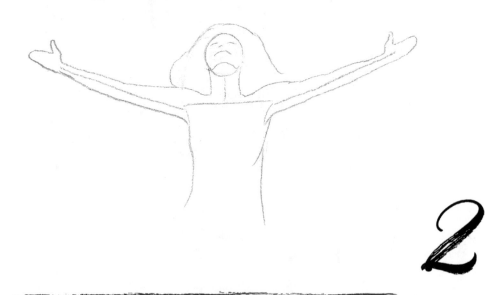

2

Add arms using the lines drawn in step 1 as a guide. Add simplified hands, hair and shoulders. Refine the face shape by drawing a chin.

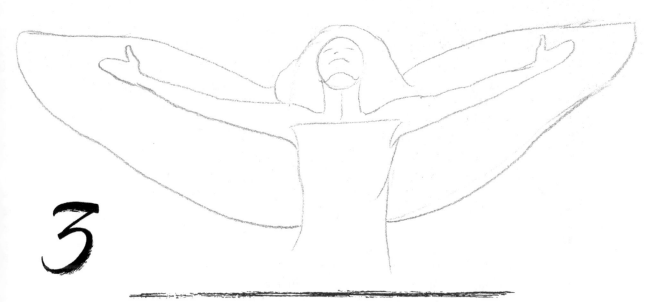

3

Draw a basic outline shape of where the wings will go.
We will refine it later. Erase arm guides.

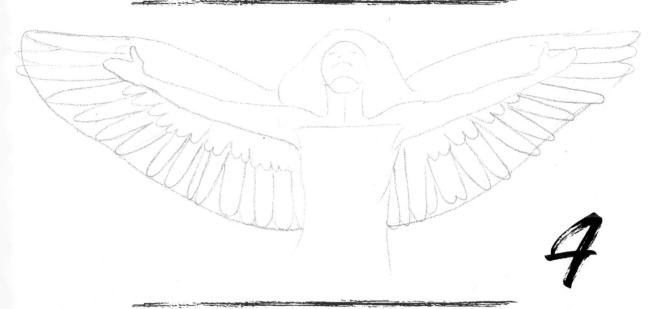

4

Add individual feathers using the wing shape guidelines to help with placement.
Be sure to fan the wings outward.

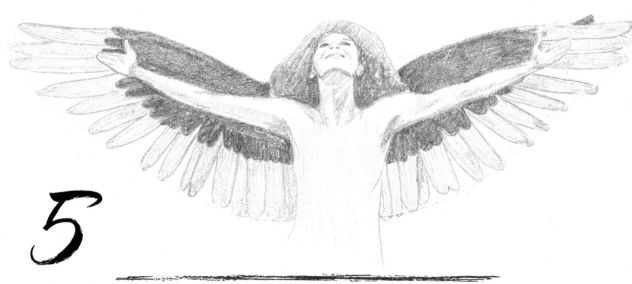

5

Erase the guidelines no longer needed. Add a layer of tone; pressing harder in areas of darkness and shadow, lighter in areas of highlight. Add light tone to indicate neck muscles, underarm shadows, chin and individual fingers. Start to add more detail to the eyes, nose and mouth.

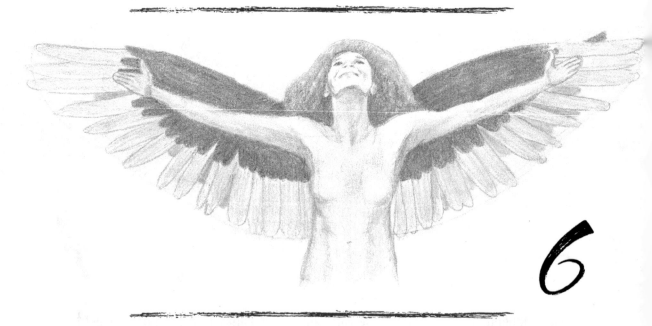

6

Blend tones with a paper stump or other blending tool. Add body detail as desired.

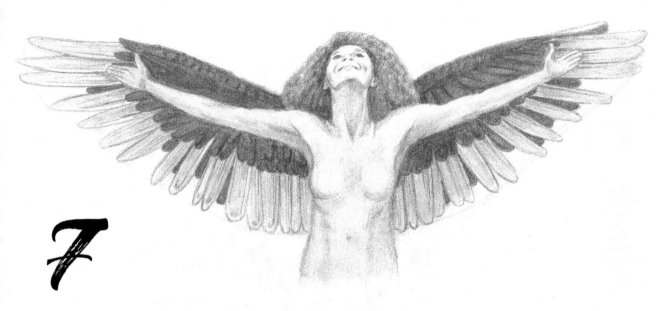

7

Refine shading to feather by adding more variations in value.
Darken hair and shadows.

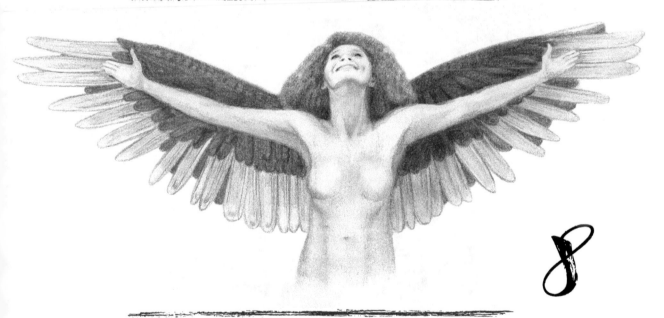

8

Refine finger shapes. Go in with a fine point pencil (mechanical) and refine facial features.
Erase smudges and darken the shadows as necessary.

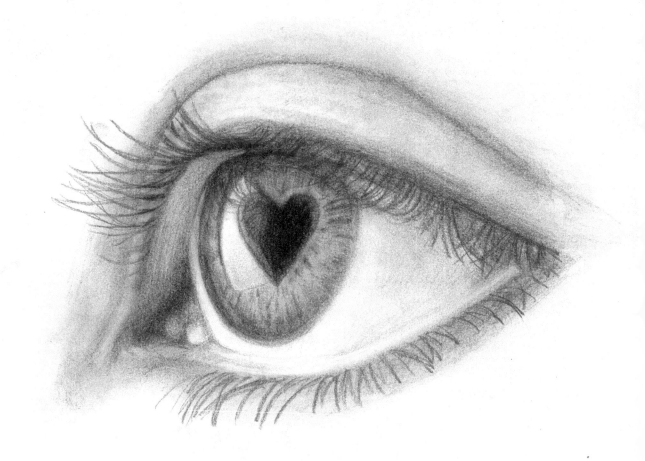

EYE'M IN LOVE

Eye'm In Love

Start with an oval for the iris with a curve running through the top as shown.

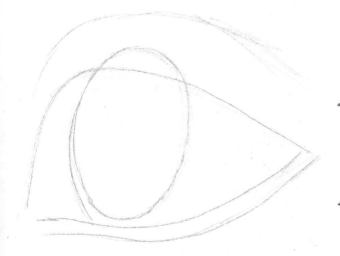

Add two curved lines for the lower lid, another curved line for the upper lid, and a last curve very close to the iris as shown.

3

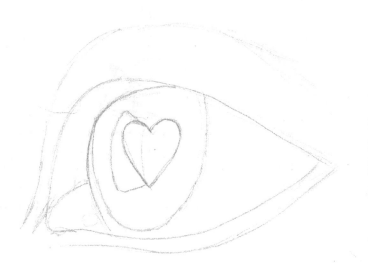

Add a highlight in eye and draw a heart shape for the pupil. Erase the top of the iris no longer needed and trim with line as shown. Leave a curved highlight area to show the spherical shape of the eye.

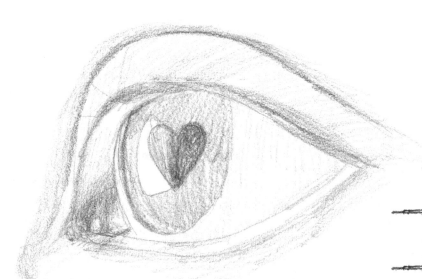

4

Add a light layer of tone.

Eye'm In Love

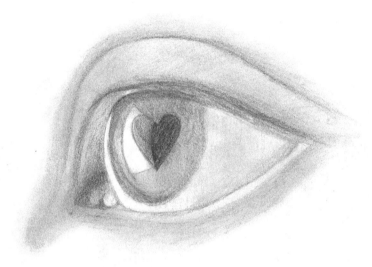

5

Blend tones. Go back and darken the pupil and shadows as they may have become muted while blending. Use a kneaded eraser to add some highlights.

6

Add some dash lines around the pupil for realism. Deepen some of the tones in the iris, pupil and shadows. Add highlights in the white part of the eye (sclera) and on the lid. Add upper and lower lashes. Notice the direction in which the eyelash hairs are drawn (They do not grow in the same direction!)

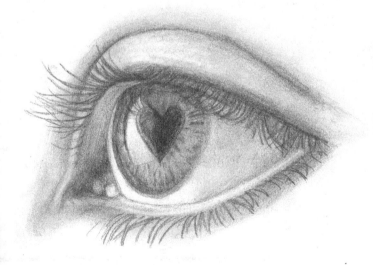

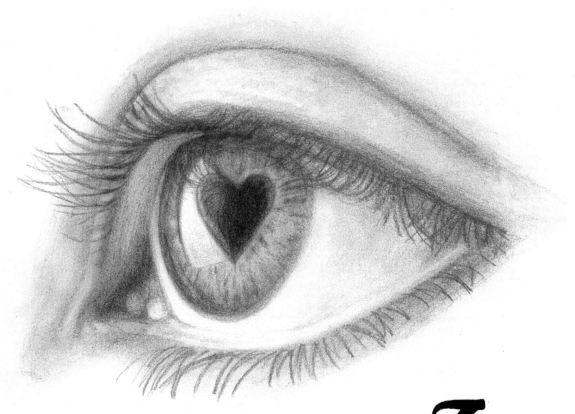

7

Add another layer of tone to deepen shadows and darken tones even further. Add more lashes and darken them to frame the eye.

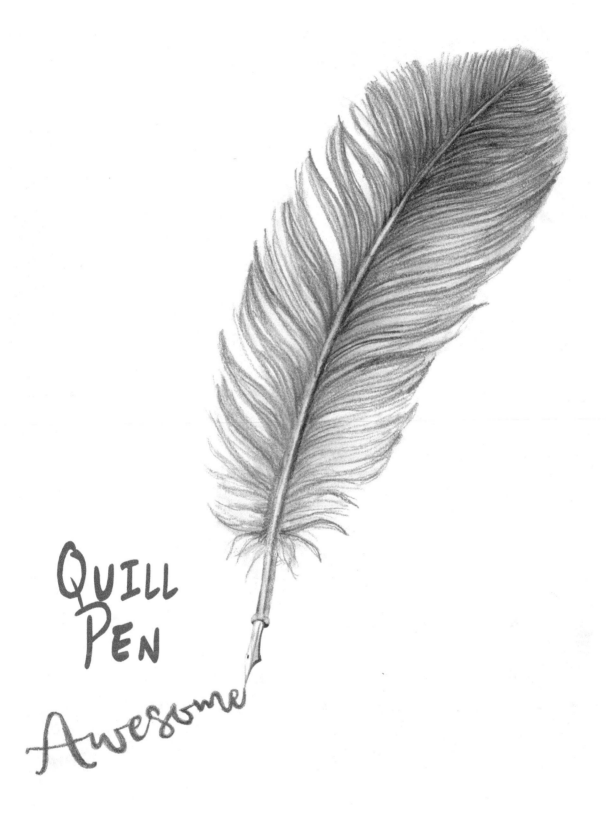

QUILL
PEN

Awesome

QUILL PEN

1

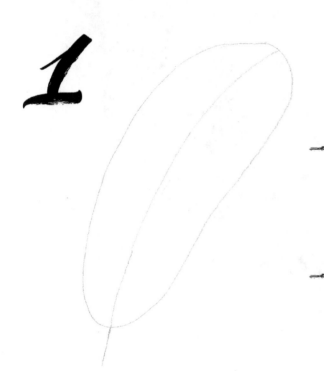

(1) Start with a curved oval shape. Draw a line for the vein going down the center.

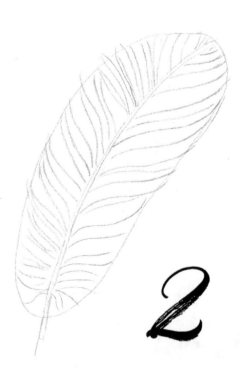

(2) Add curved lines along the length of the main vein. These will start the barbs of the feather. Note that they are mostly at a slight upward angle.

2

QUILL PEN

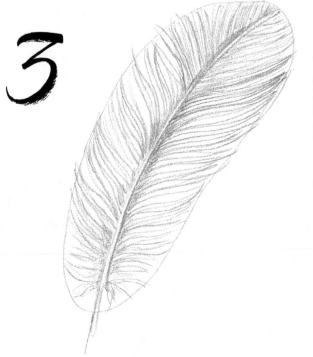

3

(3) Add a layer of light tone in the form of lines: have the lines (closer to the main vein) closer together to represent darker areas, further apart for lighter areas.

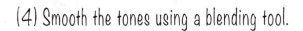

(4) Smooth the tones using a blending tool.

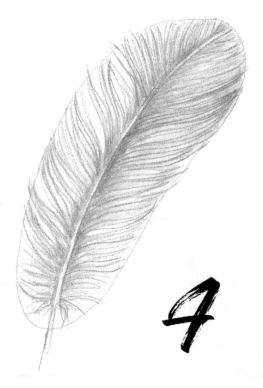

4

Quill Pen

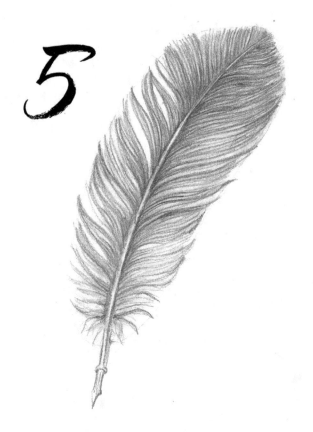

5

(5) Erase the oval guideline that is no longer needed. Add more lines that follow the contour of each barb, using heavier pencil pressure where it will be dark, light pressure where it should be light. Add a triangular tip to the writing end of the quill.

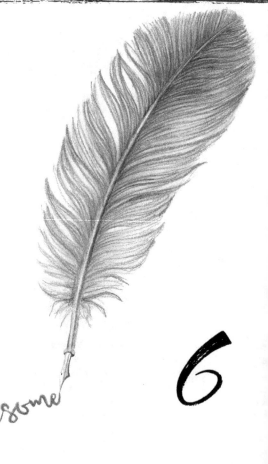

6

(6) Add more contrast of light and dark to create depth and interest. Add a written message or word coming from the pen if desired.

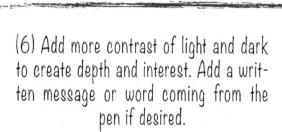

Awesome

FISHNET STOCKING

FISHNET STOCKINGS

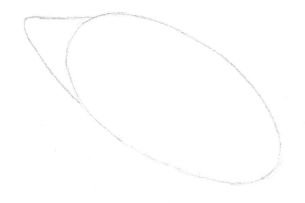

1

Start with an oval for the body and triangle shape at the tip for the nose.

2

Add fins.

Fishnet Stockings

3

Start to shape the rear "fin" which will resemble a high heel shoe. Add eye and mouth.

4

Add lines for fin detail and gils. Refine shoe shape.

FISHNET STOCKINGS

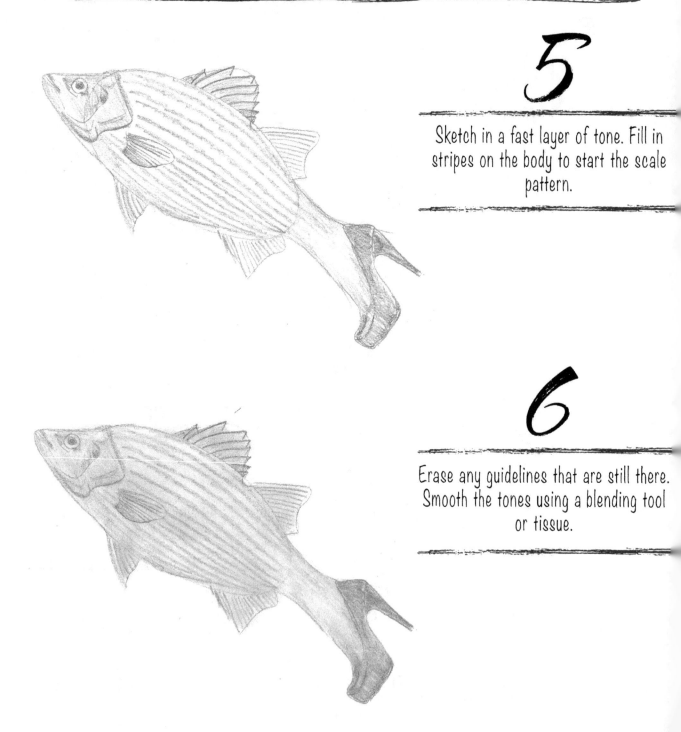

5

Sketch in a fast layer of tone. Fill in stripes on the body to start the scale pattern.

6

Erase any guidelines that are still there. Smooth the tones using a blending tool or tissue.

Fishnet Stockings

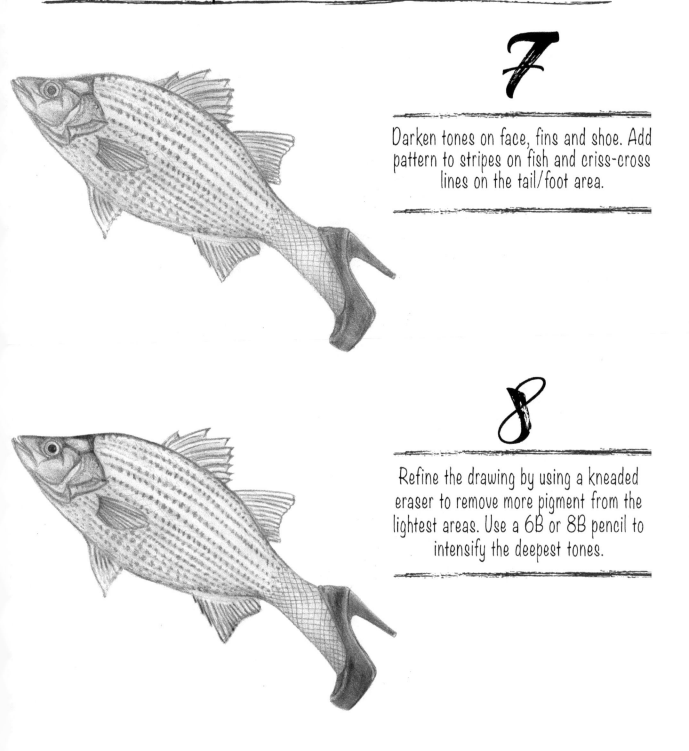

7

Darken tones on face, fins and shoe. Add pattern to stripes on fish and criss-cross lines on the tail/foot area.

8

Refine the drawing by using a kneaded eraser to remove more pigment from the lightest areas. Use a 6B or 8B pencil to intensify the deepest tones.

Flame On

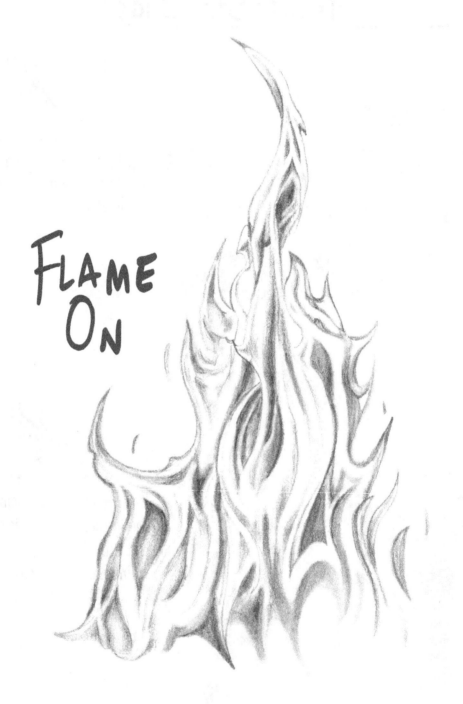

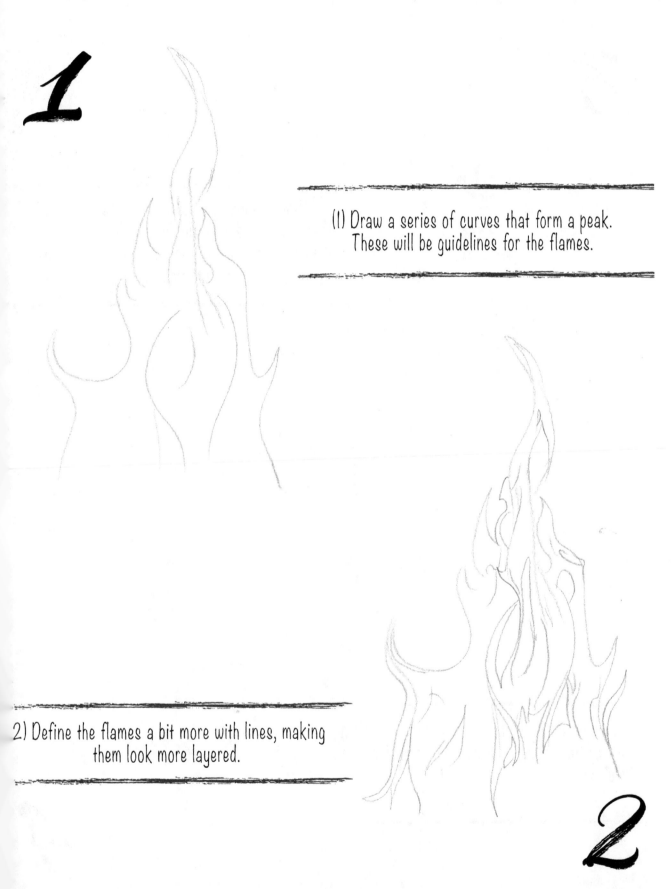

1

(1) Draw a series of curves that form a peak. These will be guidelines for the flames.

2) Define the flames a bit more with lines, making them look more layered.

2

3

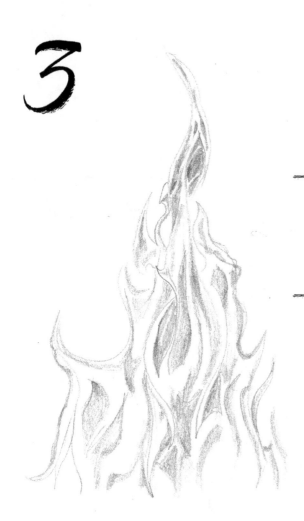

(3) Start adding tone. Draw light wisps of gray that curve and fold within the flame, keeping the edges and corners pointed towards the tips of the flames.

(4) Use a blending tool to smooth the tones. Using some of the pigment from your blending tool, "draw" smudge lines throughout the flames for subtle definition.

4

5

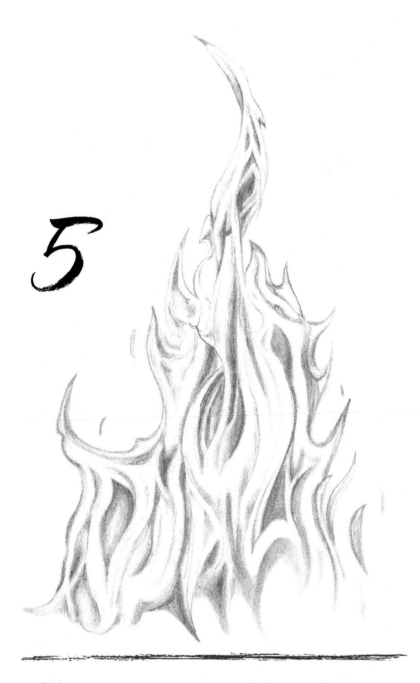

(5) Use a kneaded eraser to highlight the lightest areas.
Use more pencil pressure in areas of darkness.

FLUFFERS

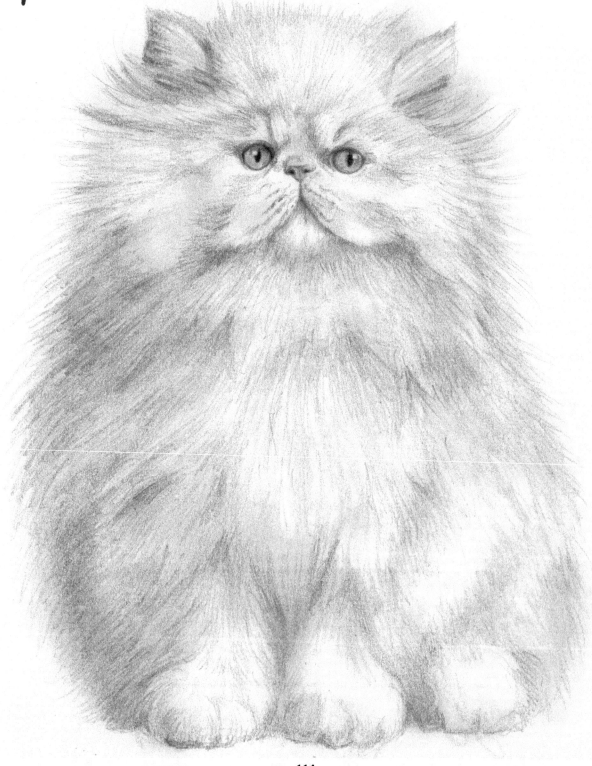

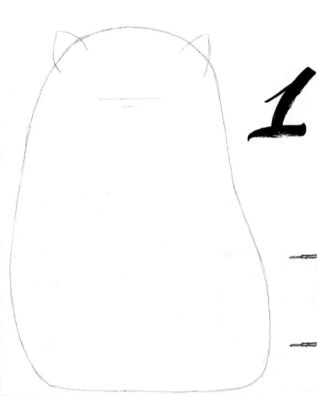

1

(1) Start with an oval shape that is flat on the bottom (looks a bit like a potato). Add curves for ears and guidelines for the eyes and nose.

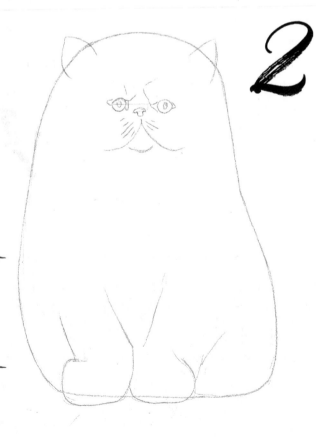

2

(2) Add facial features and paw shapes that are close together. Add lines off of the paws to suggest arms.

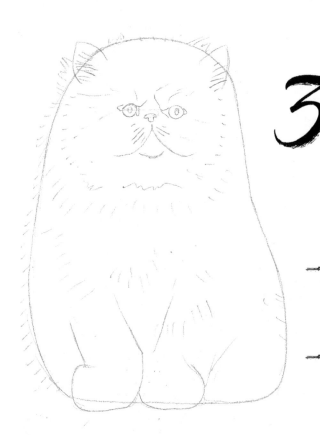

3

(3) Start to add short hatch marks that follow the contour of the body and face. These lines will be guides for the fur.

4

(4) Continuing the hatch mark technique, add a quick layer of tone, pressing harder in areas of shadow, lighter in areas of highlight.

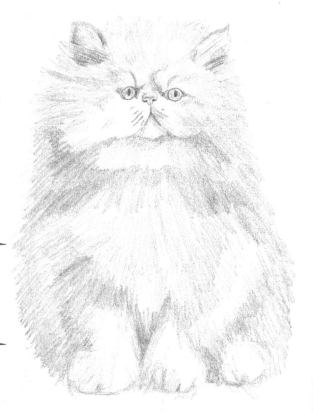

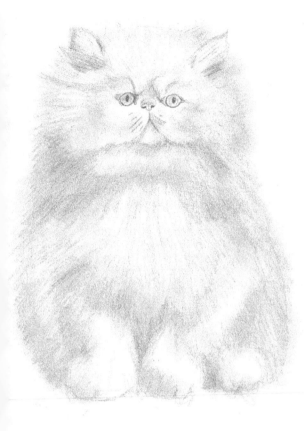

(5) Blend tones well using a tissue or paper stump. This should blur most of the lines into a fuzzy gray tone.

(6) Add long hairs to the contour of the cat that frame the body. Fill in the rest using long, light lines to replicate hairs that follow the cross contours of the form. Use a mechanical pencil to add detail to the eyes, nose, and mouth if they are too small for a regular pencil.

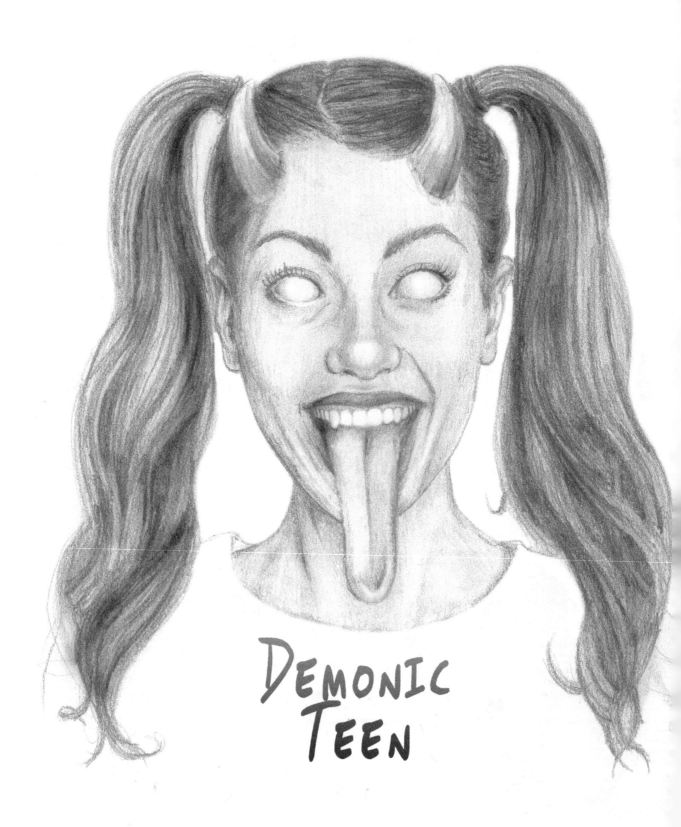

DEMONIC
TEEN

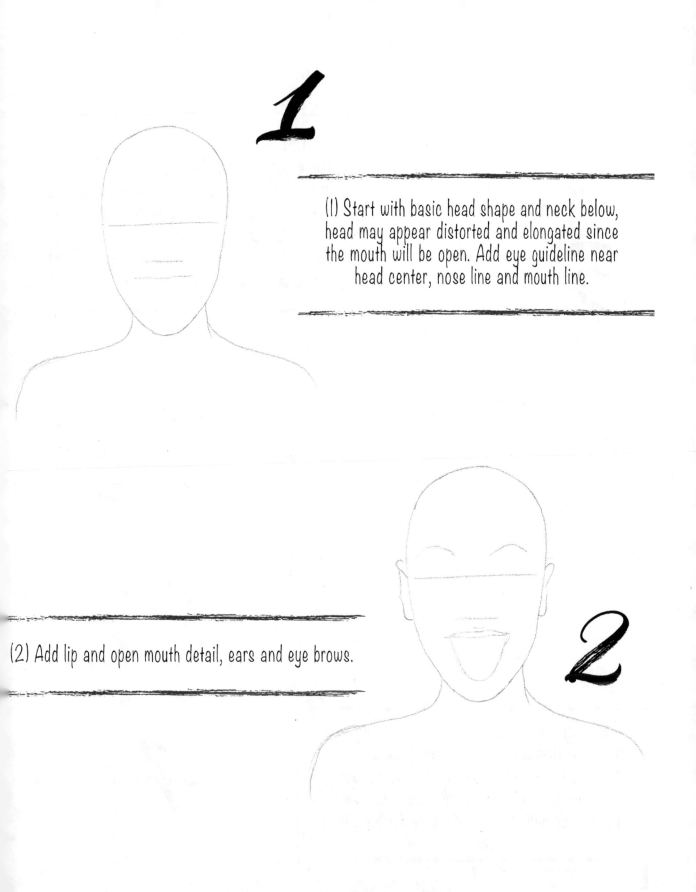

1

(1) Start with basic head shape and neck below, head may appear distorted and elongated since the mouth will be open. Add eye guideline near head center, nose line and mouth line.

(2) Add lip and open mouth detail, ears and eye brows.

2

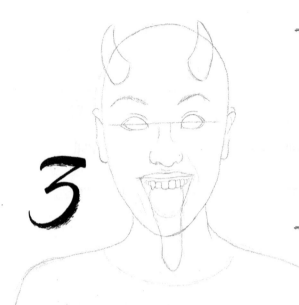

3

(3) Use the top guideline to draw the eyes, with the eyebrows slightly above them. Used curved lines for the nose on the second guideline, and add the mouth details below that, including teeth, lips and a tongue that is as long as you like. Draw curved horn shapes protruding from the forehead. Add a small curve below the neckline for clothing.

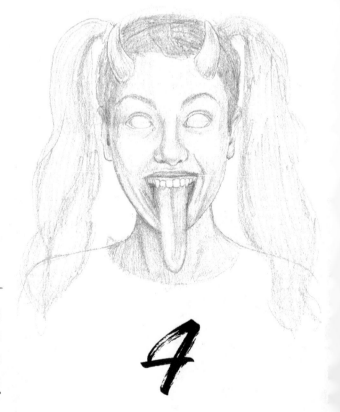

4

(4) Add a light layer of tone to start blocking in shapes and shadows. Use heavier pressure in areas of darkness around mouth and neck, less pressure in lighter areas (cheeks, bridge of nose and eyes). Add outline and some tone for hair, if desired.

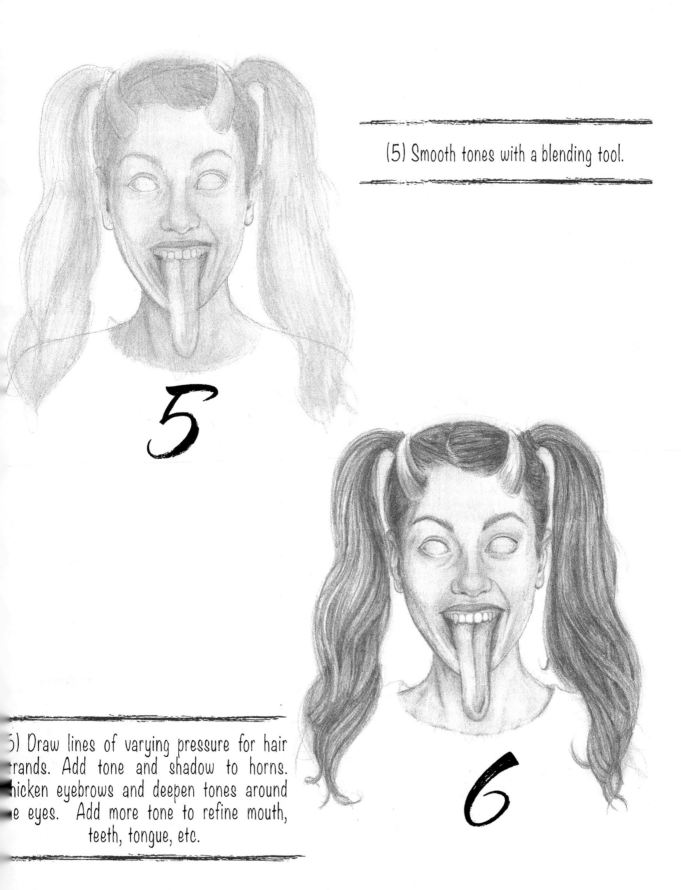

(5) Smooth tones with a blending tool.

5

6) Draw lines of varying pressure for hair
strands. Add tone and shadow to horns.
Thicken eyebrows and deepen tones around
the eyes. Add more tone to refine mouth,
teeth, tongue, etc.

6

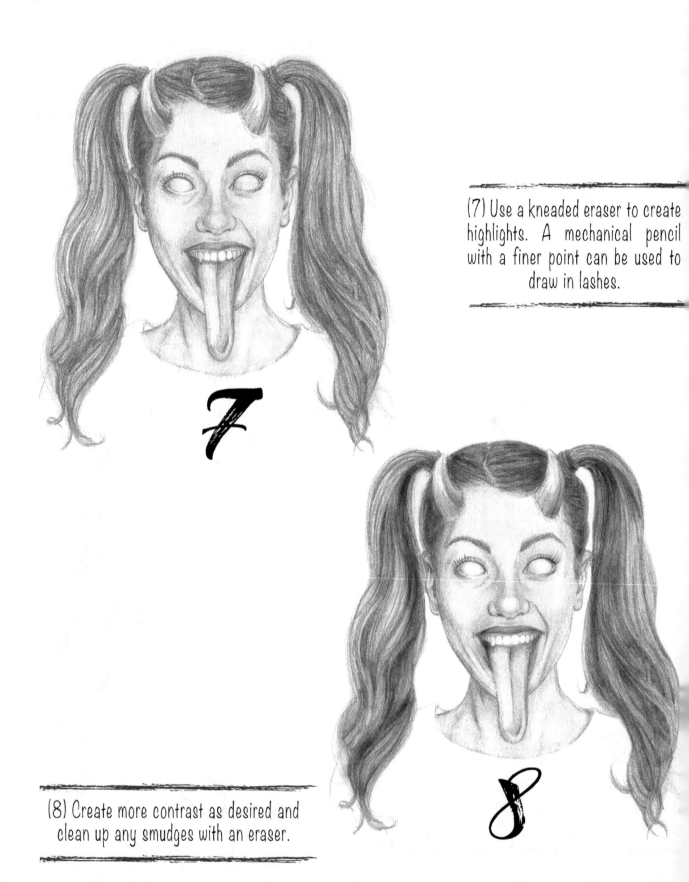

(7) Use a kneaded eraser to create highlights. A mechanical pencil with a finer point can be used to draw in lashes.

(8) Create more contrast as desired and clean up any smudges with an eraser.

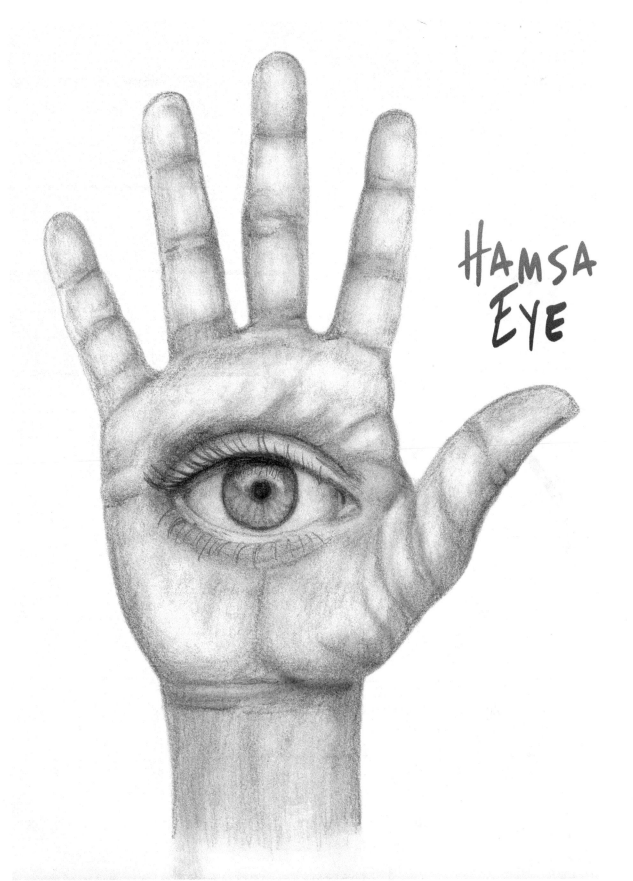

HAMSA
EYE

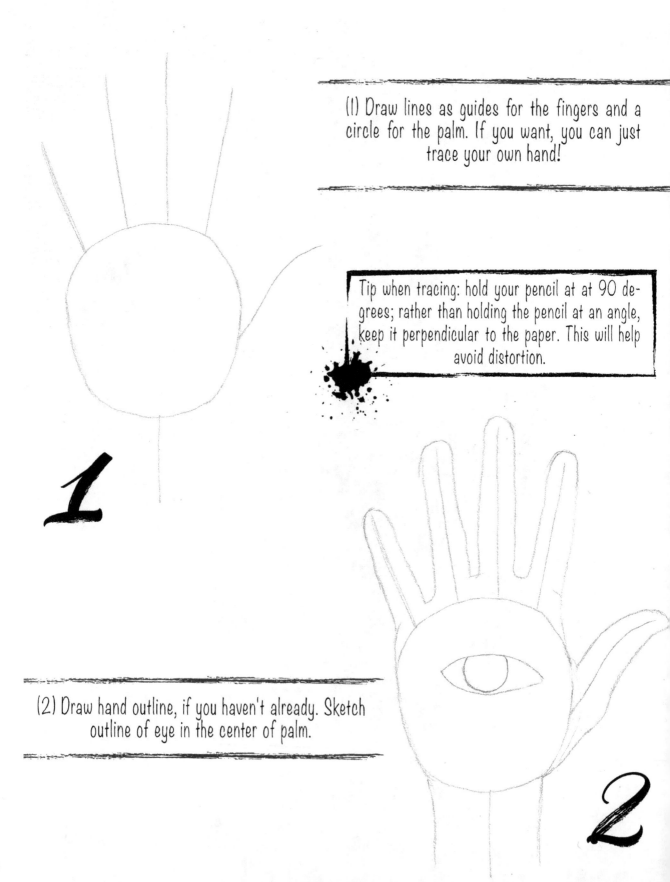

(1) Draw lines as guides for the fingers and a circle for the palm. If you want, you can just trace your own hand!

Tip when tracing: hold your pencil at at 90 degrees; rather than holding the pencil at an angle, keep it perpendicular to the paper. This will help avoid distortion.

(2) Draw hand outline, if you haven't already. Sketch outline of eye in the center of palm.

1

2

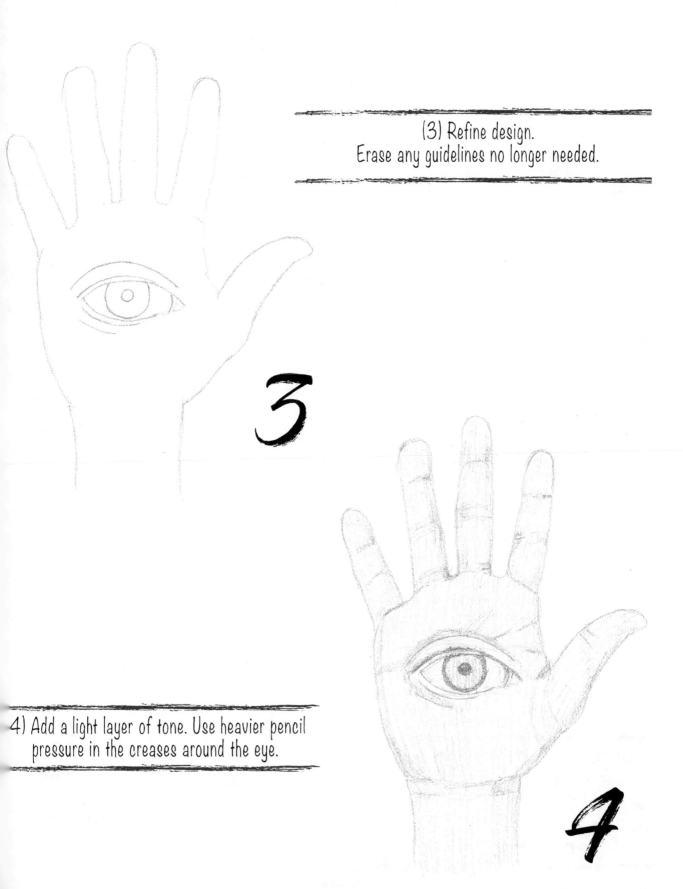

(3) Refine design.
Erase any guidelines no longer needed.

3

4) Add a light layer of tone. Use heavier pencil
pressure in the creases around the eye.

4

125

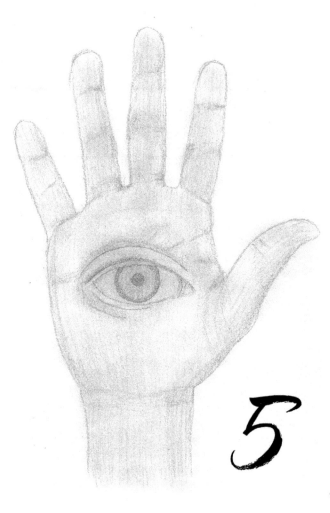

5

(6) Add more detail with tone: pressing harder in areas of darkness, lighter in areas of highlight. Add more wrinkles and skin folds as well along with spokes around the iris for realism.

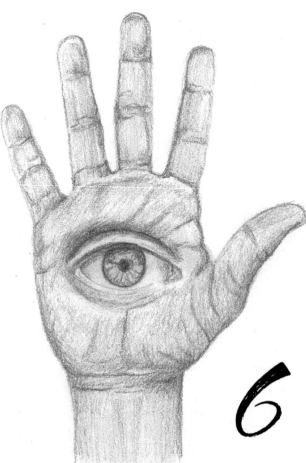

6

126

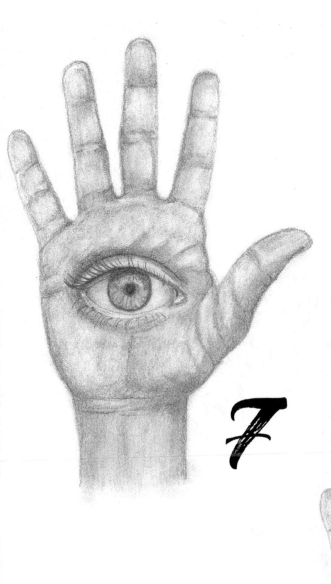

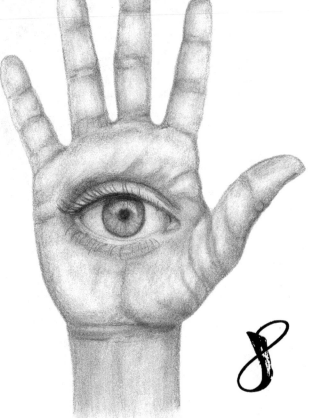

(7) Blend once more. Clean up any smudges or muddied areas with an eraser. Use a kneaded eraser to lighten any areas that may have become muddy when blending.

(8) Add deeper tone for contrast. Erase areas of highlight so they standout more. Smooth tones so that they blend in with one another.

EYE CRAWLER

EYE CRAWLER

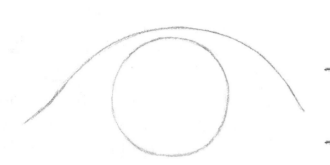

Start with an arch for the top lid and a large circle for the iris.

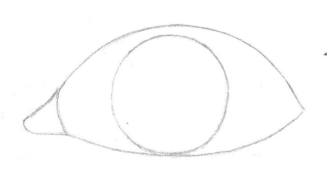

Add a curve under the circle for the bottom lid. Draw a rounded triangular shape for the corner of the eye where the upper and lower eyelids meet (canthus).

Eye Crawler

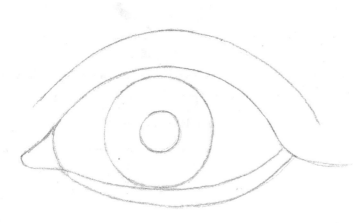

3

Draw a smaller circle in the center of the larger one for the pupil. Draw a curved line to show the thickness of the upper and lower lids.

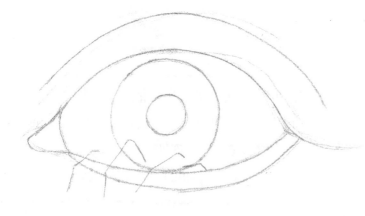

4

Draw lines to indicate fingers coming from the bottom lid.

EYE CRAWLER

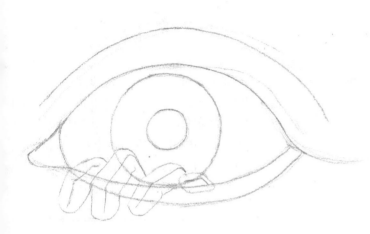

5

Add thickness to the finger guidelines, paying extra attention to where they bend at the knuckles. Notice the fingers are not lined up perfectly, each come from a different angle.

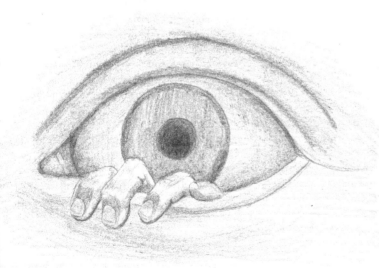

6

Erase finger guidelines. Add a light layer of tone, pressing harder in areas of darkness, including the lid and pupil; use less pressure on areas of lightness, such as the tops of the fingers and the lower lid. Lightly draw finger nails and shadow for knuckle creases.

Eye Crawler

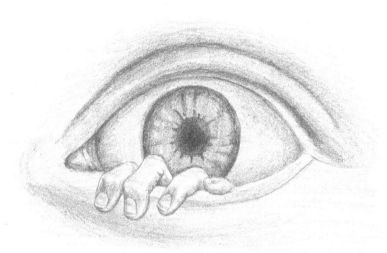

Add another layer of tone, concentrating on darkening the pupil, the upper eyelid creases, under the fingertips, and around the edges of the iris. Draw short "spokes" around the pupil (so it looks like a sun).

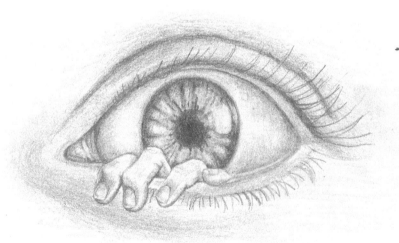

Add a few more spokes for texture. Use a kneaded eraser to lighten the white of the eye (sclera), as well as to add highlight in the iris. Add a few lashes to the bottom and top lids. Notice the direction and curvature of the lash growth.

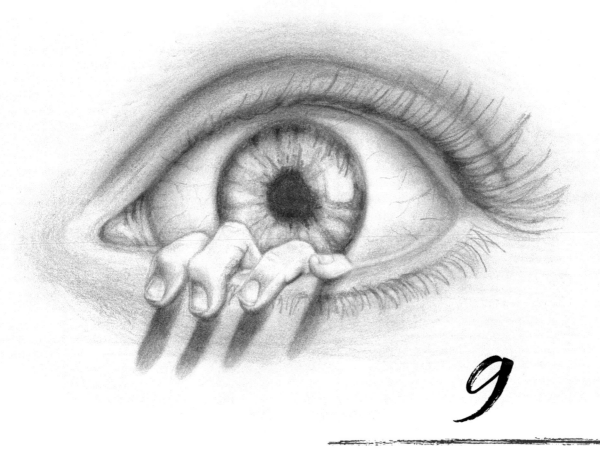

9

Add even more lashes, as well as a shadow coming from each finger, and light veins in the eye. Deepen some of the darkest tones to create more contrast and interest. Blend thoroughly for a smooth finish.

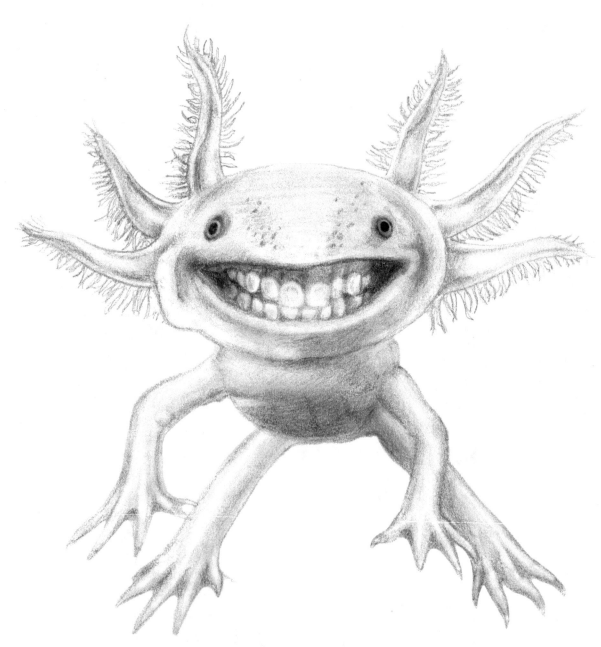

HAPPY AXOLOTL

(1) Start with an oval shape for the head and a "U" shape for the abdomen. Draw lines as guides for the legs and curves around the head for gills.

(2) Draw and open-mouthed smile with with dimple curves. Complete the gill shapes, the legs, and the toes. It's okay if the legs overlap a bit.

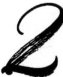

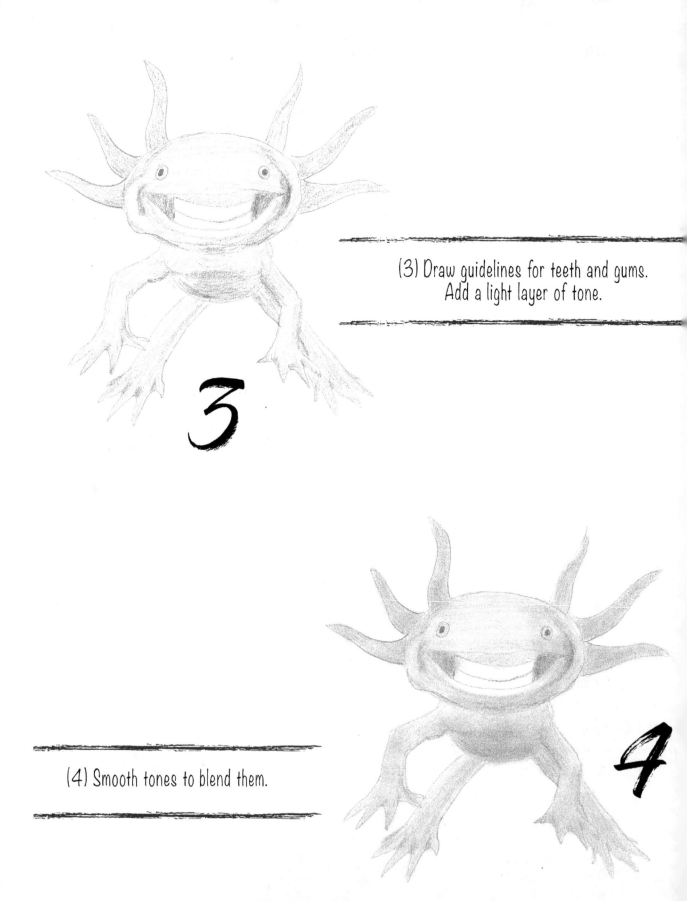

(3) Draw guidelines for teeth and gums.
Add a light layer of tone.

3

(4) Smooth tones to blend them.

4

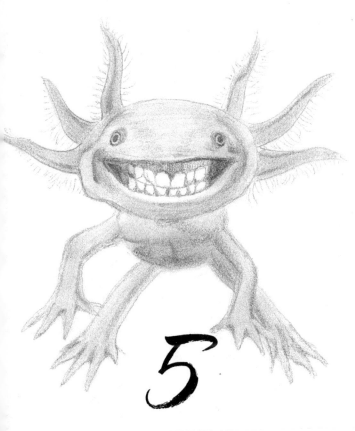

(5) Add teeth below the gum area in the mouth and short curved lines coming from the gills on top. Add another layer of tone that defines the shape a bit more while adding contrast.

5

(6) Add more detail to the mouth, gills and shadows. Add freckles between the eyes. Use a kneaded eraser to remove pigment and highlight the lightest areas.

6

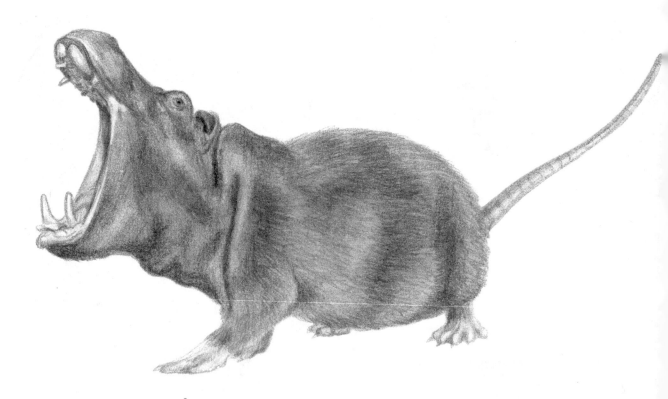

HIPPOPOTAMOUSE

Hippopotamouse

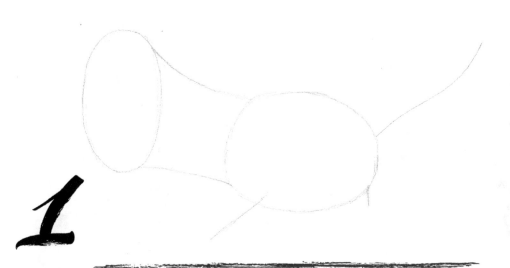

1

(1) Start with a rounded oval for the body, and an elongated oval for the head. Connect the ovals with lines as shown, also add guidelines for legs and a long line at the rear for a tail.

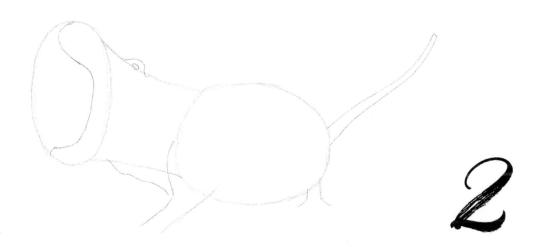

2

(2) Use the front elongated oval as a guide for an open mouth. Draw a curved line through it as shown. Add a bump near the top for an eye, refine the neck, and thicken the legs. Finish the tail.

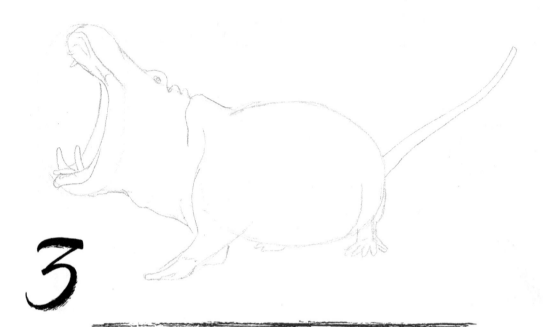

3

(3) Erase the guidelines that are no longer needed.
Add detail to open mouth, refine neck and draw the toes.

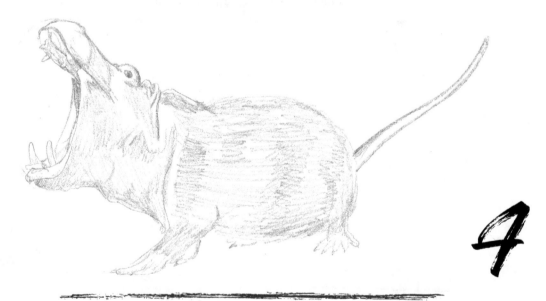

4

(4) Add a light layer of tone, using heavy pencil pressure in areas of
darkness, less in areas of highlight.

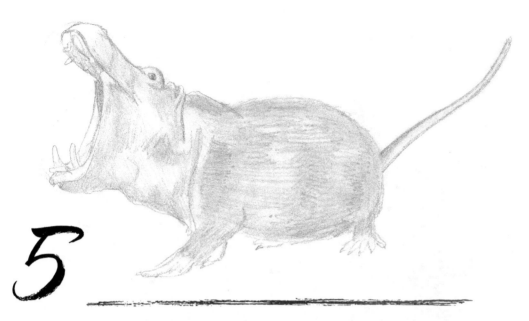

5

(5) Smooth tones with a blending tool or tissue.

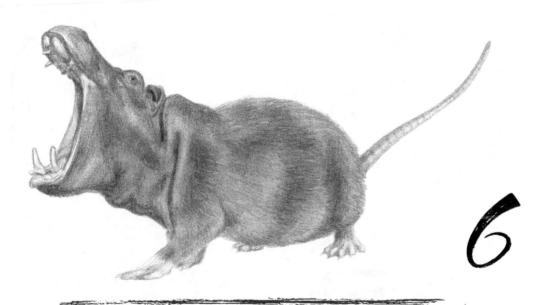

6

(6) Add another layer of tone to create more contrast as well as hatch mark lines for fur detail. Add raw curved lines to indicate textured rings around the tail.

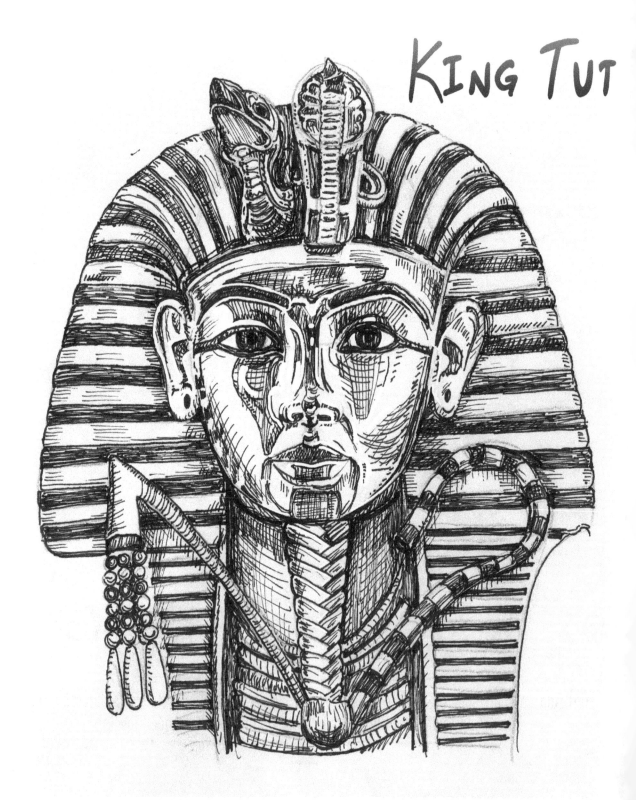

KING TUT

(1) Start with an oval shape for the head. Draw lines as guides for the facial features. Add a neck, ears, and a curved headdress.

(2) Add the facial features, ear detail and start snake detail at top of headdress. Start chin detail.

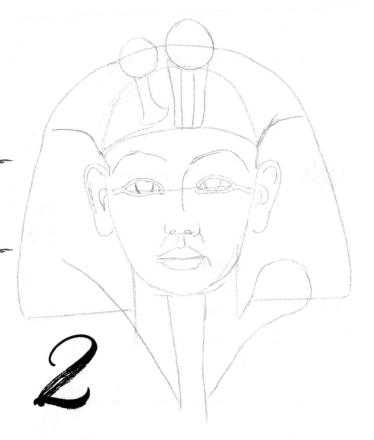

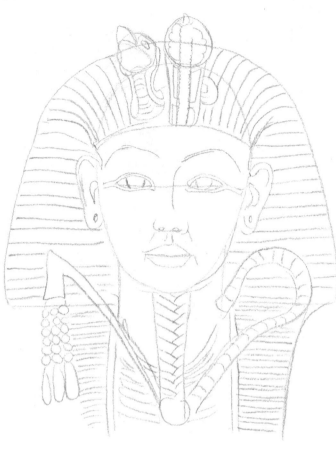

3

(3) Continue snake detail. Add stripes to headdress and ornaments. Make a braid pattern on the false beard (chin extrusion).

Tip: When shading with pen, one cannot apply shading by increasing pressure. Pens rely on texture to create the look of value. Also, Pens make crisp, decisive, confident lines, unlike the gray line of a pencil.

4

(4) Use a fine marker to start filling out the darkest areas.

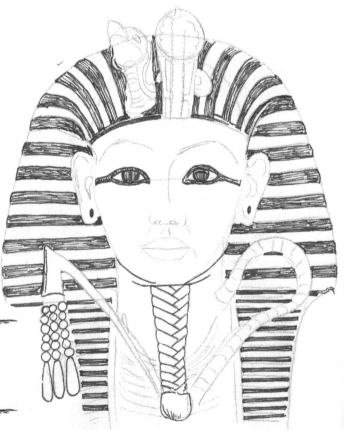

144

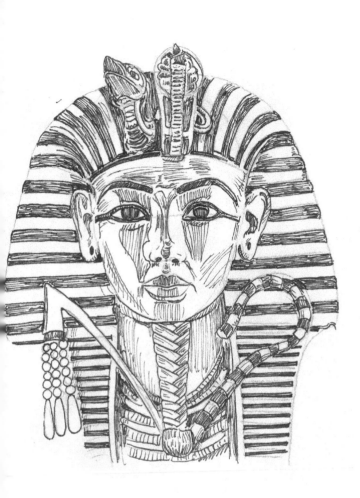

5

(5) Add hatch marks to the areas of mid tone; a medium tone that is neither very dark nor very light.

6

(6) Add another layer of hatching and cross hatching to darken the darkest areas, leaving the lights areas white (paper tone).

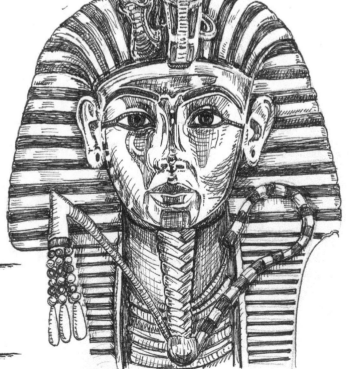

NIGHTMARE FACE

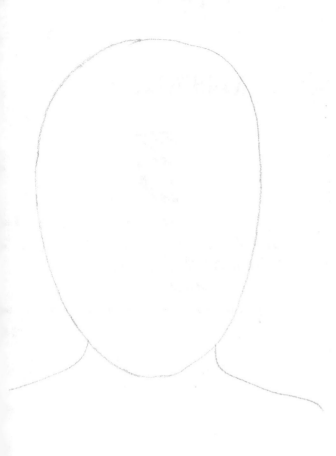

NIGHTMARE FACE

1

(1) Start with a simple oval for the head. Add lines for the neck and shoulders.

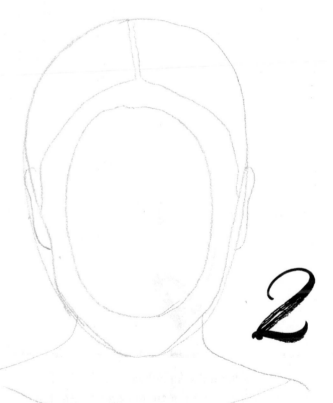

2

2) Refine the head shape. Add ears, hairline and collar bone line. Draw an oval inside of the face. This will be the start of the layers.

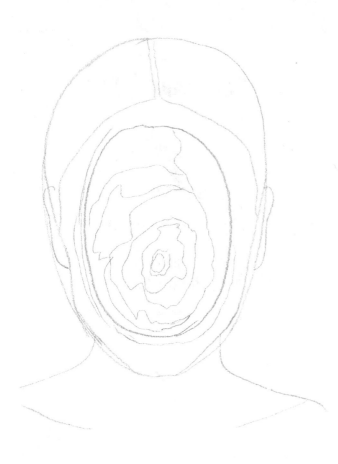

3

(3) Add a series of organic shapes inside of the face oval. These shapes will be the beginning of the inner layers.

4

(4) Add some dark shadows to the layers. This will help to add dimension and depth. Fill in the hair and add a light layer of tone to the head and neck.

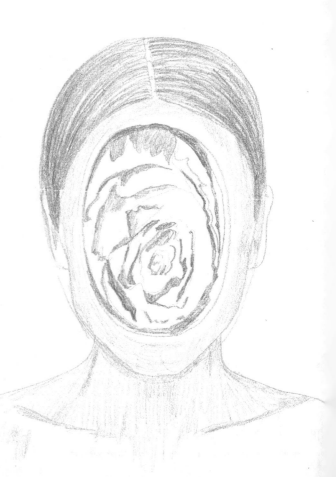

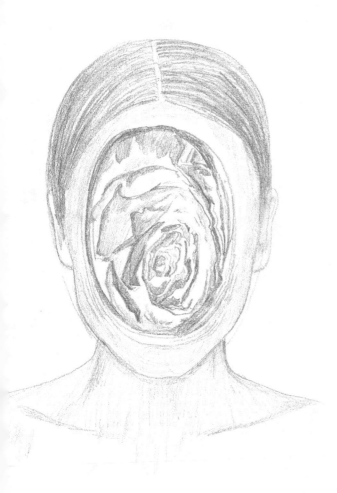

Nightmare Face

5

(5) Add more texture and shadows to the face, each layer getting smaller as it reaches the center.

6

(6) Very carefully, blend the tones with a tortillion or blending stump, smoothing one section at a time, keeping them separate.

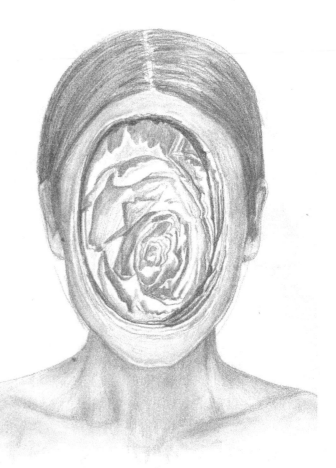

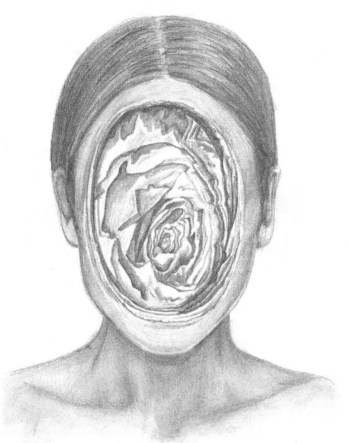

(7) Go back over the dark areas and use a mechanical pencil to make the edges look more crisp. Erase head guidelines no longer needed.

(8) Add more contrast as needed, using heavier pencil pressure or a darker shading pencil (such as 8B); use the kneaded eraser to brighten highlights.

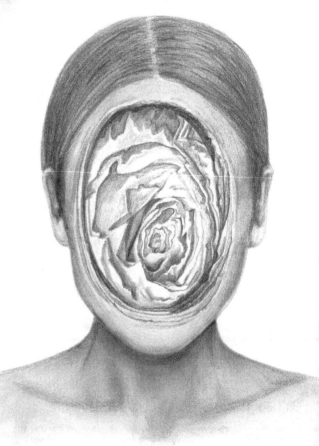

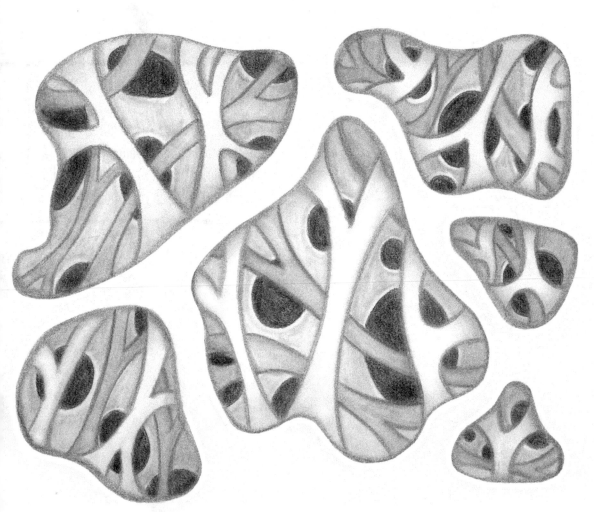

ORGANIC LAYERS

Organic Layers

1

Start with several organic shapes all around the paper. This will be the first layer of our design. An organic shape is irregular and may seem flowing and unpredictable. They look natural and are often curvilinear in appearance.

2

Using the side of the pencil, draw a thick shadow around the inside edge of each organic shape.

Organic Layers

3

Use a tissue to blend the inner parts of the shape, leaving it darker on the outer rim, lighter in the center. Clean up the smudges with an eraser.

4

Add some "Y" shapes and curves inside of the organic shapes. This time, add shadows to the outside of the "Y's" and blend. This will be layer 2. Tip: Place a blank sheet of paper over the areas you are not working on to reduce smudging.

Organic Layers

5

Draw more shapes and curves "under" the ones drawn in step 4. Shade these using a blending stump, being careful to stay inside the shapes. These should be slightly darker than the set drawn in step 4. This will be layer 3.

This lesson involves using different values and shapes to create the illusion of depth in the drawing.

6

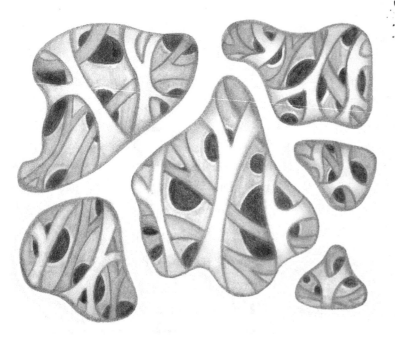

Next, make the holes. Draw organic shapes under all of the previous ones. Fil them with a heavy pencil pressure to make them as dark as you can. This wil be layer 4. Darken layer 3 as needed to create a mid-tone.

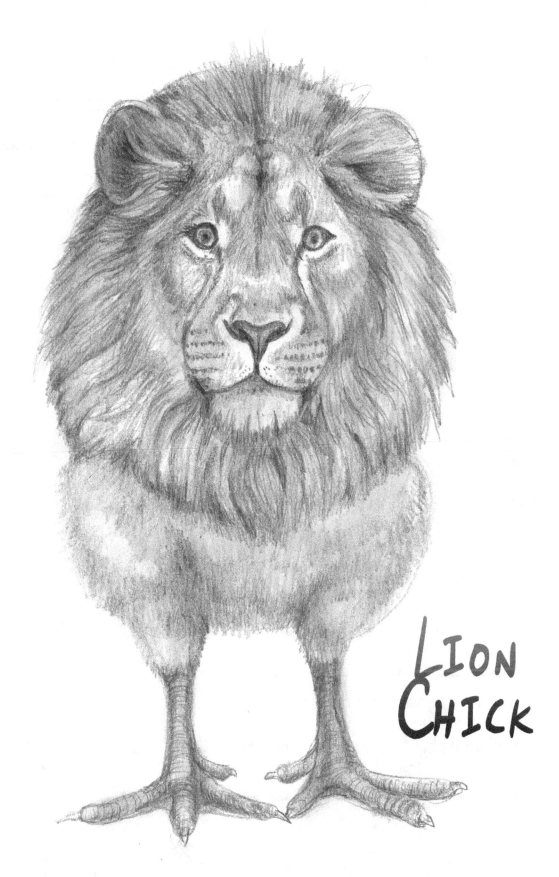

LION CHICK

LION CHICK

(1) Start with a large egg shape for the head. Add two ovals with curved lines beneath it for the legs. Draw a curve to connect the oval part of the legs.

1

2

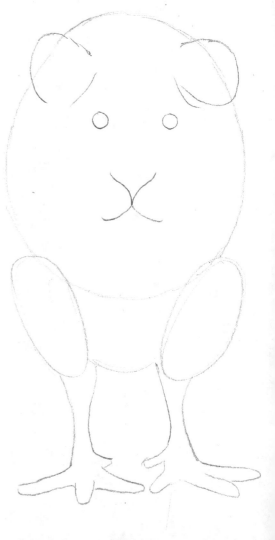

(2) Add curves for ears, two small circles for eyes, and a curvy "X" shape to start the mouth and nose as shown. Add lines to fill out the legs, as well as curvy toes to the feet.

LION CHICK

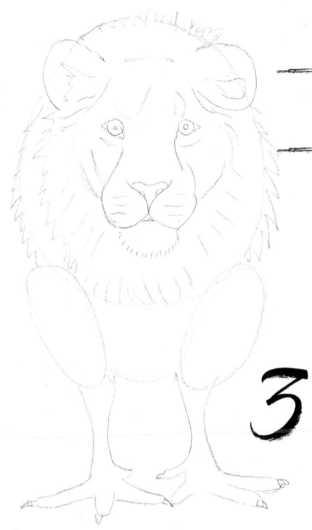

(3) Add facial features and simple fur lines to the face. Draw tiny claws on the toes.

3

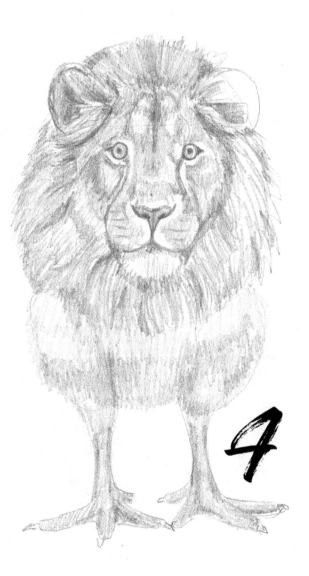

4) Add a layer of tone; use heavy pencil pressure in areas of darkness and less pressure in areas of lightness.

4

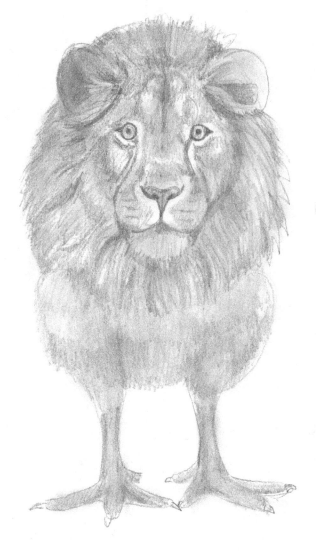

(5) Smooth tones with a blending tool or tissue

5

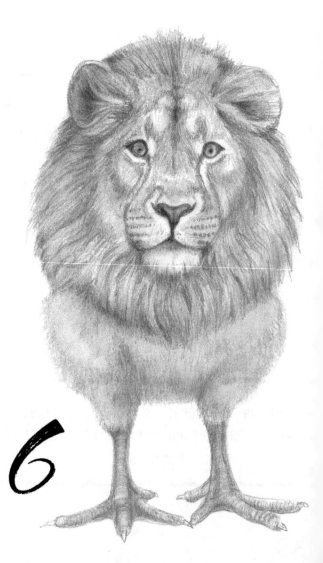

6

(6) Add more fur lines; denser lines will make areas of the fur appear darker while lines spaced apart will appear lighter. Smooth once this is done to blend the hairs. Also, add curved lines around legs to indicate cross contour form and texture.

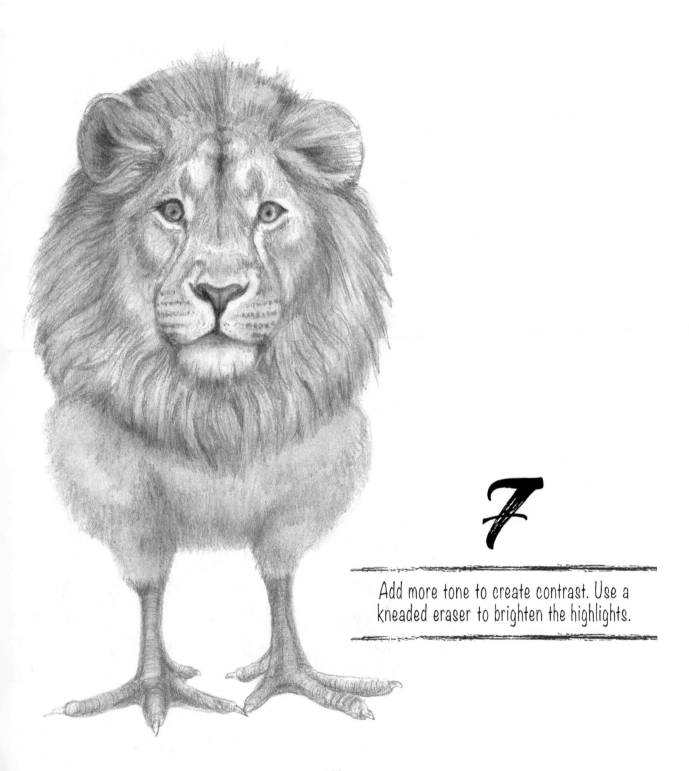

7

Add more tone to create contrast. Use a kneaded eraser to brighten the highlights.

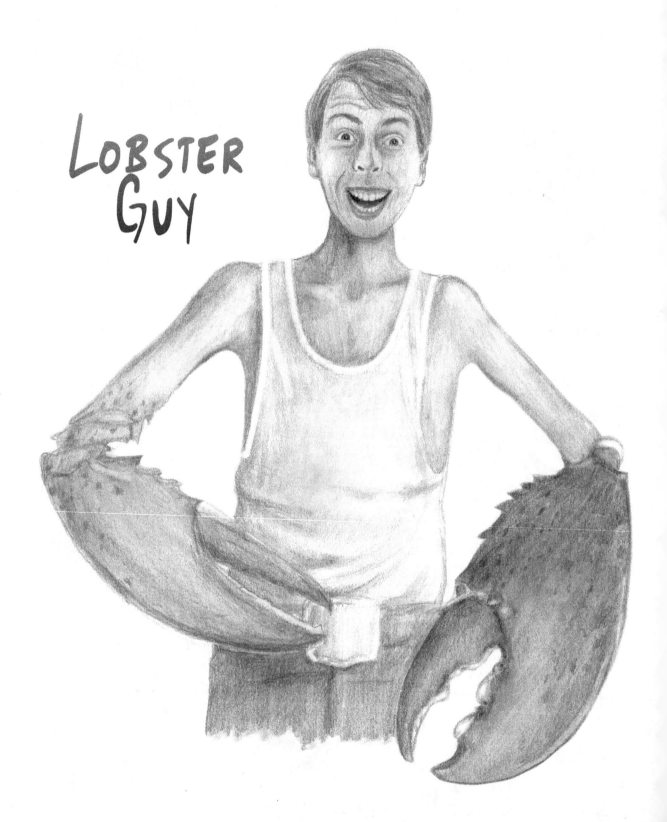

LOBSTER
GUY

LOBSTER GUY

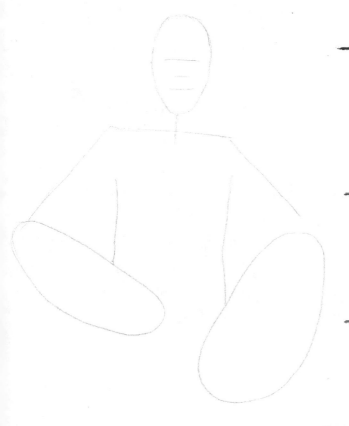

1

Start with an oval head with guides for the facial features. Add guidelines for the neck, arms and torso. Draw ovals for the claw hands.

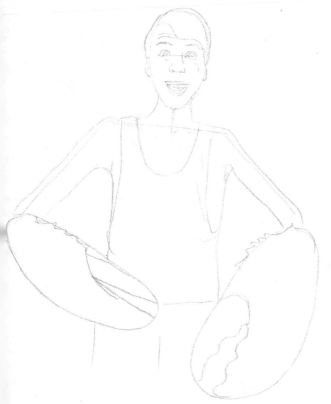

2

Draw the basic features of the head and face. Add a torso and arms with oversized claws at the ends. Draw light lines to indicate clothing.

LOBSTER GUY

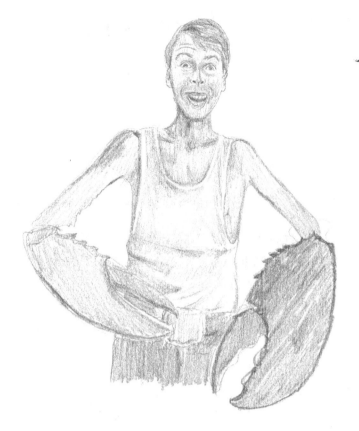

3

Erase the guidelines that are no longer needed. Add teeth details and a light layer of tone. As well as details for claws, hair, and shirt folds.

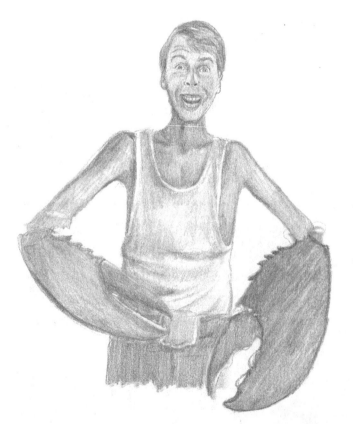

4

Blend

LOBSTER GUY

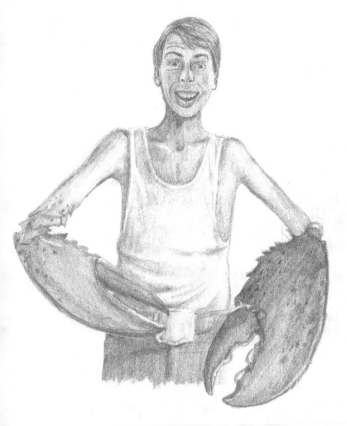

5

Add further tone to refine the shading and details. Clean up any smudges and add more contrast as needed.

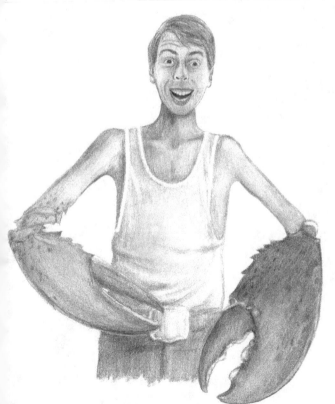

6

Finally, define the drawing by adding another layer of tone. Use heavy pencil pressure to create dark contrast and a kneaded eraser to create highlights.

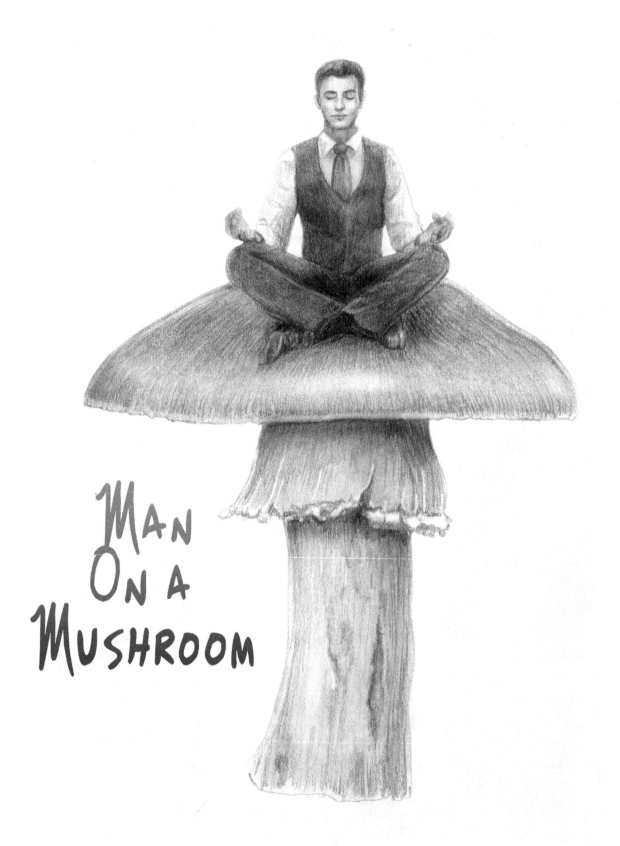

Man
On a
Mushroom

MAN ON A MUSHROOM

1

Start with the mushroom shape, a half circle with an opening at the top. Add guidelines for man sitting on top: an oval for the head, lines for the torso, arms, shoulders, hands, and crossed legs.

2

Fill in the sitting stick figure man with bulk. Draw light guidelines for the facial features. Also add a skirt shape to mushroom's stem to add some realism to its shape.

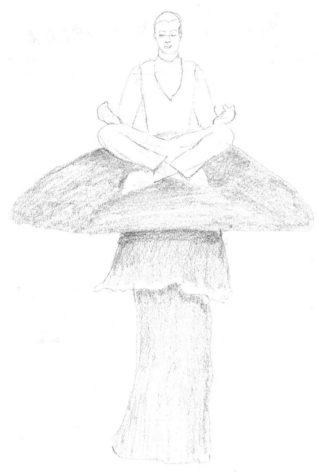

MAN ON A MUSHROOM

3

Erase the guidelines that are no longer needed. Draw simple facial features and clothing lines to the man. Add a light layer of tone to the mushroom.

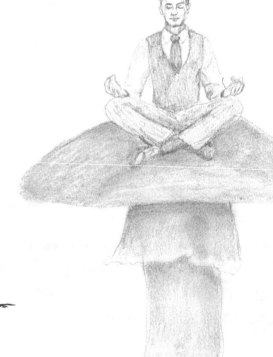

4

Blend tones on the mushroom. Add a light layer of tone to the man.

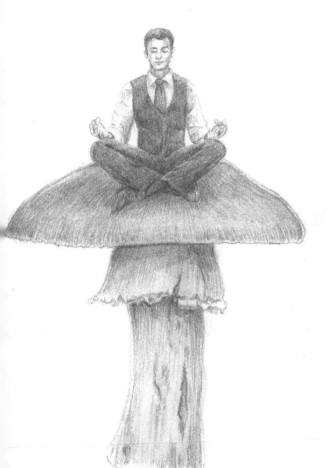

MAN ON A MUSHROOM

5

Add another layer of tone to the mushroom, using lines that follow the cross contours for definition. Blend in the tones on the man to smooth them, then add more variation to the tone with pencil, pressing harder is areas of darkness including folds in the fabric.

6

Add even more contrast of darks and lights. Highlight clothing wrinkles and mushroom shine spots with an eraser. Deepen and darken areas of shadow.

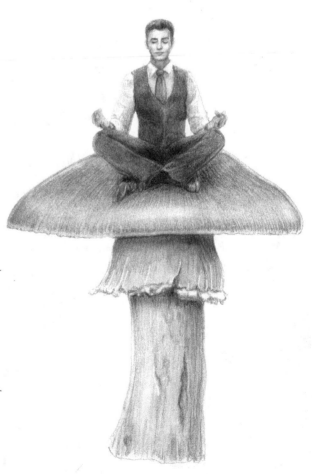

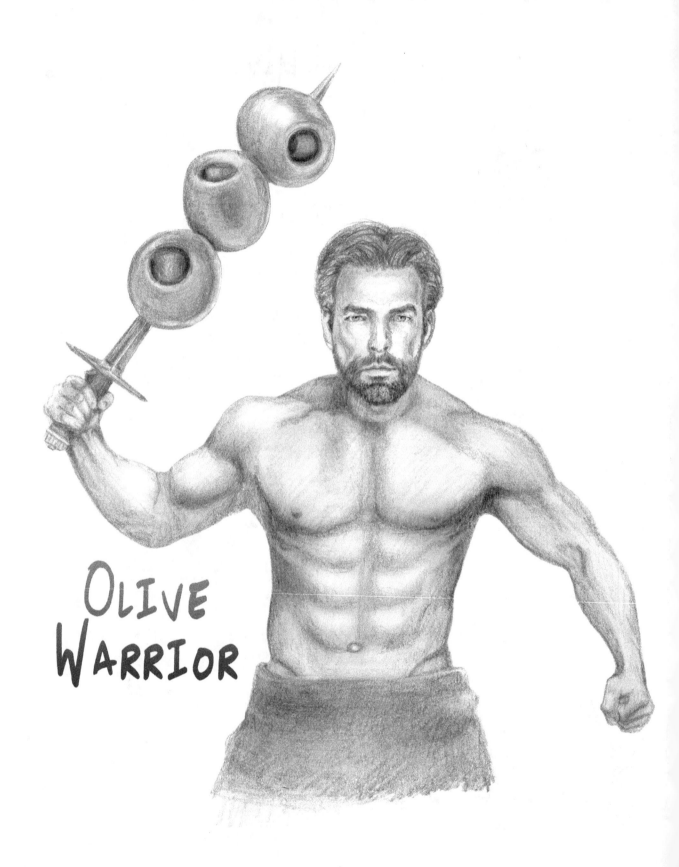

OLIVE WARRIOR

OLIVE WARRIOR

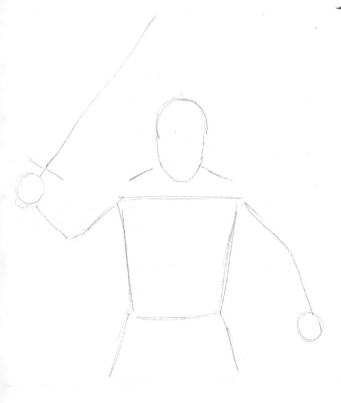

1

Start with an oval head. Add simple guidelines for the body, small circles for fists, and a line for the sword.

2

Draw lines for guides on the face. Draw muscles and a torso around the body guidelines. Add finger details and fill in the sword. Add stacked circles on the sword. These will be olives!

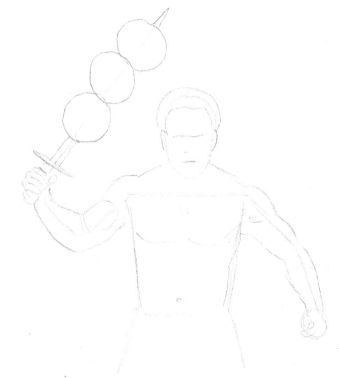

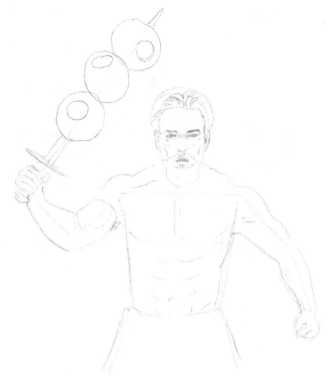

OLIVE WARRIOR

3

Draw facial features and define muscles more. Draw circles on the olives.

4

Add a layer of tone; use heavy pencil pressure in areas of darkness and less pressure in areas of lightness. The shading will help to define more details to the torso and face.

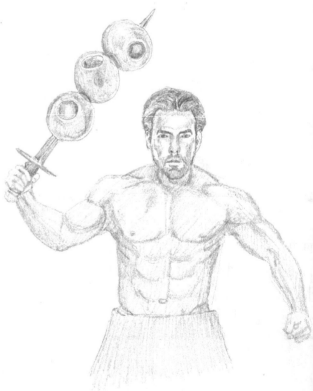

OLIVE WARRIOR

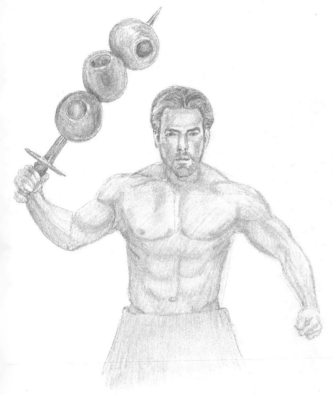

5

Use a blending tool to smooth the tones.

6

Go back in and add more contrast, using a 6B or 8B pencil to create even darker tones.

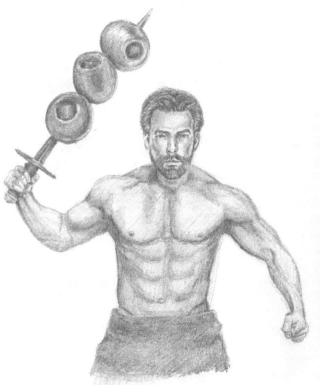

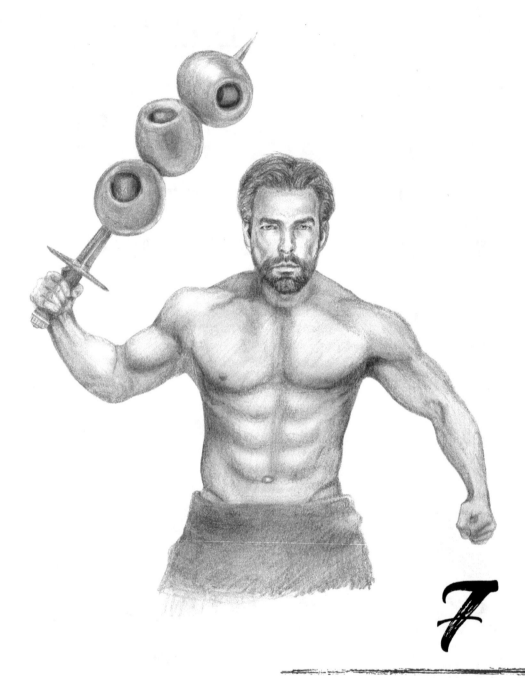

7

Refine the work by cleaning up smudges, highlighting light areas with a kneaded eraser, darkening the deepest tones with a 6B or 8B pencil and smoothing any stray lines.

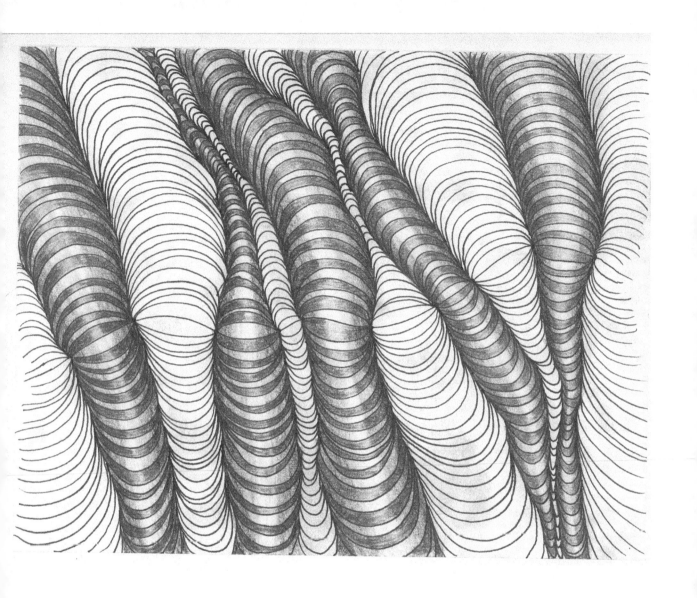

OP Art Lines

OP Art Lines

Start by drawing a slightly curved line (in the middle of the page) across the paper with a fine pen. Add 8 to 10 dots along the line at varying lengths apart. Make sure there is a dot close to the edges of the paper.

Connect each dot with a curved line as shown. The curved lines coming from the dots closest to the edge of the paper will go off the page.

3

Draw another set of curved lines under the original line drawn in step 1.

Add another set of curved lines above the ones drawn in step 2. They should still meet the dots, however, they should not touch the other curves.

5

Keep repeating this step. The curves will start to become difficult to touch the dots, however, try and get it as close as you can into the divot. The curves will eventually go off the top and bottom of the paper. Add these curves to the underside as well.

It should look like rows of curves when you are done.

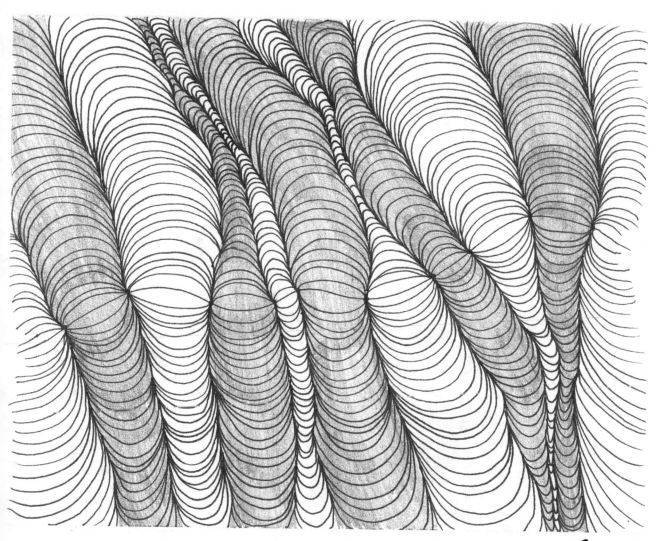

Next, shade in every other row using pencil with a medium tone.

6

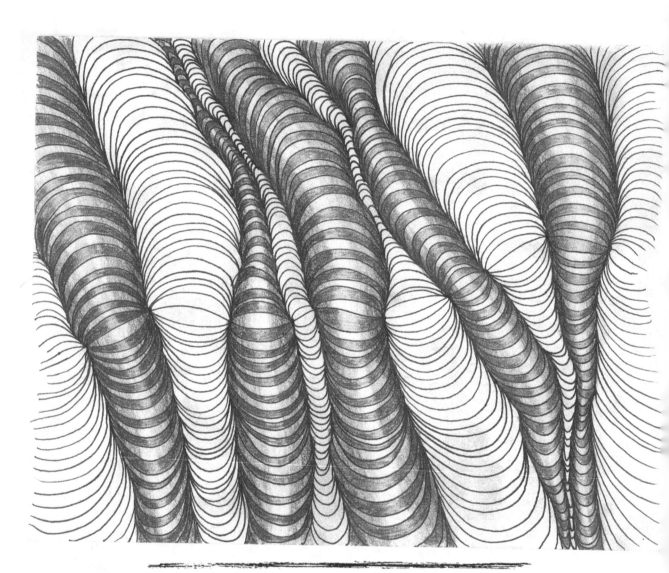

 Then, using heavy pencil pressure, darken every other curve as shown. Finally, shade in the sides of each shaded row using heavy to medium pencil pressure to make the row appear as if it is moving backward into space on the sides. Run a kneaded eraser down the center of each shaded row for a highlight.

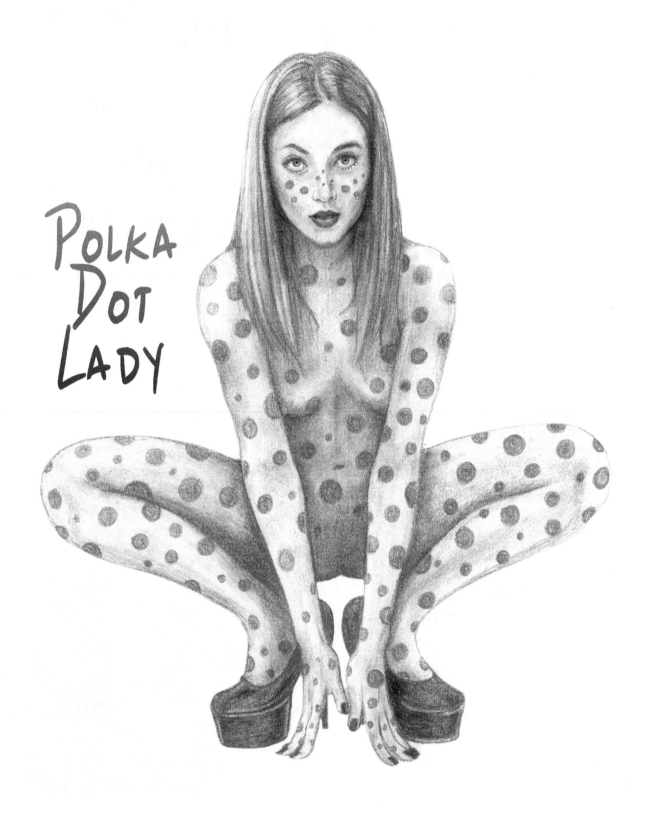

POLKA
DOT
LADY

POLKA DOT LADY

1

Start with a stick figure in the squatting position, as well as an oval shaped head.

2

Use stick guidelines to form the body. Add facial feature guidelines and the shape of high heeled shoes.

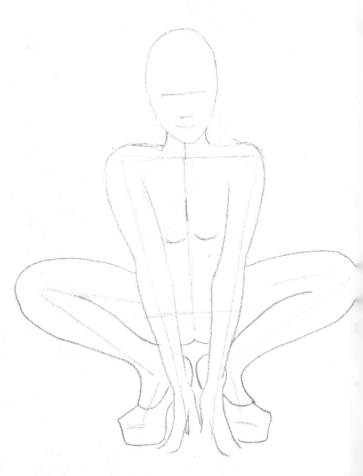

POLKA DOT LADY

3

Erase guidelines that are no longer needed. Add facial features, hair and finger details.

4

dd a light layer of tone, using heavier encil pressure on areas of darkness and less on areas of light and highlight.

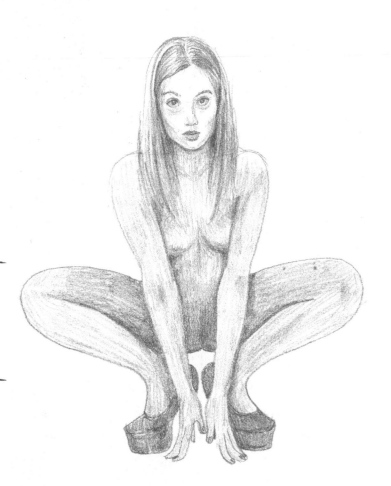

Blend tones.

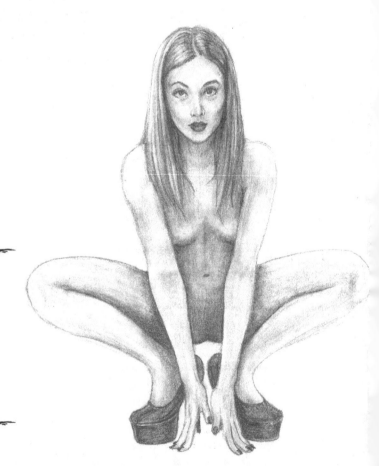

6

Use a kneaded eraser to remove the smudges and to create highlights, especially for the shiny spots on the hair and the areas of the body that protrude outward. Use heavier pencil pressure on areas of shadow to create contrast.

POLKA DOT LADY

Add a pattern to the body. I used polka dots, however, any pattern that follows the cross contours of the body will look awesome!

Smooth the facial tones and use a kneaded eraser to bring out the highlights. Repeat on the remainder of the body as necessary.

Cross-contour lines describes the form and volume of an object. The pattern you create should travel across and around the form.

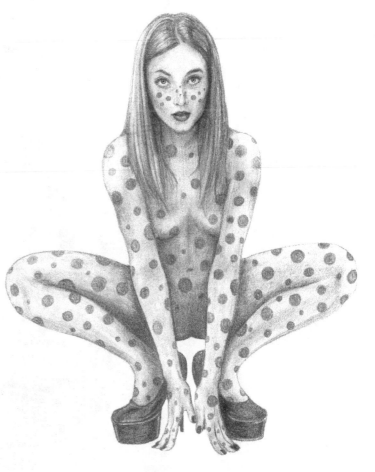

POTIONS

POTIONS

1

(1) Start with a simplified flask shape as a guideline. Make three of them, they can overlap.

2

(2) Add curves at the base and top of each task to show dimension.

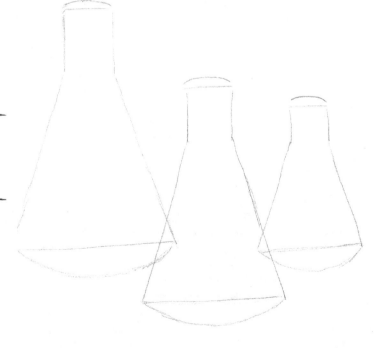

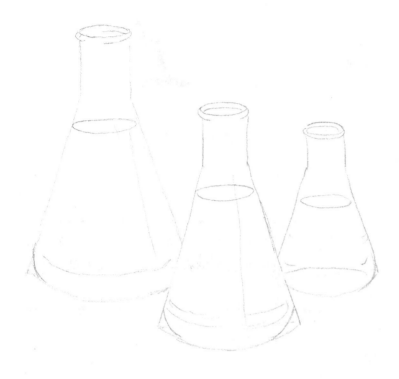

3

(3) Erase the guidelines no longer needed. Round the corners of the base of each flask. Draw an ellipses shape at the top of each, as well as where the liquid line is within the flask. Refine bases with line detail.

4

(4) Add a layer of tone to the "fluid" in each flask.

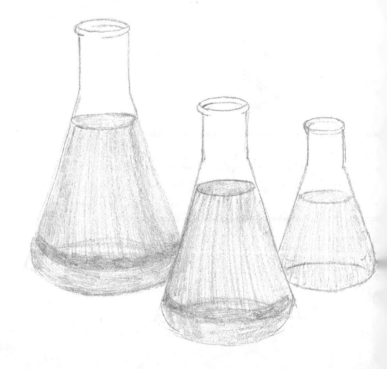

POTIONS

5

(5) Blend tones to smooth them. Add various sized circles for bubbles with outlines on them for highlights.

6

(6) Start to add some variation to the tone in each flask; focus on darker values on the sides, create contrast at liquid lines, and add texture at the bases. Add some tone to the bubbles.

POTIONS

7

(7) Smooth tones inside the bubbles then use a kneaded eraser to remove most of the pigment. This should leave a light, transparent look. Add more detail to the flasks to indicate the texture, depth, shadows and highlight.

8

(8) Erase the center of each bubble to make it appear even more transparent. Clean up any smudges in the flasks and add a more intense highlight on each by using a kneaded eraser.

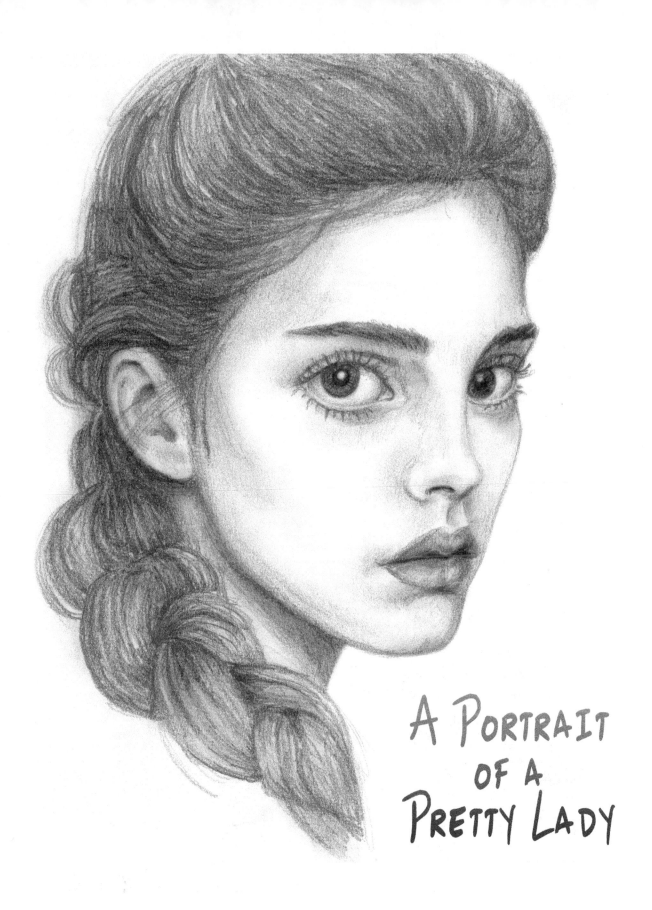

A Portrait
of a
Pretty Lady

PRETTY LADY

1

Start with an upside down egg shape. Draw a line through the center/side for the eye line. Draw short a line between the eye line and the bottom for the nose. Draw a line between the nose and the bottom for the lip guideline.

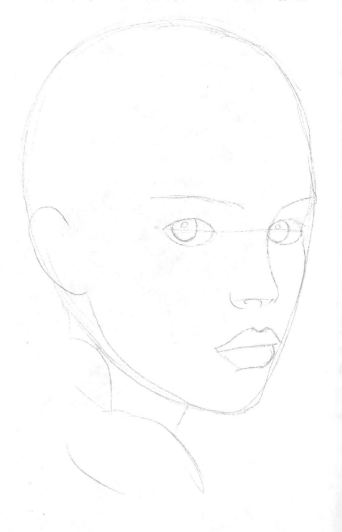

2

Add facial features on the guidelines. Refine the head shape to include brow bones and cheekbones. Draw a curve for the ear.

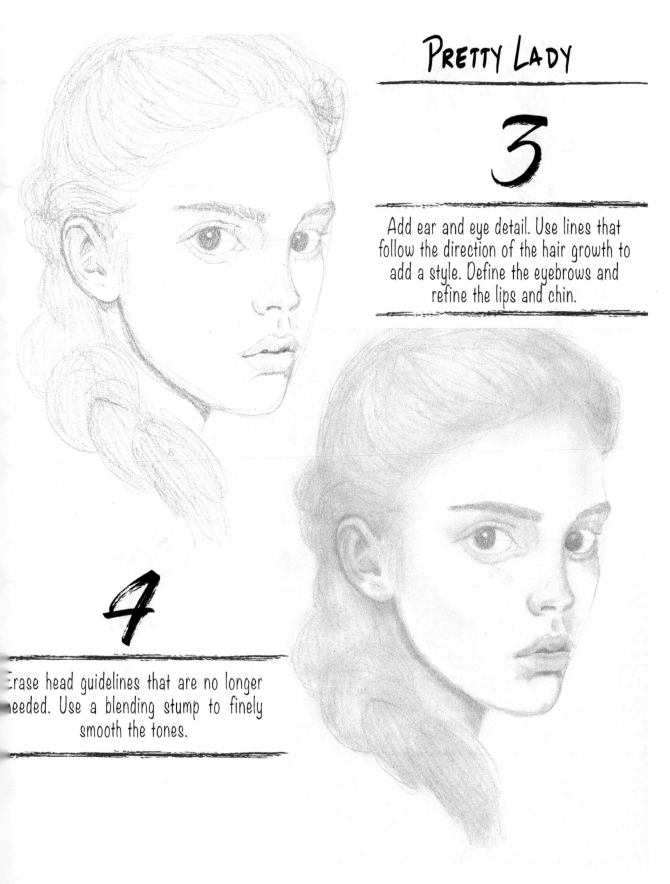

PRETTY LADY

3

Add ear and eye detail. Use lines that follow the direction of the hair growth to add a style. Define the eyebrows and refine the lips and chin.

4

Erase head guidelines that are no longer needed. Use a blending stump to finely smooth the tones.

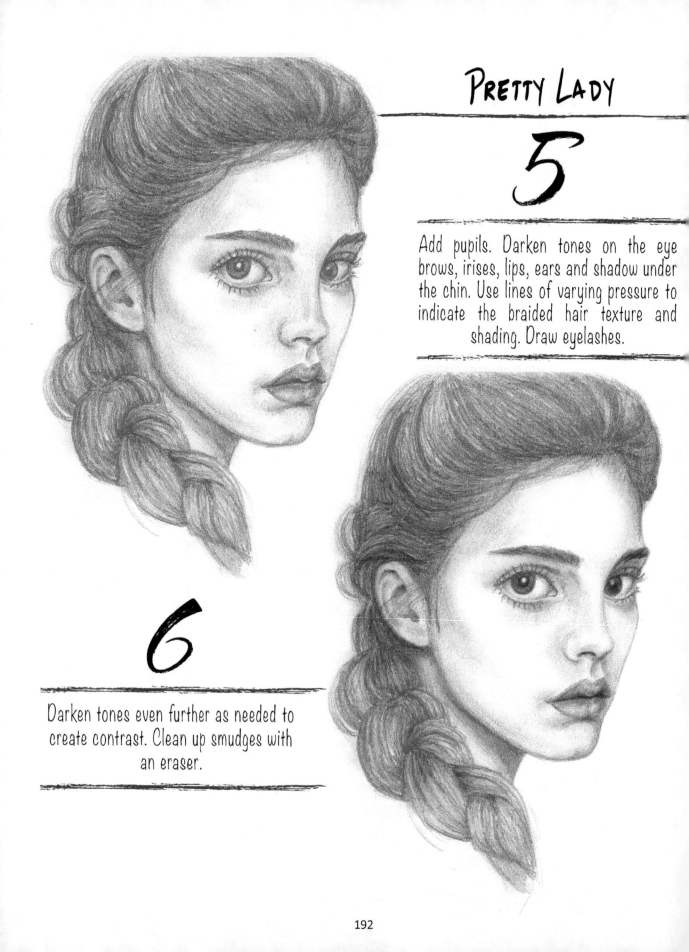

PRETTY LADY

5

Add pupils. Darken tones on the eye brows, irises, lips, ears and shadow under the chin. Use lines of varying pressure to indicate the braided hair texture and shading. Draw eyelashes.

6

Darken tones even further as needed to create contrast. Clean up smudges with an eraser.

MIDDLE FINGER

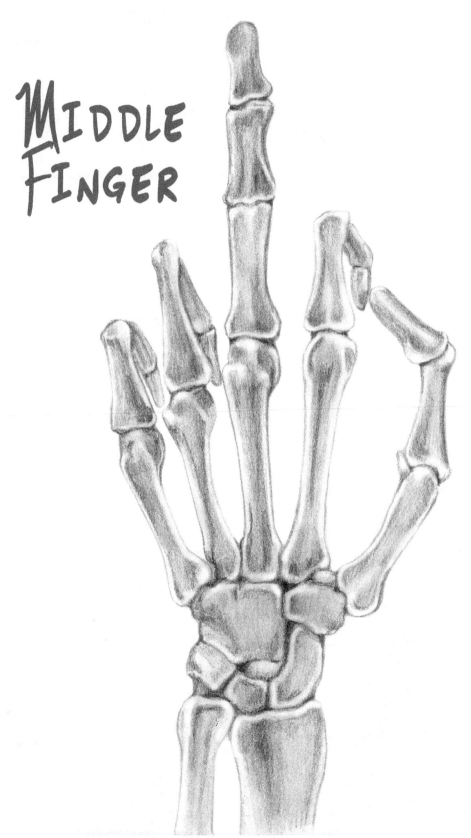

1

Middle Finger

(1) Draw lines as guides for the fingers and a line for the arm. If you want, you can just trace your own hand! Tip when tracing : position your hand in the proper pose and hold your pencil at a 90 degree angle to the paper to avoid distortion.

(2) Draw outline of bones. You can tell where each bone is located by looking at your own hand. Wherever there is a knuckle, that is a joint that separates the bones. Fingers have three, the thumb has two.

2

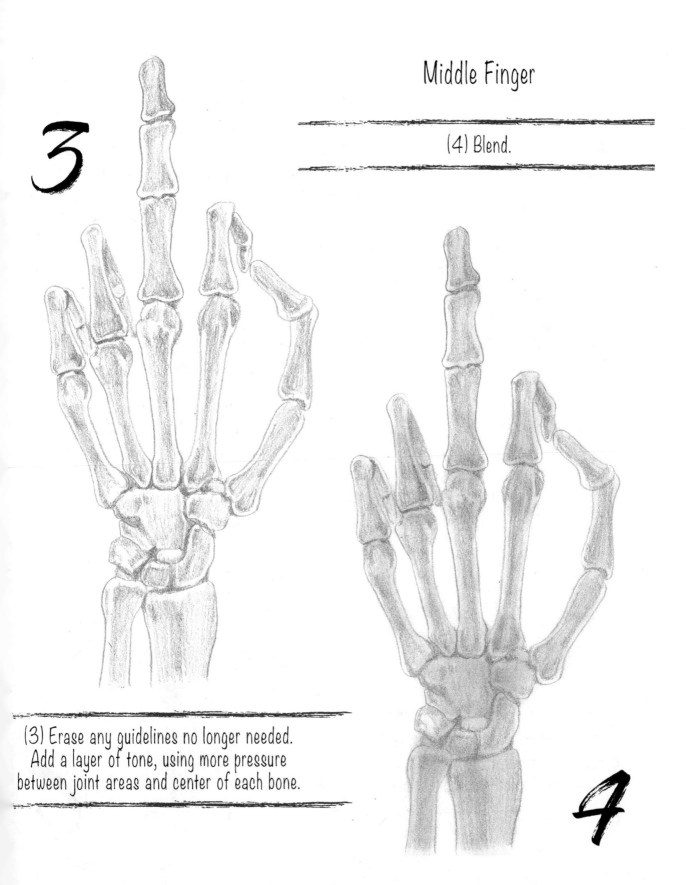

Middle Finger

3

(4) Blend.

(3) Erase any guidelines no longer needed. Add a layer of tone, using more pressure between joint areas and center of each bone.

4

Middle Finger

5

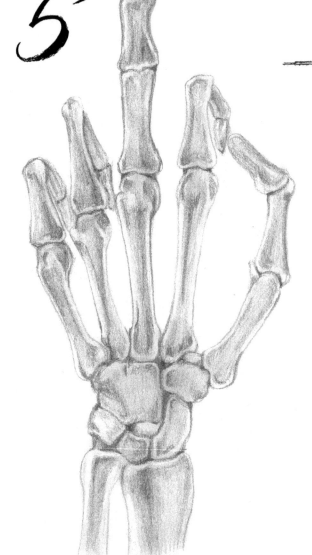

(6) Add contrast by making the dark areas darker and the light areas lighter by using a 6B or 8B pencil and a kneaded eraser, respectively. Clean up edges.

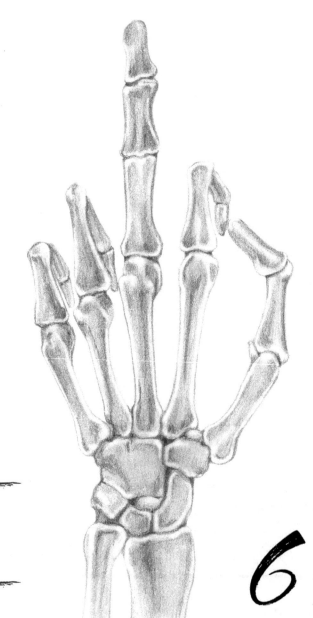

(5) Clean up smudges with eraser. Add more detail with tone: pressing harder in areas of darkness, lighter in areas of highlight.

6

196

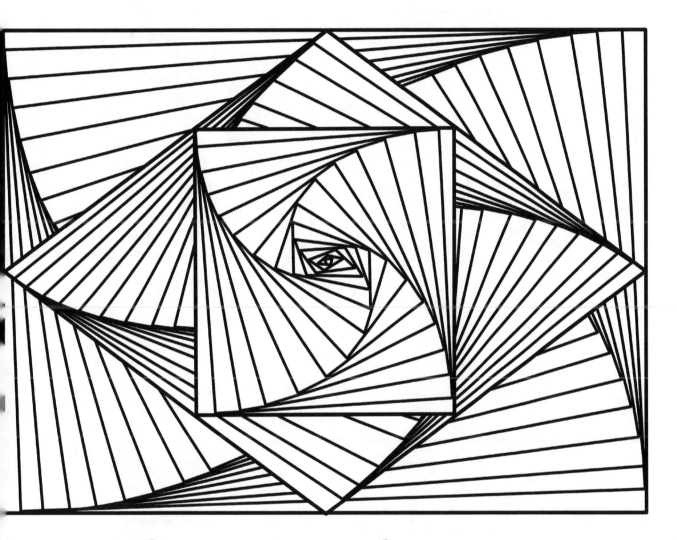

SPINNING SHAPES

Spinning Shapes

Start by drawing a rectangle using a fine point pen. You can use a ruler, however, it will still look cool if you draw it free hand! Draw a rhombus (diamond shape) inside of it. If you want to get technical, find the center of each side of the rectangle, mark it, and make sure each point of your rhombus touches the mark.

Draw a square inside the rhombus.

Spinning Shapes

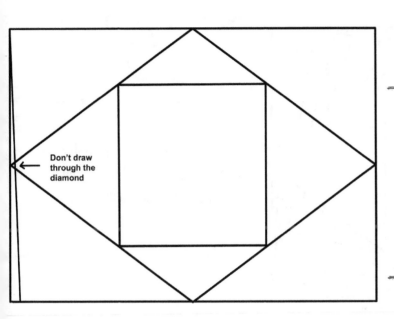

Don't draw
through the
diamond

Then, starting from any corner of the original rectangle, draw a straight line to the opposite side of the paper to form a long skinny triangle. Be sure to skip over the center rhombus shape, just pick the line up on the other side.

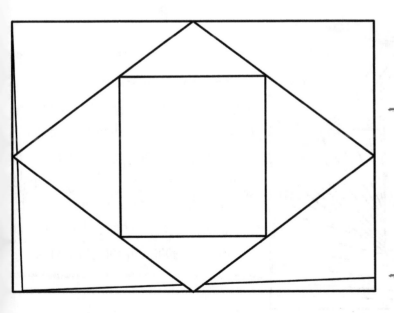

4

Start another long, skinny triangle where the wide end of the first one finished, and continue the new triangle to the adjoining perpendicular wall of the rectangle. Again, do not draw through the rhombus shape.

Spinning Shapes

5

Repeat drawing lean triangles until the whole area behind the rhombus is full. The end result will be fan-like.

6

Do the same thing again, this time inside of the rhombus. Start from any corner inside the rhombus, draw a straight line to the opposite side of the shape to form a long skinny triangle. Be sure to stop drawing once you hit the center square shape, then pick up the line again on the other side.

7

Finally, follow the same steps inside the square: Start from any corner inside the square, draw a straight line to the opposite side of the shape to form a long skinny triangle. You don't have to stop this time, just keep going until the entire space is closed.

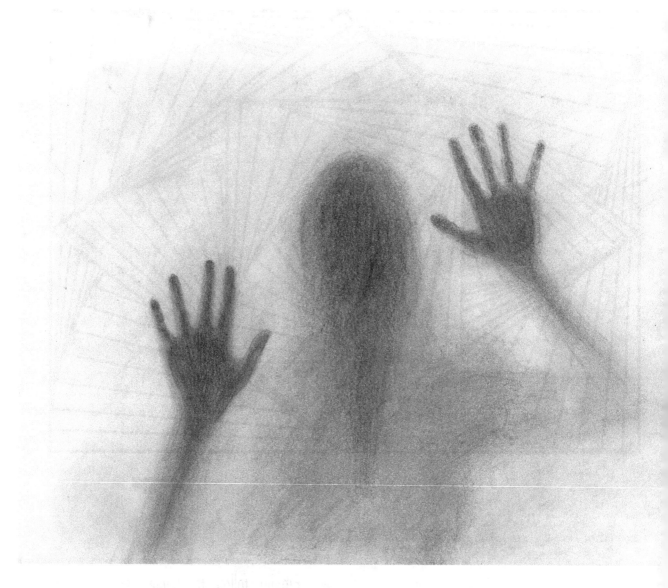

Spooky Silhouette

Spooky Silhouette

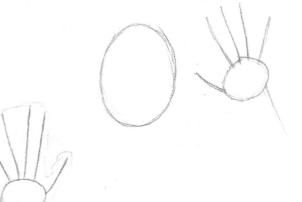

Start with simple head shape and two circles to indicate palms of hands. Add lines to indicate fingers.

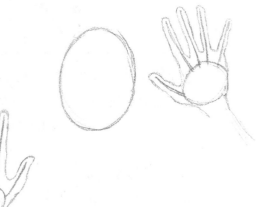

Add wrists. Refine the hand by shaping the fingers, using the lines as guides.

Spooky Silhouette

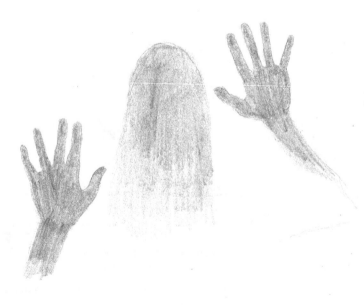

3

Erase the guides no longer needed. Further extend wrists, creating loose suggestion of arms.

4

Start to fill in with a light layer of tone. I used a 6B pencil on it's side (as opposed to the tip). I also used the original circle head shape as a guide to create a more undefined shape. This should be shaded with heavier pencil pressure near the top that gradually gets lighter as it moves downward.

Spooky Silhouette

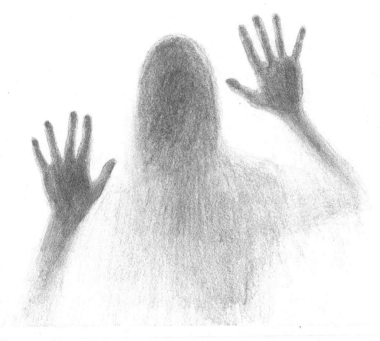

5

Add another layer of tone. Darken the hands, taper off the tone as it moves down the arms and away from the head.

6

Add a light layer of tone the the area around the silhouette. Use the side of the pencil to quickly block in the area. Blend all tones using a tissue moving in a swirling, circular motion. Smaller blending tools will be too fine.

Spooky Silhouette

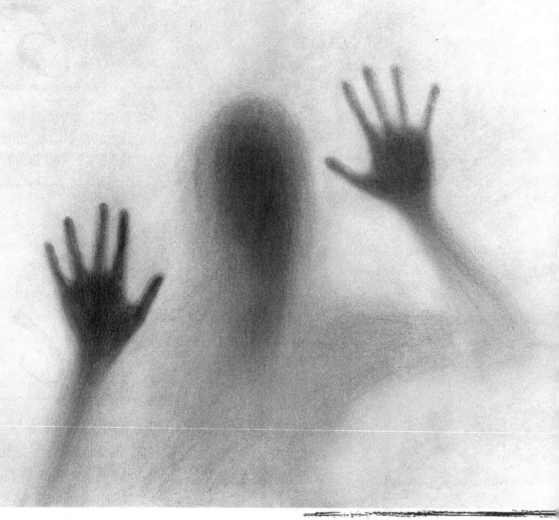

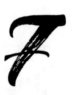 This blending will have likely smoothed away some of the darkest and lightest tones, creating a flat gray. Go back in with a dark pencil (6B or 8B) and recreate the darkest darks. Then clean up the lightest areas with a kneaded eraser.

SQUISHY EYE

SQUISHY EYE

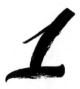

1

Start with a circle for the eye and lines as guides for where the fingers and hand will go.

2

Using the guidelines, draw the fingers and hand. Also add where pupil will be.

Squishy Eye

3

Refine the finger shapes by adding lines at the joints. Draw the folded fingers and add finger nails and wrinkles. Also add further detail to eye.

4

Add a light layer of tone, using heavier pencil pressure in areas of shadow and less pressure in areas of highlight.

Squishy Eye

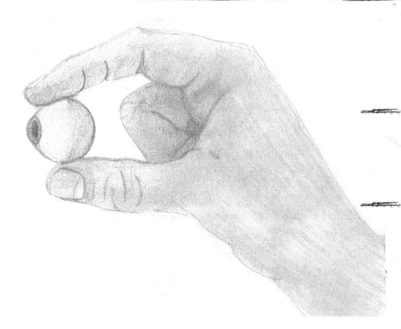

5

Smooth the tones with a tissue to lightly blend them.

6

Remove any remaining guide lines. Add variation to the tone, pressing harder in areas of darkness including skin creases and shadows. Draw small lines on iris and sclera of eyeball.

Squishy Eye

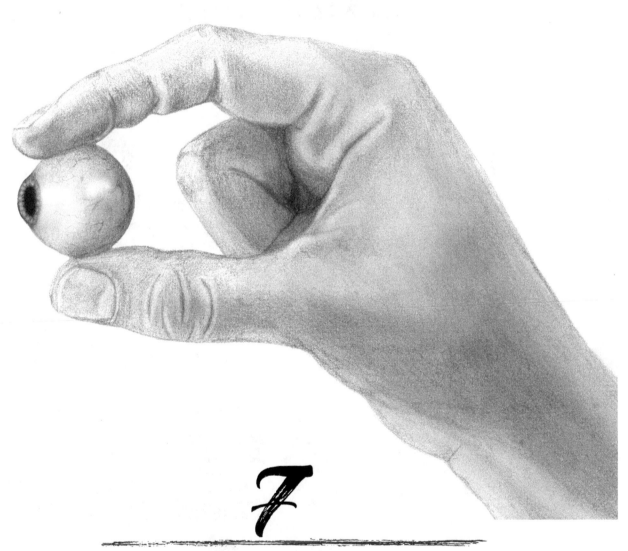

7

Add the finishing touches, including more pencil pressure in areas of darkness for contrast and using a kneaded eraser for highlight. Concentrate on lightening the edges of the knuckle creases and shiny spots on the eye ball.

STRETCH HEADS

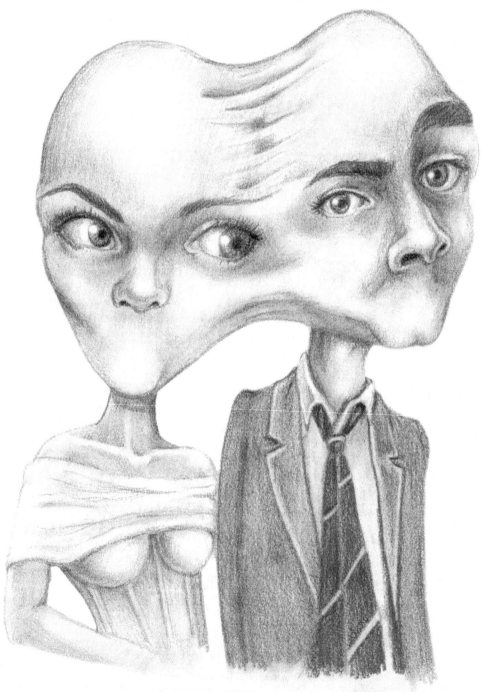

STRETCHY HEADS

1

1. Draw two ovals for heads and lines for bodies as shown. Draw simple lines to indicate where the eyes and nose will be.

2

2. Add facial features and an arm as shown. The sizes don't have to match up. Have fun with the placement! Notice how one of the eyes is drawn partially off of the head.

STRETCHY HEADS

3

3. Connect the heads with curved lines. Add lines to indicate a clothing style of your choice. I put fancy outfits on them.

4. Remove guidelines and add a quick layer of tone, pressing harder in areas of shadow, lighter in areas of highlight.

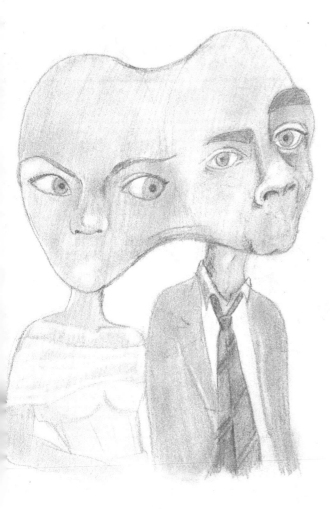

5

5. Blend tones using a paper stump or tissue. Go back in later with a kneaded eraser to remove pigment from highlights. Add deeper tone to darkest areas using a 6B pencil.

6

6. Add another layer of tone to create more contrast. Add in wrinkles, more detail to clothing, and more detail to the face.

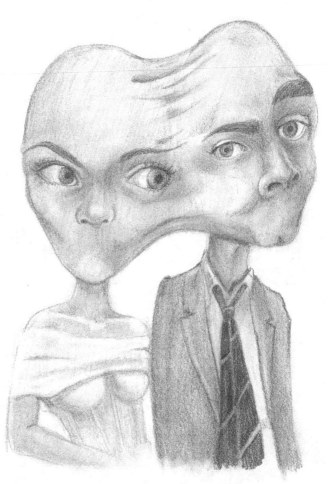

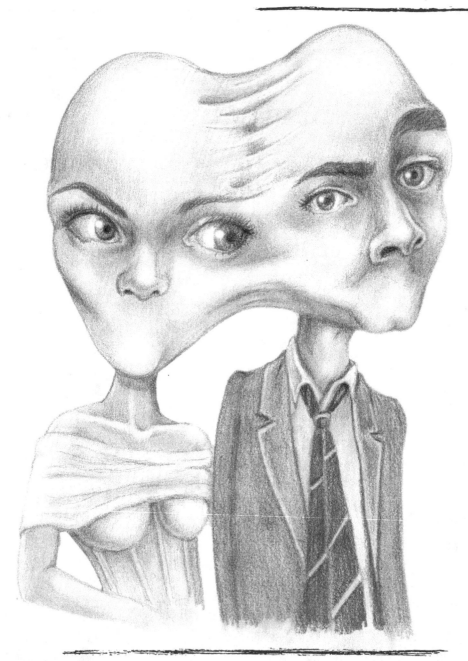

7. Clean up any smudges with an eraser, also use said eraser for highlight areas (stretch marks, clothing, and facial features). Darken the darkest areas to create even more contrast, including the pupils, upper eye line and shadows.

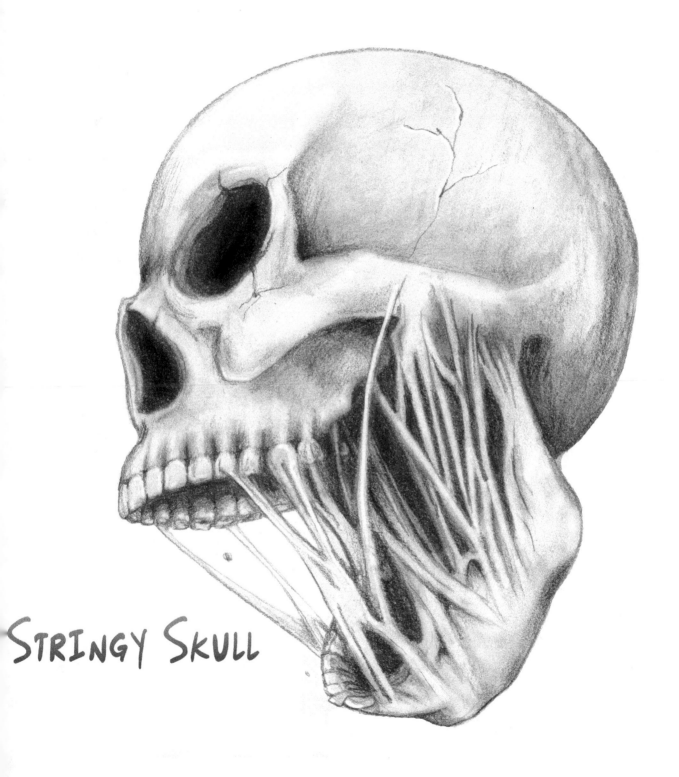

STRINGY SKULL

STRINGY SKULL

1

Start with a circle for the cranium. Add curves for jaws. Draw an oval shaped eye hole. near the top left of the circle. The angle of the skull in this drawing calls for an unusual shape and placement of the eye socket.

2

Add protrusion for nose area. Refine jaws to make them more 3D.

3

Erase guidelines. Add teeth. Draw long stringy lines connecting the the top of the cranium to the bottom jaw. Draw the lines closer together as they near the back teeth.

4

Add a layer of tone. Press harder in areas of shadow and lighter in areas of highlight.

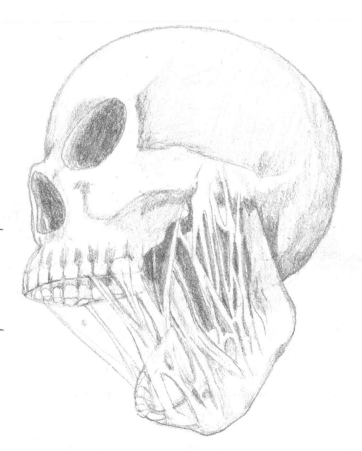

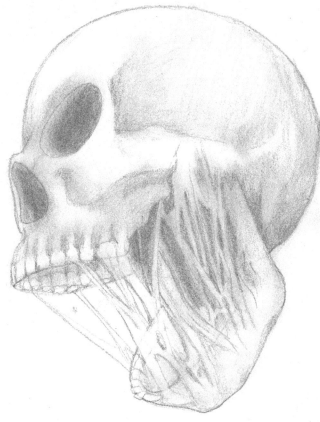

5

Blend tones.

6

Clean up smudges with an eraser. Add a variety of values: pressing harder in areas of darkness, lighter in areas of highlight. Add cracks on the side of the skull. Use an eraser along the edge to bring out the highlights in the cracks.

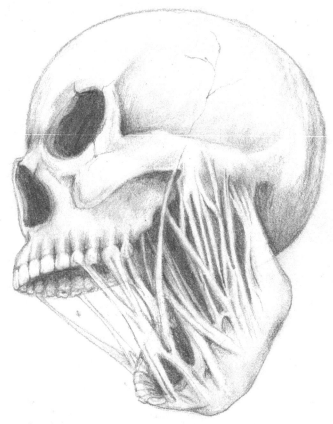

220

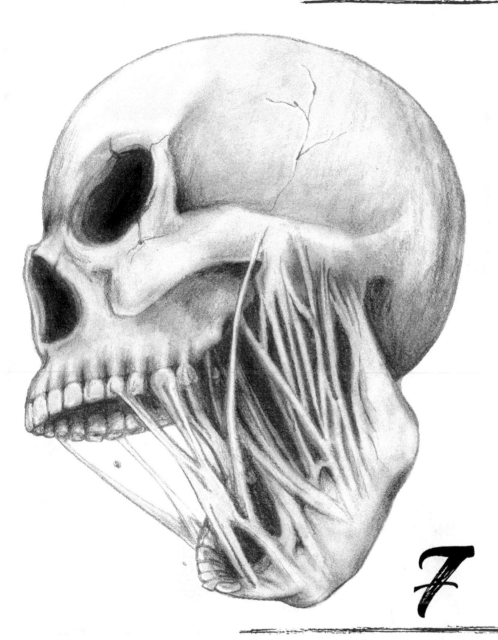

7

Clean up edges again. Create more contrast using
heavy pressure in dark areas, use a kneaded eraser
to highlight the lighter areas.

TIP TOES

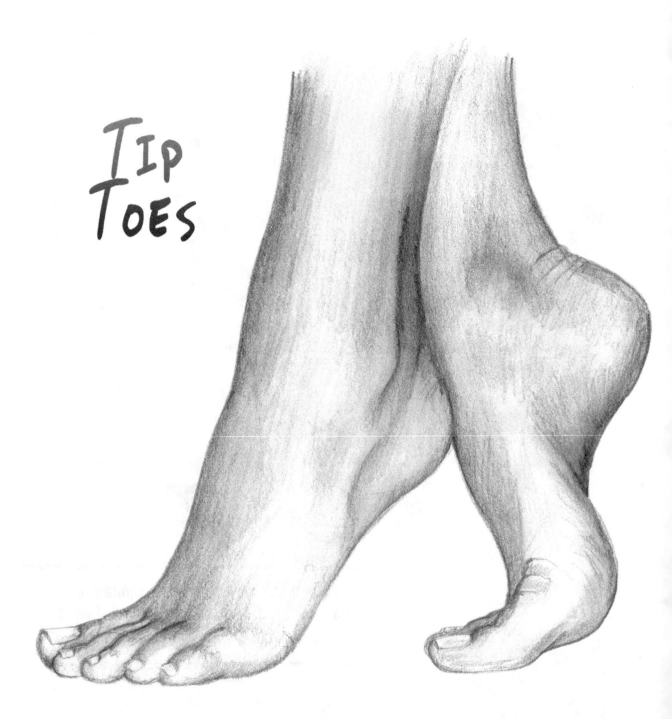

TIP TOES

1

Start with circles for the heels. Draw guidelines below them to help lay out the bend of the foot. Draw curved lines above to form the back of the legs.

2

Use the guides to form the feet. Add ankle detail and toes.

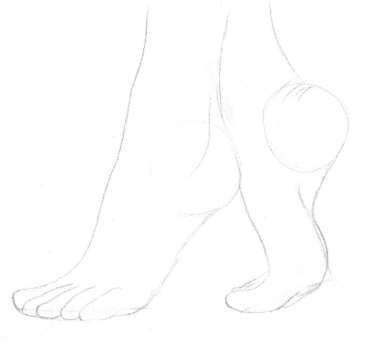

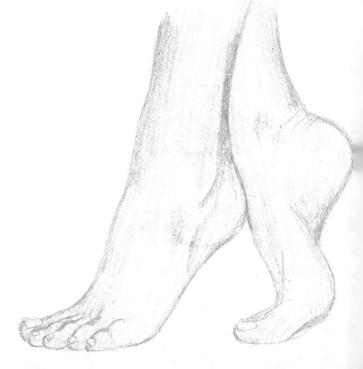

3

Add toe nails. Erase the parts of the circle guidelines that are no longer needed. Also add wrinkles/creases of skin.

4

Add a light layer of tone.

TIP TOES

5

Blend tones to smooth them.

6

Go over the drawing again with another layer of tone, using heavier pencil pressure for areas of darkness, light pressure for areas of highlight.

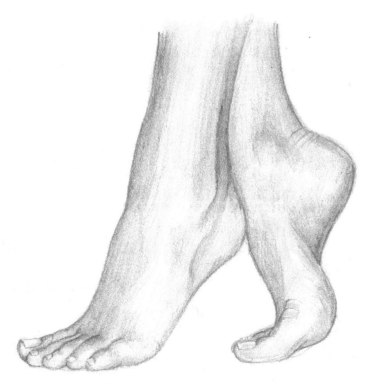

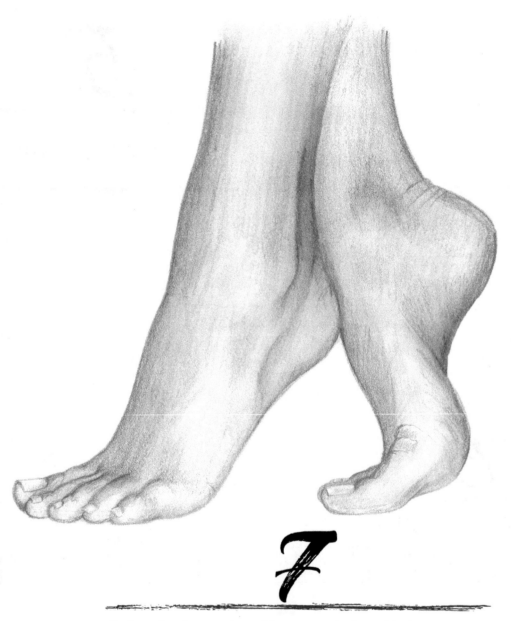

7

Refine the drawing by adding more dark and light contrast
to create depth and interest.

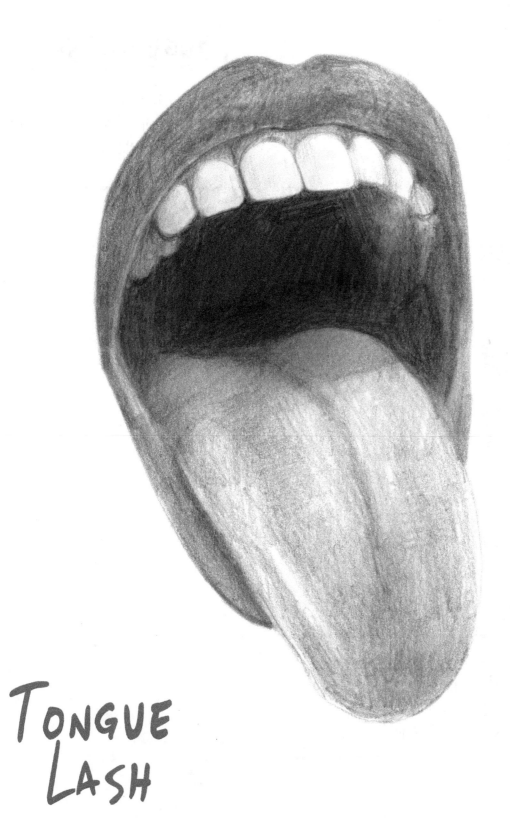

TONGUE
LASH

TONGUE LASH

(1) Start with a circle for the open mouth and a tongue shape coming from it. Add a curved line above for the lip guideline.

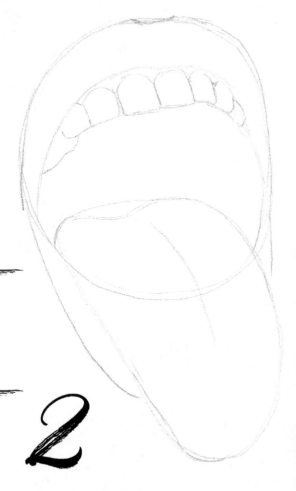

(2) Refine the mouth to include a cupid's bow and lower lip. Reshape the tongue and add an upper row of teeth, curved at the top to represent the gum line.

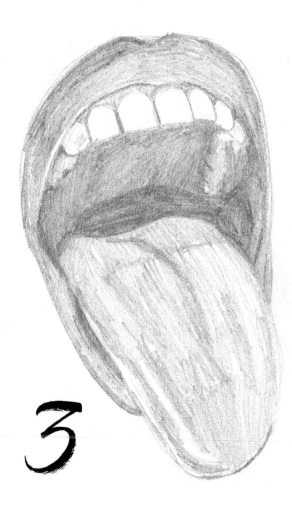

3

(4) Blend tones and add another layer of
shading, pressing harder with the pencil for
darker tone, lighter for areas of highlight.

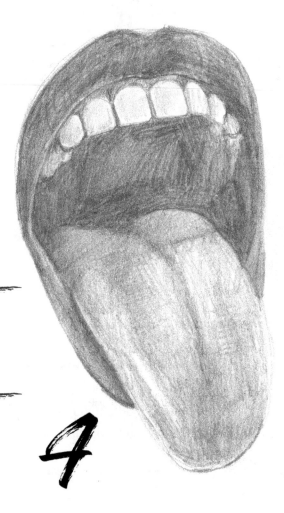

4

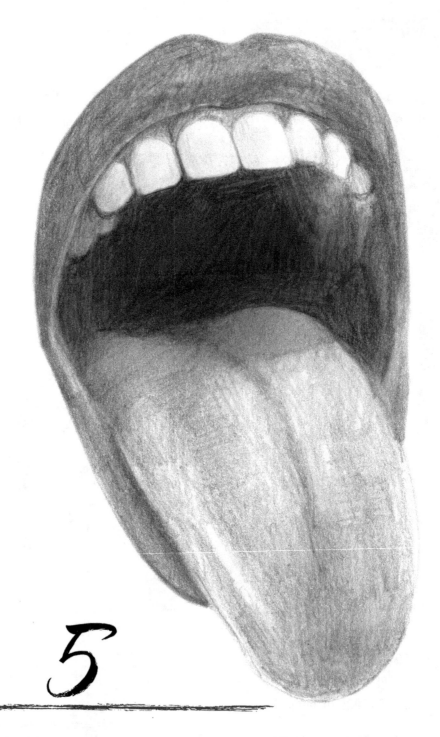

5

(5) Refine the drawing by adding more contrast as needed and cleaning up any smudges with an eraser.

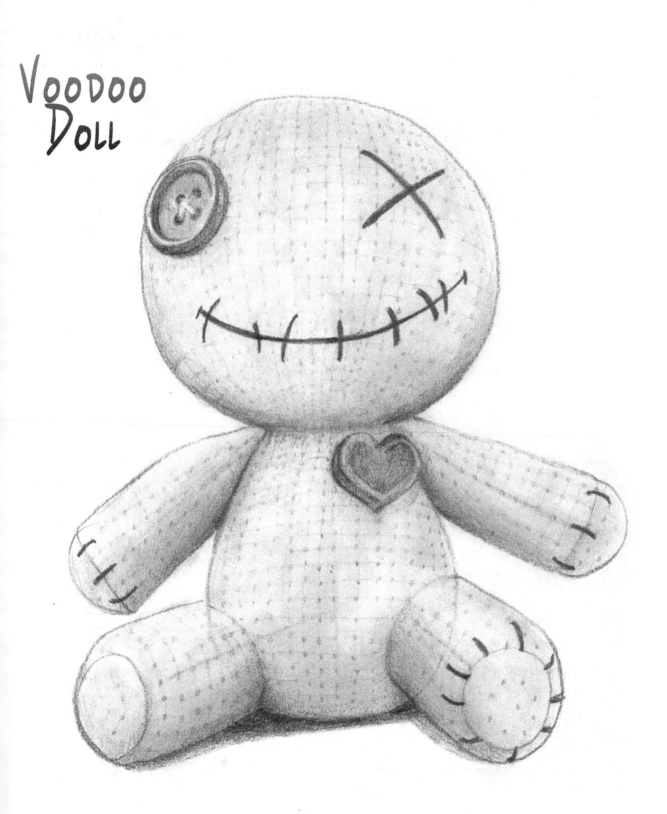

VooDoo
DolL

Voodoo Doll

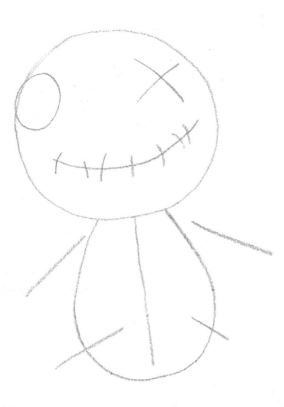

1

Start with large circle head. Add lines as guides to indicate torso, arms and legs.

2

Draw fun facial features such as a circle button eye or simple stitches. Use the center guideline to draw a rounded body shape.

VOODOO DOLL

3

Add the arms and legs. Curve the ends of each so they look cylindrical. Draw a heart or other button style on it's chest.

4

rase the guidelines that are no longer eeded. Add a light layer of tone. This in-ludes added depth and highlight to the button eye.

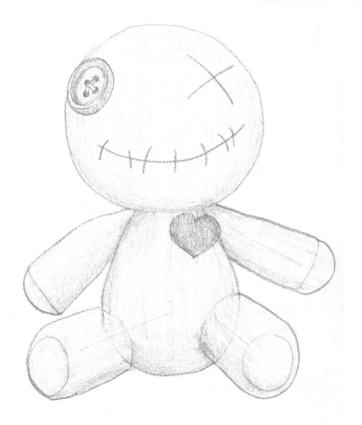

Voodoo Doll

5

Use a blending tool to smooth the tones into one another.

6

Add another layer of tone. Deepen shadows near where head and arms and legs meet the body. Draw cross-contour lines that wrap around the doll to indicate volume and form. They will also serve as a pattern.

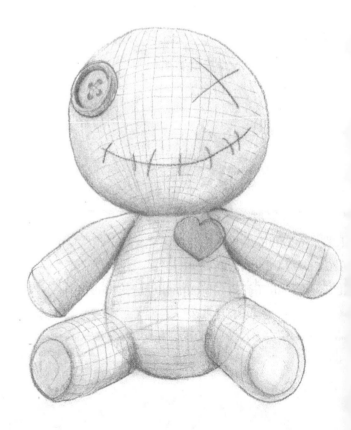

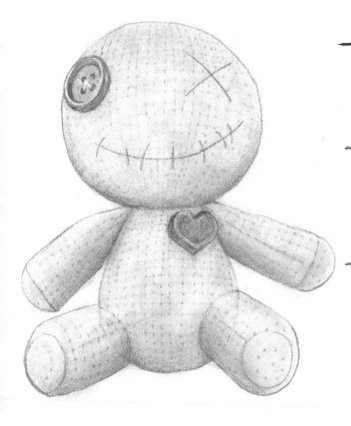

Voodoo Doll

Draw small dots where cross contours meet. More contrast/shading on button, eye, and heart. Bend tones to smooth them more. Lighten highlights with kneaded eraser.

Darken stitches in the shadowed areas if necessary. Use a kneaded eraser to remove most of the pigment from the center of the face and belly as well as the tops of the arms and legs. Finalize the drawing with a subtle shadow under the doll.

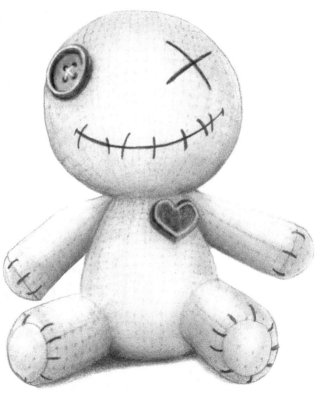

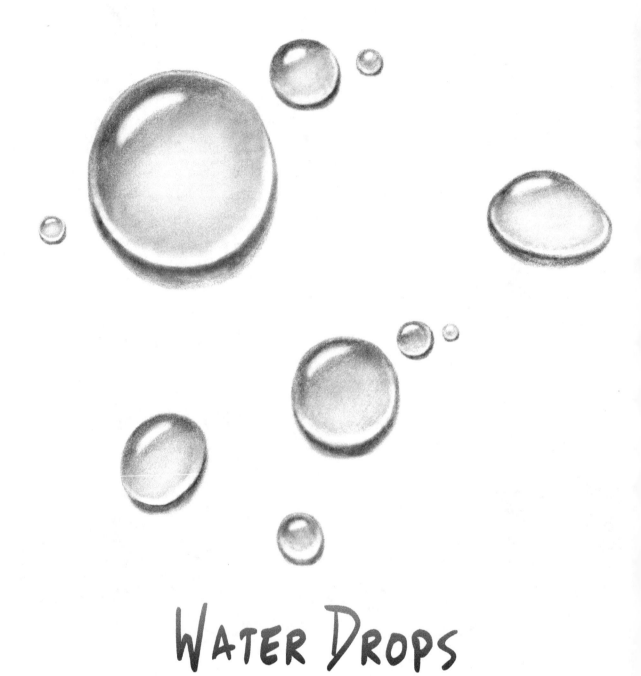

WATER DROPS

WATER DROPS

1

Start with a few circular/organic shapes. These will be the outlines for the water droplets.

2

Add a shadow to the underside of each drop as shown. Lightly outline the areas where the brightest spots will be.

WATER DROPS

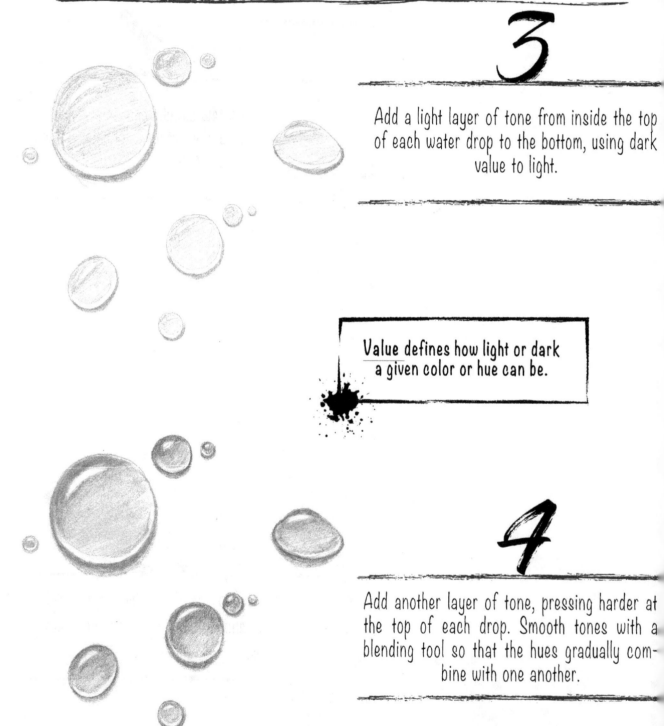

3

Add a light layer of tone from inside the top of each water drop to the bottom, using dark value to light.

Value defines how light or dark a given color or hue can be.

4

Add another layer of tone, pressing harder at the top of each drop. Smooth tones with a blending tool so that the hues gradually combine with one another.

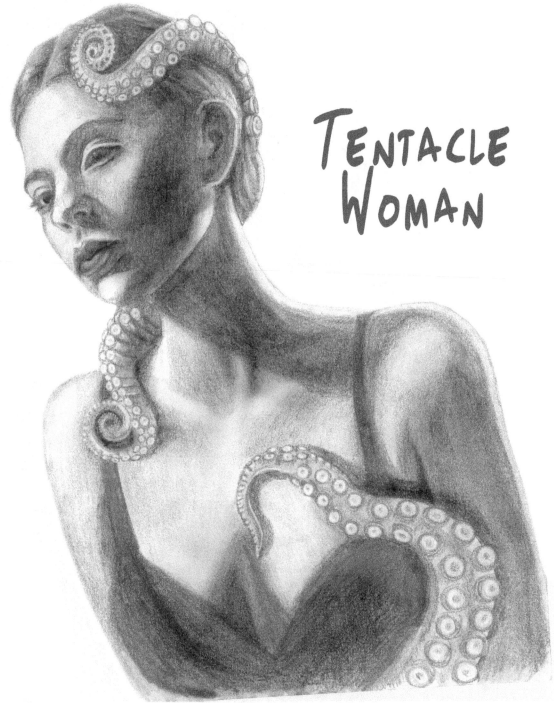

TENTACLE
WOMAN

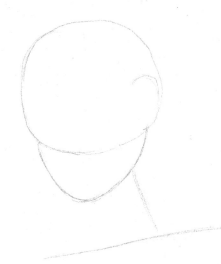

TENTACLE WOMAN

1

(1) Start with a circle for the top of the head and a curve for the jawline. Add guidelines for the neck and shoulders. Draw a small curve for the ear.

2

(2) Add guidelines for facial features and collar bones. Start to mark in the arms and bust.

3

(3) Start to add facial features and curved lines as guides for the tentacles.

4

(4) Add a layer of tone. Notice the sharp shadows falling across the form, indicating an intense light source. Add tone for hair and clothing.

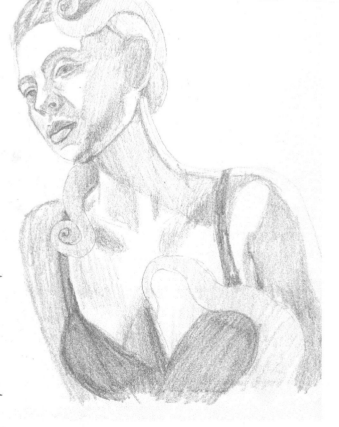

TENTACLE WOMAN

5

(5) Add more tone to create sharp shadows and more contrast.

6

(6) Use kneaded eraser to highlight areas, including tentacle cups. Darken shadows for even more contrast.

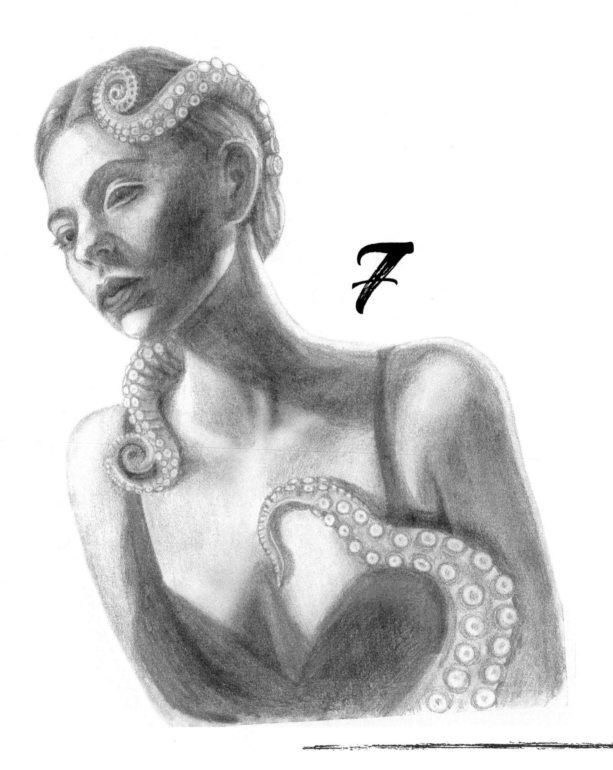

7

(7) Use a kneaded eraser to highlight areas, including tentacle cups. Darken shadows for even more contrast.

Draw Awesome Stuff

Congratulations on making it this far in the book! Did you know that the majority of people who purchase books never actually finish reading them? But you have, and that shows your dedication to your art goals. Now, let's take your skills to the next level with some exciting and unconventional drawing ideas.

While step-by-step tutorials are beneficial to beginners, it's important not to limit your creativity by strictly following each and every step. Instead, it's essential to explore your own ideas and experiment to develop your skills as an artist. By doing so, you can discover your own unique style and approach, which can set you apart from others. Additionally, experimentation helps you to develop a deeper understanding of different techniques and mediums, allowing you to create more complex and meaningful works of art. So, I would like to encourage you to go your own way and challenge yourself to create something completely from your imagination! After all, It's through taking risks and experimenting that true artistic growth can occur.

The upcoming pages feature a variety of wacky drawing prompts that are designed to push you out of your comfort zone and ignite your creativity. I'll provide you with the necessary tools to bring these awesome drawings to life, but the rest is up to you! I've also given these same ideas to my students and included their results at the end of each prompt.

Just remember - it's not a competition! **Have fun** and don't worry about making your drawing look as awesome as someone's else's, the purpose here is to inspire you and give you a glimpse into how other artists can interpret the same idea! Once you've created your masterpiece, feel free to share it on social media and tag us! We'll do our best to repost and share your art with the rest of the world.

Now, let's draw some awesome stuff!

IDEA #1

DRAW AN AVOCADO SUPERHERO
(WITH CARROT NUNCHUCKS)

DRAW AN AVOCADO

(1) Start with an oval for the outer layer with a large circle inside for the seed.

(2) Add rough, thicker line around the outside to represent the skin.

DRAW AN AVOCADO

(3) Add a light layer of tone, concentrating on making the seed darker than the flesh.

(4) Darker the outer skin rim. Create shadow around the seed. Blend.

DRAW A CARROT

(1) Start with a long, lean triangle with slightly bumpy edges for the carrot. Add a few lines at the top for the carrot greens (fronds).

(2) Add lines through the length of the carrot to help indicate form.

DRAW A CARROT

(3) Add a light layer of tone.

(4) Use a kneaded eraser formed into a point and drag it above the short lines drawn in step 2 for highlight. Blend.

Draw Your Own!

Turn the page to see examples from my students!

Ethan, Age 11

Taya, Age 8

C. Andreas

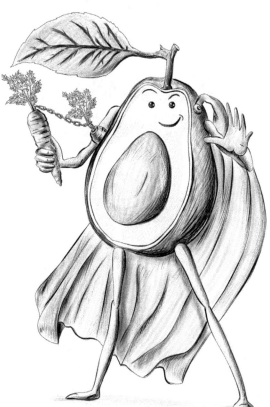

Count Catcula

Does the title make you think of a vampire? If so, use the tutorial below to help you draw some awesome fangs.

Other ideas:

Widows peak, black cape

Count Catula

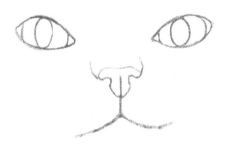

(1) Draw almond shaped ayes, a mushroom shaped nose and "W" mouth as shown.

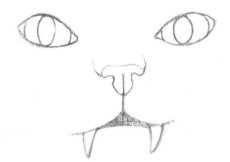

(2) Add fang and mouth detail.

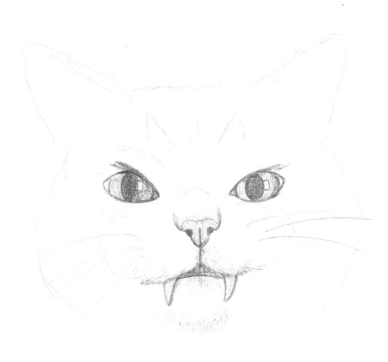

COUNT CATULA

(3) Add a light layer of tone.

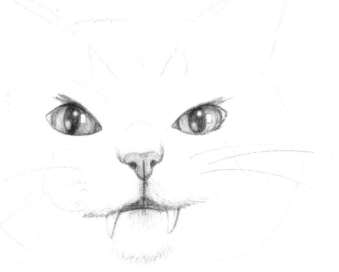

((4) Add more contrast as needed.

DRAW YOUR OWN!

I asked my students to draw Count Catula, turn the page to see what they did...

257

Teddy, Age 11

Teddy, Age 11

Katie

C. Andreas

Idea #3

Evil Coffee Cup

All you need is a coffee cup then you can go from there.
Coffee cup form is based on the **Cylinder.**

Other Ideas:

Add a pointy devil tail or horns.

Evil Coffee Cup

(1) For a slight birds eye view, draw two ellipses. The lower one can be a bit smaller.

> A cylinder is a three-dimensional shape consisting of two circular or elliptical bases joined by lines on the sides.

(2) Connect with lines as shown.

EVIL COFFEE CUP

(3) Erase the portion of the lower ellipse that is no longer needed.

(4) Add handle as desired.

Draw Your Own!

I asked my students to draw an evil coffee mug, turn the page to see what they did...

Pete

Charlotte, Age 8

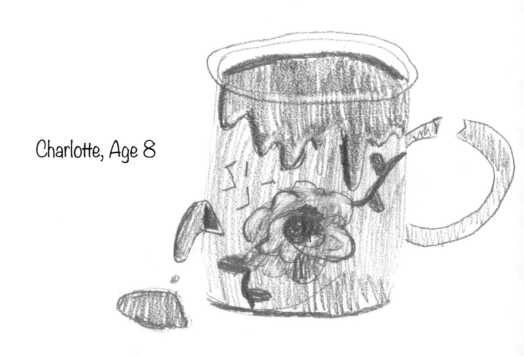

Katie

C. Andreas

Idea #4

Adorable Shy Ocean Creature

A shy creature might hid behind its flippers/fins or just have
their eyes peeking over the surface of the water. Let's draw
a set of adorable eyes with larger pupils and lots of shiny
spots for an innocent appearance . . .

Adorable Eyes

(1) Start with a circle inside of a circle.

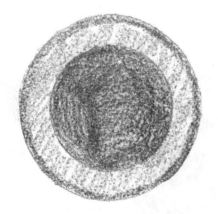

(2) Add a light layer of tone. The inner circle should be darker than the outer.

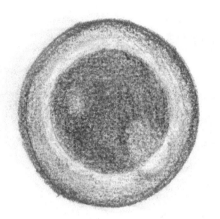

Adorable Eyes

(3) Use a kneaded eraser and remove pigment around the rim of the pupil. Darker outer iris. Use eraser to mark highlights. (Images for these are in eyes 1)

(4) Clean up smudges and deepen the dark tones and lighten the light tones.

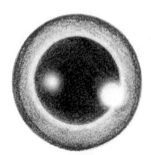 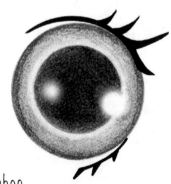

(5) Add long lashes.

DRAW YOUR OWN!

I asked my students to draw an adorably shy ocean creature, turn the page to see what they did...

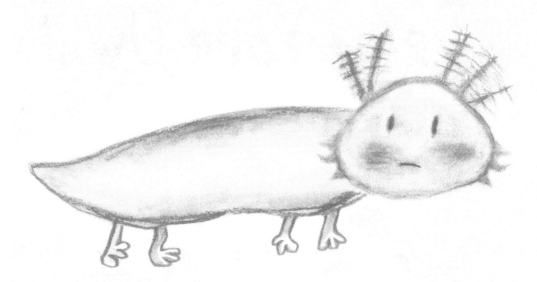

Charlotte, Age 8

C. Andreas

Katie

Idea #5

Spaghetti Monster
Playing the Violin

Draw Some Spaghetti

Tubes. Tube form is based on the cylinder. Since spaghetti is very long and thin, the ellipses on the cylinder will be very small and the connecting lines will be very long. Simplify with simple lines if you don't have the time or patience, however, try not to scribble!

(1) Draw two small ellipses.

(2) Connect with lines as shown

(3) Erase the portion of the lower ellipse that is no longer needed - or keep both for a twisty appearance.

VIOLIN

(1) Start with two ovals; one for the top of the violin and one for the base.

> A great shape to start with for this is the oval.

(2) Connect oval with lines shown.

VIOLIN

(3) Outline this shape by closely following its contour.

(4) Follow the contours again to make a 3D edge as shown.

VIOLIN

(5) Add the neck and F holes

(6) Erase the guidelines no longer needed. Add center details including tailpiece, strings and scroll.

DRAW YOUR OWN!

CVH

Jeff Menice

Katie

C. Andreas

WHY IS ART IMPORTANT?

Art has long been a cornerstone of human culture, transcending time and space to enrich our lives and shape our understanding of the world. Its significance stems from its ability to communicate complex emotions, ideas, and experiences, which makes it a powerful tool for personal expression and societal reflection.

Firstly, drawing serves as a powerful medium for self-expression and emotional release. It allows artists to externalize their thoughts, feelings, and perspectives, fostering introspection and self-awareness. By translating complex emotions into tangible artwork, artists can better comprehend and manage their internal world, contributing to their overall well-being.

Secondly, artistic drawing plays a crucial part in cognitive development. It engages multiple areas of the brain, stimulating neural pathways and fostering the growth of new connections. Drawing enhances problem-solving, memory, attention, and spatial awareness, equipping individuals with vital skills for success in various aspects of life.

By working through drawing exercises, artists not only bolster their creativity and artistic self-assurance but also acquire potent tools for comprehending the intricacies of visual creations. Students are essentially rewiring their brains to perceive the world in a novel way. This empowers them to express themselves while becoming proficient, astute, literate, imaginative, inventive, and insightful in both art and life. With enough practice, students will outgrow the need for a "how-to" guide. A mental shift will transpire, and they'll effortlessly dissect the simple image concealed behind the complex one without any help.

So, spread the word to your students, colleagues, and the whole world that ART MATTERS! And if you found value in this book, please leave it a kind review and share it with your friends and family :)

Thank you!

Catherine V. Holmes

OTHER BOOKS IN THE "HOW TO DRAW COOL STUFF" SERIES

How to Draw Cool Stuff shows simple step-by-step illustrations that make it easy for anyone to draw cool stuff with precision and confidence. These pages will guide you through the basic principles of illustration by concentrating on easy-to-learn shapes that build into complex drawings. With the step-by-step guidelines provided, anything can become easy to draw.

This book contains a series of fun, hands-on exercises that will help you see line, shape, space and other elements in everyday objects and turn them into detailed works of art in just a few simple steps.

How to Draw Cool Stuff is suitable for artists of any age benefiting everyone from teachers and students to self-learners and hobbyists. How to Draw Cool Stuff will help you realize your artistic potential and expose you to the pure joy of drawing!

How to Draw Cool Stuff: Basics, Shading, Texture, Pattern and Optical Illusions is the second book in the "How to Draw Cool Stuff" series. Inside you will find simple illustrations that cover the necessities of drawing cool stuff. Specific exercises are provided that offer step-by-step guidelines for drawing a variety of subjects. Each lesson starts with an easy-to-draw shape that will become the basic structure of the drawing.

From there, each step adds elements to that structure, allowing the artist to build on their creation and make a more detailed image. Starting with the basic forms, the artist is provided a guide to help see objects in terms of simplified shapes. Instructions for shading to add depth, contrast, character and movement to a drawing are then covered. The varieties of texture and pattern that can be included in an artwork offer another layer of interest and depth to a design.

How to Draw Cool Stuff: Holidays, Seasons and Events is a step-by-step drawing guide that illustrates popular celebrations, holidays and events for your drawing pleasure. From the Chinese New Year to April Fools' Day, Father's Day to Halloween, Christmas and New Year's Eve - this book covers over 100 fun days, holidays, seasons and events, and offers simple lessons that will teach you how to draw like a pro and get you in the spirit of whichever season it may be!

The third book in the "How To Draw Cool Stuff" series, this exciting new title will teach you how to create simple illustrations using basic shapes and a drawing technique that simplifies the process of drawing, all while helping you construct height, width and depth in your work. It will guide you through the creative thought process and provide plenty of ideas to get you started.

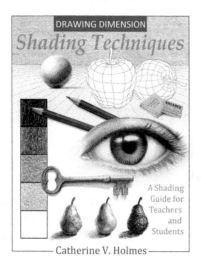

Drawing Dimension - A Shading Guide for Teachers and Students offers a series of shading tutorials that are easy to understand and simple to follow. It goes beyond the standard "step by step" instruction to offer readers an in-depth look at a variety of shading techniques and their applications.

Inside this book is a series of lessons designed to teach you how to add dimension to your own drawings, how to analyze real life objects and shade, create highlights, blend tones, and produce realistic drawings with ease. We will explore hatching, cross hatching, and stippling techniques and learn how to use contrast to set a mood and create a focal point. At last- we'll put all of these skills to the test and work together to produce a beautiful piece of art.

Five minutes may not seem like a lot of time to allow yourself to work on a drawing, as artists have been known to take days, months, and even years to complete a single work of art. However, as this book will prove, you can draw some really cool stuff in just under five minutes. By limiting their time, artists will start to see only the most essential parts of a subject while communicating action, movement, and expression into one timed drawing.

The fifth book in the "How To Draw Cool Stuff" series, **How to Draw Cool Stuff: The 5 Minute Workbook** will teach you how to create simple illustrations using basic shapes and a drawing technique that simplifies the process of drawing, all while helping you construct height, width, and depth in your work. It will guide you through the creative thought process and provide plenty of ideas to get you started.